David Shepherd

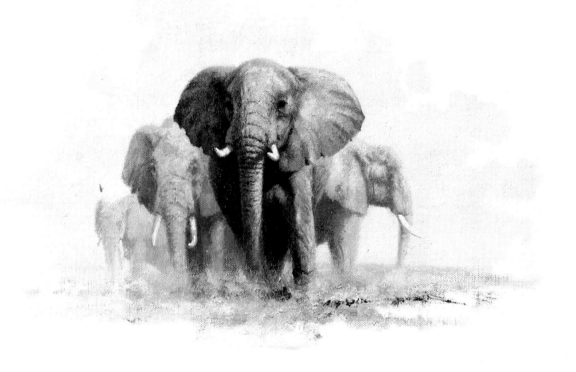

A message from HRH The Prince Philip, Duke of Edinburgh.

BUCKINGHAM PALACE.

 Lucky are those who can earn
a living by doing what they enjoy;
blessed are those who use their
talents in a good cause.

 Everyone committed to the
conservation of nature and wildlife
recognises the massive contribution
that David Shepherd has made to this
good cause.

From the Office of His Excellency, the President, Dr Kenneth D. Kaunda (following a visit to Zambia to raise funds for the Wildlife Conservation Society of Zambia)

My dear David,
Thank you for coming to share this period with us. Remember there is an inner feeling that defies all description in all those who serve God and man to the best of their ability. For your part, David, we shall always be grateful. Keep smiling all the way.
God Bless.

KENNETH KAUNDA

From HRH Prince Bernhard of the Netherlands

I am very glad that this book has appeared. It will make many people familiar with my friend David Shepherd's beautiful paintings and will cause them to marvel at the wide variety of his subjects, which go from loco-motives to wild animals. It was through the success of his wildlife paintings that David was able to buy his two locomotives, but, more important, he has also been able to raise funds for wildlife conservation to which he is truly de-voted; this he has time and again proved in a most generous way. I, of course, wholeheartedly applaud this attitude!

I sincerely hope that David Shepherd will go on painting for years and years to come – not so much as a benefactor to wildlife, but as a source of pleasure to all his admirers, and for his own happiness and well-being.

BERNHARD

From James Stewart
Hollywood

David Shepherd's paintings of the environment and the wildlife of Africa have a certain dignity and class that are unmatched.

JIMMY

David Shepherd

THE MAN AND HIS PAINTINGS

with text by the artist

DAVID & CHARLES
Newton Abbot London North Pomfret(Vt)

British Library Cataloguing in Publication Data

Shepherd, David, *1931–*
 David Shepherd: the man and his paintings.
 1. Shepherd, David, *1931–*
 I. Title
 759.2 ND497.S4

 ISBN 0–7153–8756–1

Phototypeset by ABM Typographics Ltd, Hull
and printed in Spain
by Printer Industria Gráfica SA, Barcelona
for David & Charles (Publishers) Limited
Brunel House Newton Abbot Devon

Published in the United States of America
by David & Charles Inc
North Pomfret Vermont 05053 USA

CONTENTS

WINDSOR OAKS

1953 was a gloriously hot summer. I had for many years been attracted by the marvellously gnarled and twisted shapes of the incredibly ancient oak trees in Windsor Great Park – some, I was told, having been mentioned in Domesday Book. With the unpredictable English weather for once kind to me as day followed day of brilliant sunshine, I spent seven days painting this particular tree which, it seemed, would be there for all time. A large chunk of the tree had broken away (probably in about the year 1400!) and it gave me a wonderful opportunity to indulge in my passion for painting dead wood – a passion which was to develop several years later, in Africa.

I feel that this painting 'came off' quite well and, like a few others of that period, I have kept it because no one would pay me the original asking price of, I think, £50.

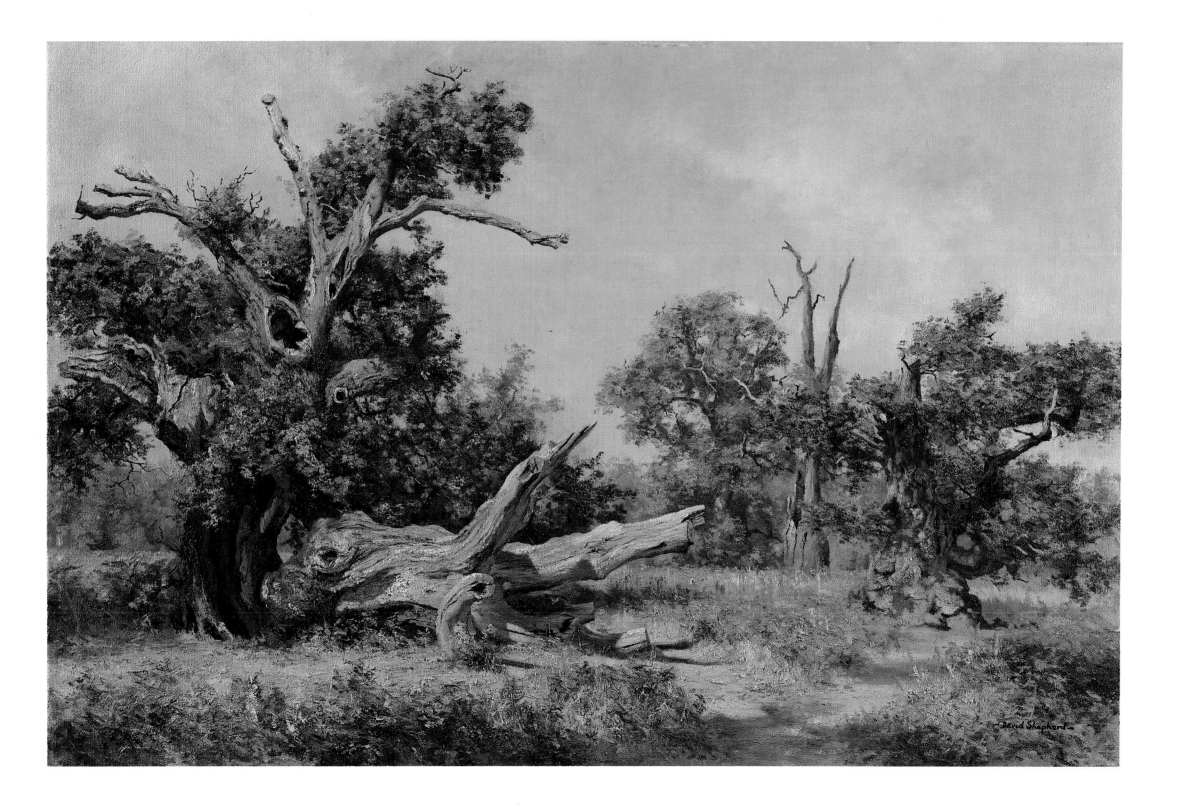

VISCOUNT OVER MANHATTAN

I have a very great affection for this particular painting, for personal reasons. My wife and I had a love affair with this aeroplane just before we were married and, in a sense, it brought us both together.

In 1955 Capital Airlines of Washington placed an order with Vickers Armstrongs for seventy-five of the new Viscount turbo-prop airliner. This order was a great success story for the British aircraft industry at that time, and it was won in the face of the fiercest and often ruthless competition from America's own aviation industry. Capital Airlines had to have their representative stationed at Hurn Airport, near Bournemouth, for the whole period of delivery of all seventy-five aircraft, and my future wife was his personal secretary.

The American ferry crews used to come over at regular intervals to fly the brand new aircraft to the United States. Being a short to medium haul airliner, they had to fly to Scotland, Iceland, Greenland and then onto Washington. Only a few seats were fitted into the aircraft before delivery and we used to watch some amusing scenes at Hurn. The ferry crews used to go into Bournemouth to visit the antique and junk shops; they purchased huge Victorian dressers and sideboards, and even street lamps, and all these were loaded into the aircraft.

Because my future wife was the representative's secretary, I was able to get a lift on one of the aircraft going out to Washington, and it was a fascinating journey. Before I left Hurn, I painted this picture of one of their Viscounts flying over Manhattan Island, hoping that if I showed it to Capital Airlines they might buy it. When I arrived in Washington with the painting, they did.

Many years later, Capital were taken over by one of the major American domestic carriers. During this period of transition the painting was, I was told, thrown out on a rubbish tip; but apparently it was rescued in the nick of time by one of the management, and hangs in his house to this day.

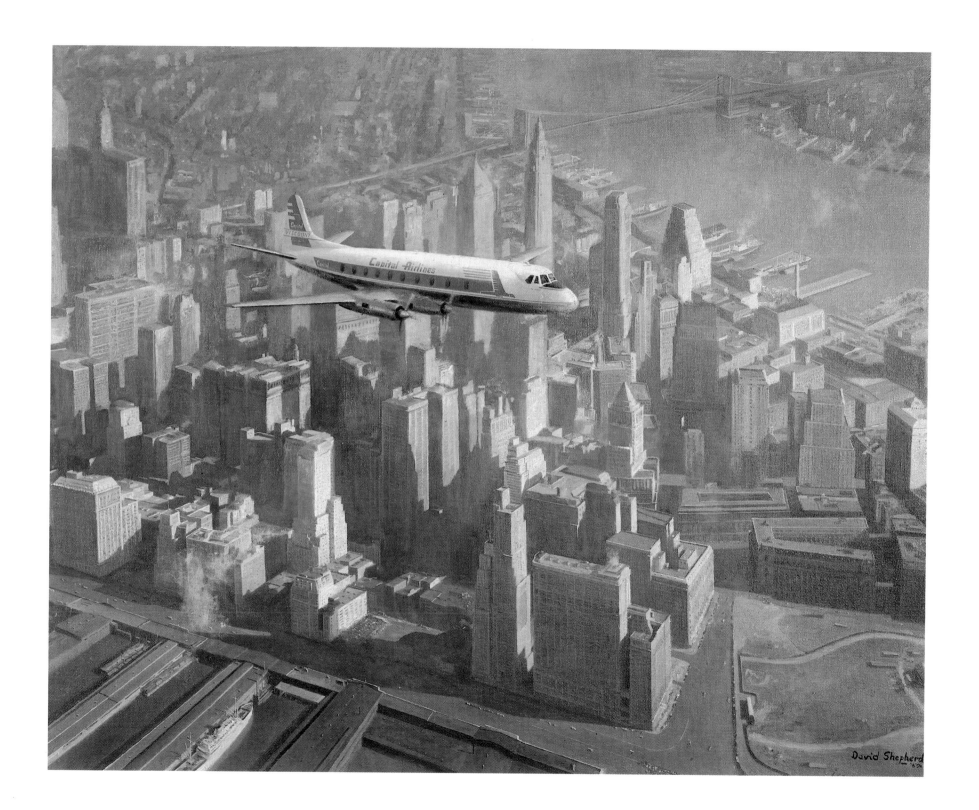

David Shepherd
'54

SOMERSET HARVEST

'Somerset Harvest' is one of my earliest works, painted when elm trees still graced the English landscape. In 1954 there were plenty of these trees in Somerset, and the corn was still stooked in the old-fashioned way. This painting was one of my very first to be reproduced as a fine art print, long since out of circulation.

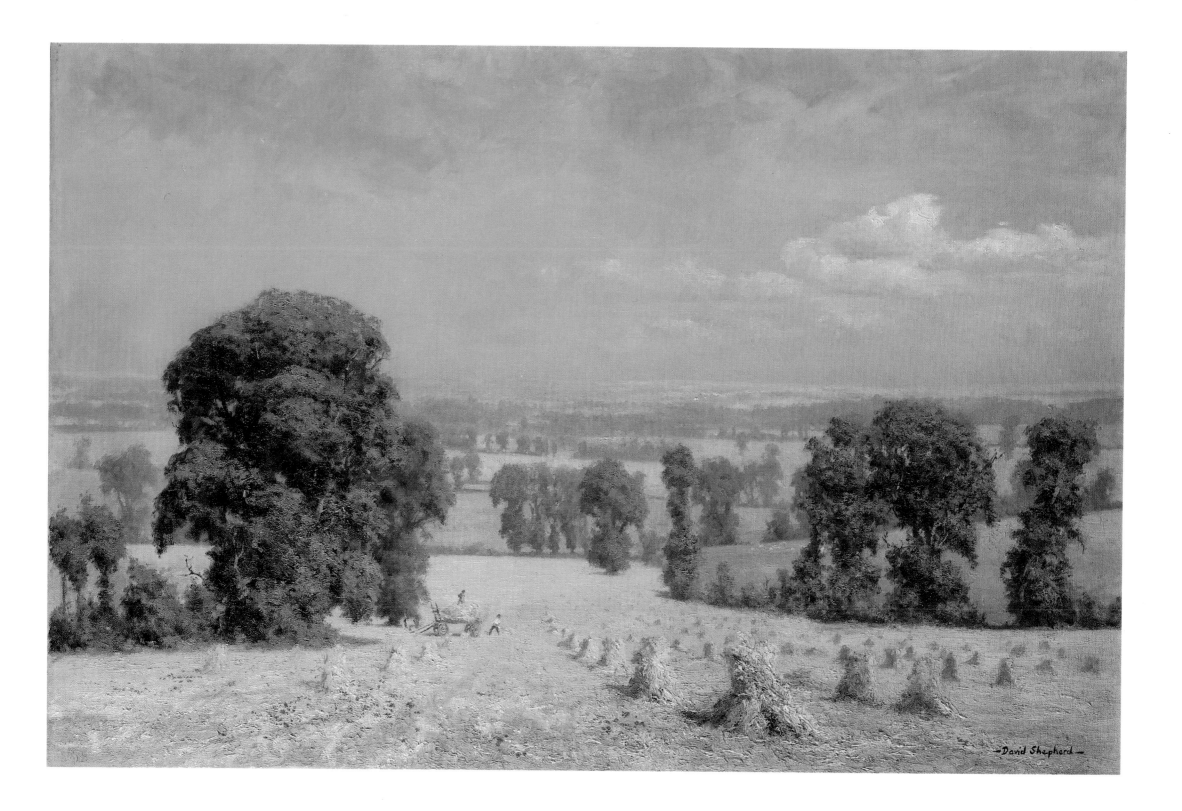

SHEPHERD STREET, MAYFAIR

This painting, dated 1954, was one of thirteen that I painted in Shepherd Market and the surrounding area, during and immediately after the period of my training with Robin Goodwin. It was one of my first to be reproduced as a fine art print, long since out of circulation. I still have it because no one would pay the £25 I was originally asking!

I could write a book about the things that used to happen to me between setting up my easel at ten in the morning and painting until evening, in this relatively unspoilt area of London. Shepherd Market was known in those days as one of London's 'red light' districts. I believe it still is – the only probable difference being that instead of the local life standing on the street corners, many of the girls no doubt now drive home to their sumptuous houses in Surrey in Aston Martins.

Both Robin and I used to frequently sell our pictures as they were being painted. Being such an attractive part of London, many tourists used to walk through Shepherd Market and Americans used to love buying half-finished paintings straight off the easel. They could then take them back, still wet, to the United States, and tell their friends that they had actually purchased a genuine 'hand painted' picture because they actually saw it happening.

When I was training, Shepherd Market was like a country village. Now, sadly, there are yellow lines on the road, the old Victorian shop-fronts have been replaced with plastic horrors, and ghastly highrise blocks dominate the skyline. Moreover, the volume of traffic would make it almost impossible to paint as we used to then.

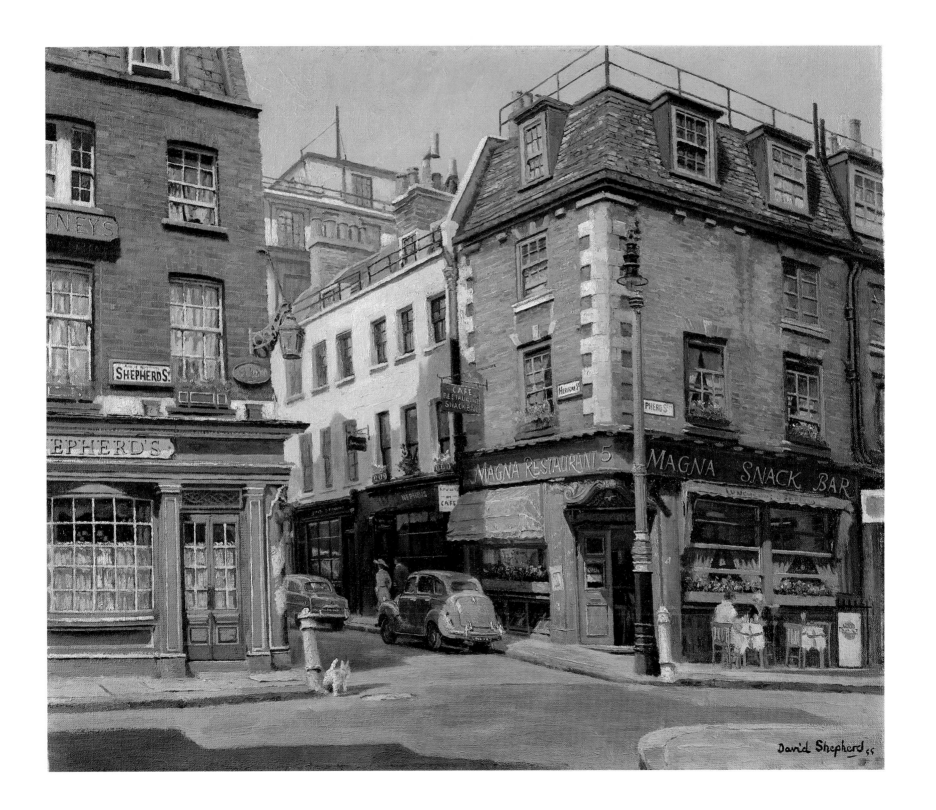

THE BRABAZON HANGAR AT FILTON, BRISTOL

In the early 1950s, I used to torture myself by tackling the most challenging subjects – painting, always, from life. I was putting into practice what Robin had taught me. Someone had told me about the hangar that had been built at Filton, near Bristol, for, originally, the short-lived Brabazon airliner project of the late forties. In 1955, the Bristol Aeroplane Company was using the hangar as an erecting shop for the Britannia airliner, for BOAC and other airlines. I was accorded every facility and allowed to set up my easel on the hangar floor. I had every possible co-operation from all concerned; they even avoided moving the aircraft if I was in the middle of actually painting them. I believe I became quite an attraction to those watching from the offices overlooking the interior of the building; also from this source came endless fortifying cups of tea.

The hangar roof was the great challenge. I must have had incredible stamina in those days. Eight days were spent on the whole picture, and five of these were spent painting every girder and every pane of glass in the roof itself. On its completion the painting was critically inspected by all my friends at Filton and the roof passed with flying colours. There is only one small mistake and I would like to think that the architect who designed the hangar wouldn't be able to find it; I can't remember where it is.

Painting this sort of subject was marvellous training. When it was finished I offered the picture to the company for £30. Maybe that was too much because I still have it.

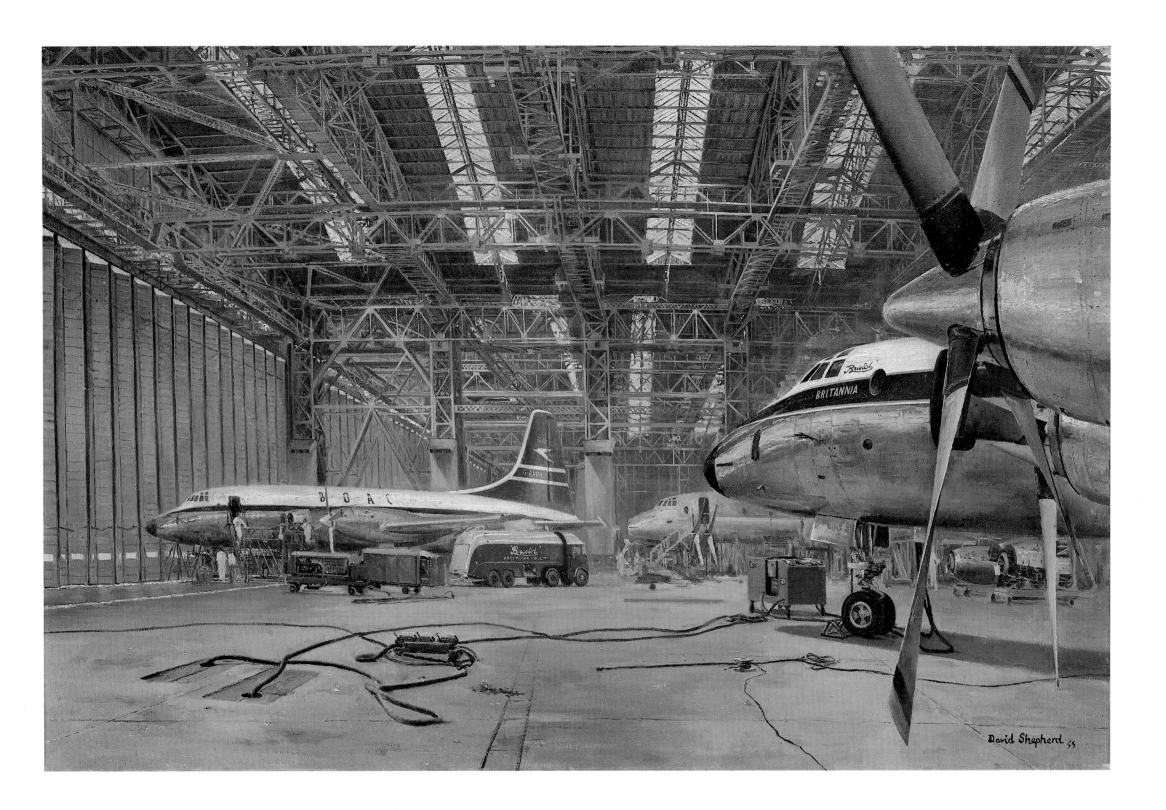

David Shepherd 55

WILLESDEN STEAM SHEDS

I have never been the sort of railway enthusiast who stands on the end of platforms taking engine numbers. This sort of activity never appealed to me; the fascination of steam railways came to me through the eyes of an artist. After I finished my training I had a good deal of time to spare, to paint for the sheer enjoyment of it. It was then, in 1954 and 1955, that I realised just how much Britain's steam railways could offer me as the most wonderful subjects for paintings.

I have often said that, if Rembrandt had been alive in the Industrial Revolution, he would have taken the opportunity to go into some of the great locomotive sheds of Britain's steam railway era. There, in the 'cathedrals of steam', he would have found the sombre tones and colours so suited to his palette. Dvořák, the composer, was a steam enthusiast; and apparently, when he was in England composing some of his great symphonies, he used to go into the nearest steam shed to find relaxation and spiritual refreshment. That is one of the reasons, surely, why he wrote such great music.

Express trains charging towards me have never seemed satisfactory subjects to paint. I have always believed that this sort of thing is best left to the camera. The interiors of these great depots are another matter, and in 1955 I took the opportunity to paint five railway pictures, all of them from life.

Willesden sheds was the first place that I visited, and I painted two pictures in that long since demolished steam depot. The co-operation I received from the railwaymen was absolutely marvellous. Every brush mark of the painting was painted on site, and in the most appalling conditions. It was winter, and I remember the snow falling through the roof. By the time it reached the floor, it was brown. I stood in the freezing shed fortified by several layers of thick sweaters and endless cups of tea given to me by the sympathetic railway employees. They were only too ready to move engines around especially for my benefit and, if I happened to be painting a portrait of a particular locomotive, they ensured that the engine would not be moved before I had finished my work. For all I knew, a few trains could even have been cancelled, all in the name of art!

It was a challenge. While I was working on the engine in the foreground I had several drivers and firemen, who knew infinitely more about the workings of a steam locomotive than I ever would, looking over my shoulder to make sure that I made no mistakes. If I did, they were perfectly prepared to say so; and I respected their superior judgement. I made many friends amongst the railwaymen of Great Britain in those days and they taught me a lot.

Of the five paintings, British Railways purchased four, including one of the Willesden sheds, for £60 each. After hanging in the old Euston station for some time, these are now part of the National Collection. They didn't want this one, which I think is the better of the two.

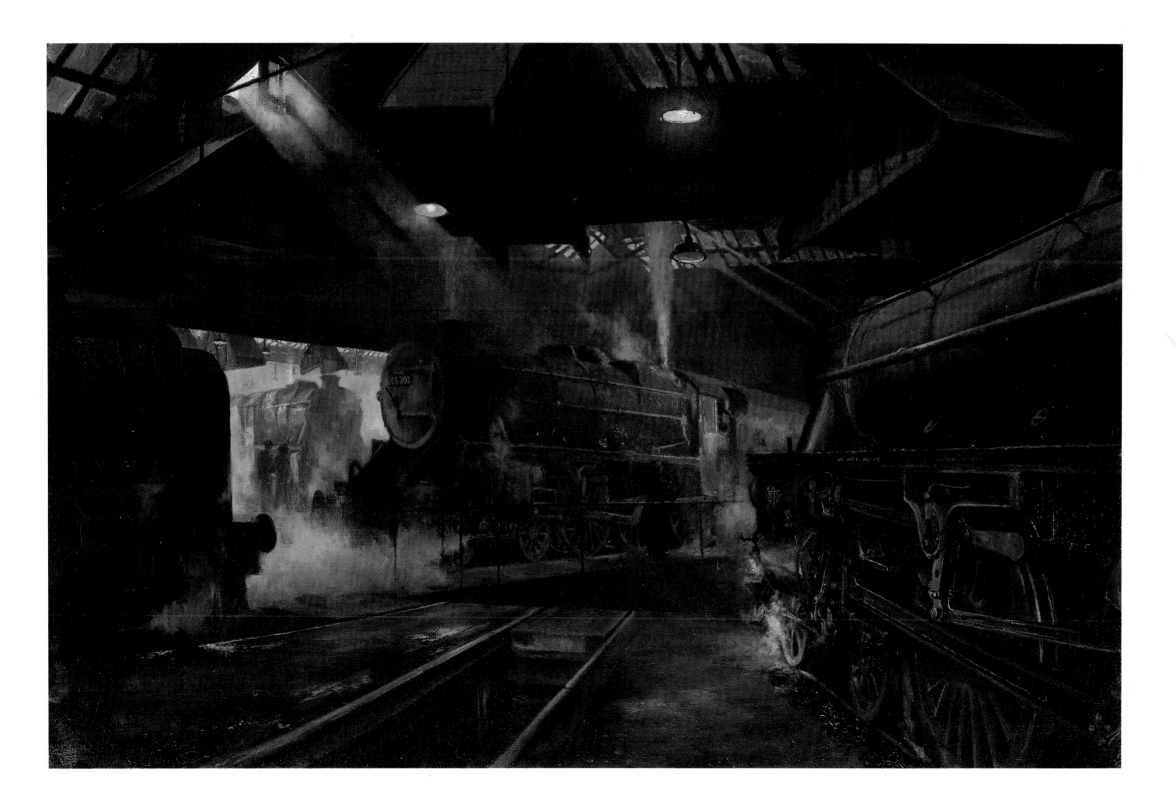

LUDGATE HILL IN 1890

Reproduced by permission of W. N. Sharpe Ltd

In the early part of my career I was painting a large number of pictures for Christmas cards and there is no doubt that they played some small part in putting my name around. I got a bit fed up with painting snow but, after all, it was for Christmas. What I could never understand was why every subject had to depict 1890. Apparently the public demanded it.

Out of almost thirty different subjects that I did for Sharpes Classic Christmas cards, over several years, I believe that my painting of Ludgate Hill in 1890 was their biggest success. In doing my research for this painting, I searched through a great many photographs taken at the time, and went to a lot of different people for help. One man, who was a walking encyclopaedia on railways, told me immediately what sort of steam engine would have gone over the bridge at the bottom of Ludgate Hill in that year. This had to be correct, otherwise the company and myself would have been bombarded with letters from railway enthusiasts who knew, or thought they knew, far more about these things than we did. Similarly, everything else had to be as authentic as possible. One of the most interesting photographs I found showed the whole of the left-hand side of Ludgate Hill at that time, and the detail gave me the shop fronts and the notices such as 'ready made two piece suits, 16/6d!' The horse-drawn bus with its advertisements is correct in every detail.

Apart from the snow, I was always asked to put a dog in. At that stage in my professional life I was never really very good at dogs, and the breed of the animal in the picture is, to say the least, slightly obscure.

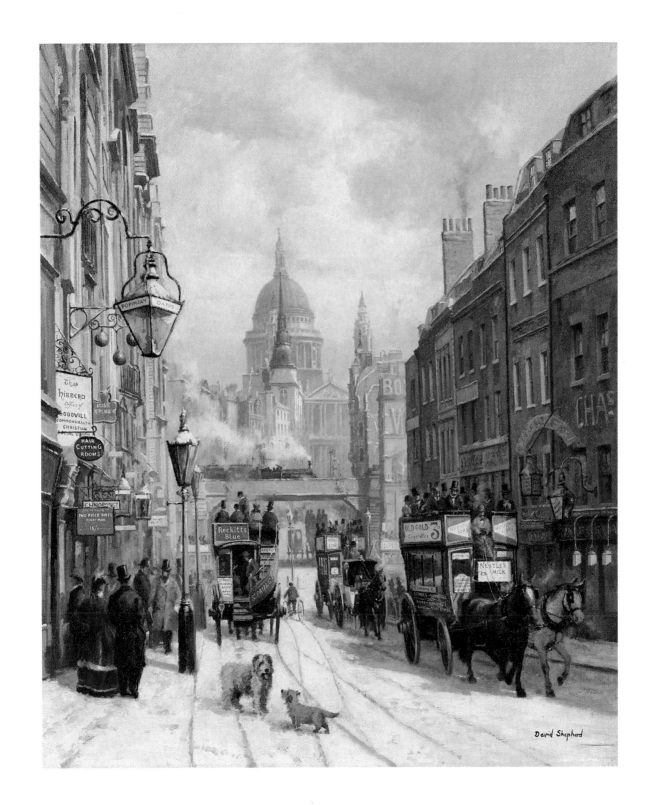

THE IMMORTAL HERO

Reproduced by permission of Royal Air Force Uxbridge

Very occasionally, man invents a machine so near perfection that it is difficult to say anything that has not already been said. This must apply to the truly immortal Spitfire, a beautiful aeroplane designed by a genius.

My painting of the Spitfire was done in 1957, and originally hung in the Battle of Britain bar at Royal Air Force Kenley.

As a small boy living in London during World War Two, I was fascinated by the aircraft of both sides. My brother and I used to display our fine collection of souvenirs – bits of crashed Messerschmitt, incendiary bomb tails, shrapnel and leaflets, all of which I still have – to help raise money to buy Spitfires. One of the greatest excitements for small boys in those days was to pay a modest sum for the privilege of sitting for a few moments in the cockpits of captured German aircraft. There was always a queue waiting their turn under the not very attentive eye of a rather sleepy 'Home Guard' soldier. Always keen to add to our collection of war souvenirs, more damage was often done to that aircraft by the time the last person had climbed down the ladder than the Royal Air Force did in shooting it down!

The Heinkel III, designed as an airliner in the 1930s but then used for less peaceful purposes was nevertheless, like its famous adversary, one of the most shapely aircraft ever designed. During the Battle of Britain they fell in large numbers over the harvest fields of Southern England but life had to go on.

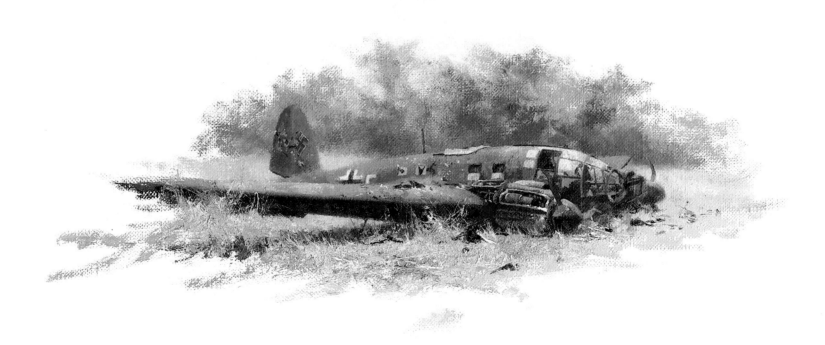

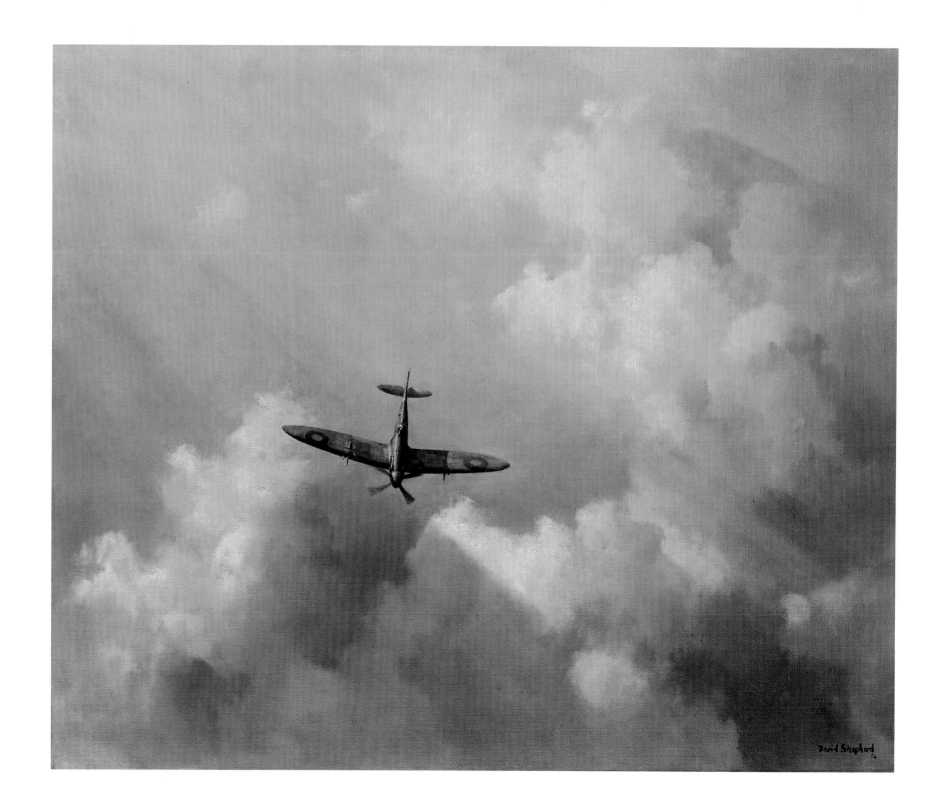

SMOKEY THAMES

Reproduced by permission of Sir Eric & Lady Mensforth

During the days of my training and shortly after, Robin and I used to go down the Thames, and we painted many pictures between Chelsea and Woolwich. In those days the river was full of shipping activity and the ships actually still looked like ships. Tugs, steam powered, bustled about everywhere, fussing over their strings of barges.

One of our favourite viewpoints was from Bowater's Wharf across to St Paul's and Blackfriars. In those days, the sky line was how Wren intended it – St Paul's was the dominating feature. Alas, now, the view would offer no inspiration whatsoever as St Paul's has almost disappeared against a background of highrise faceless concrete architecture. Such, once again, is progress – and all the ships seem to have gone too.

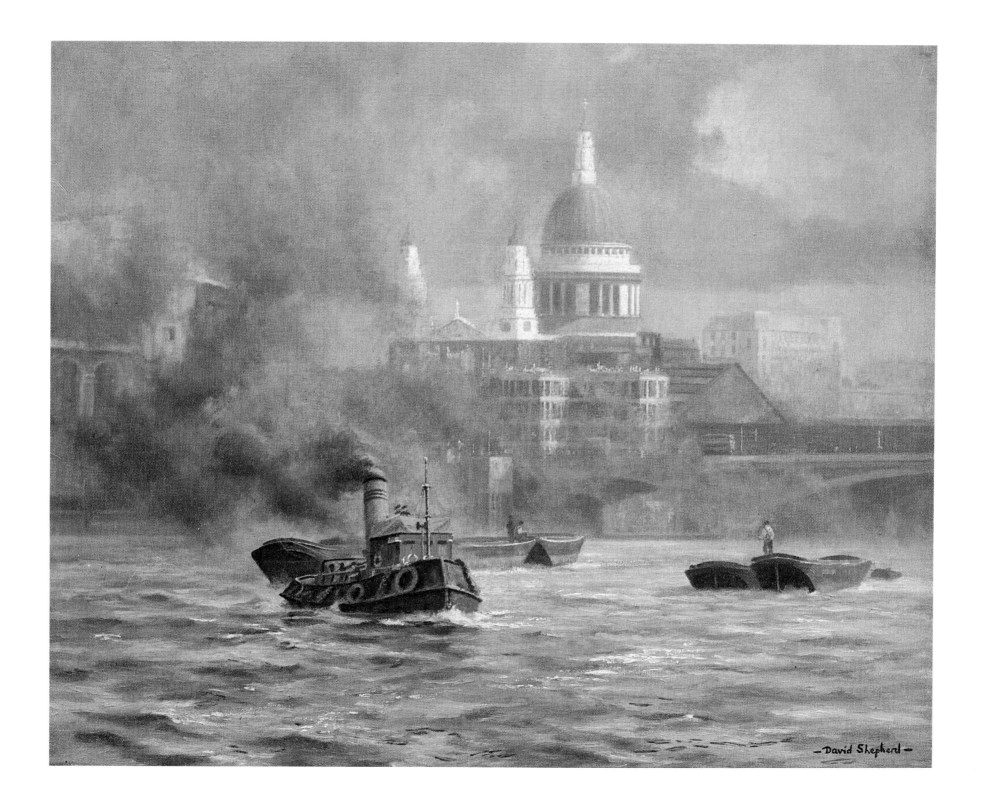

THE OLDE METAL CRAFT SHOPPE

I have always felt strongly that the English do not care as much about their heritage as they should. Since the days when I was painting in London, so many of these lovely old shops have been swept aside by the property developers in the name of progress, to be replaced by anonymous modern concrete. If not succumbing to that treatment, they have been vandalised out of all recognition, with beautiful woodwork and gold-leaf lettering replaced by the horrors of the plastic age.

Such a case is Beauchamp Place, just off Brompton Road. When I set my easel up on sunny Sundays it was relatively quiet, and I painted at least five of these beautiful little shop fronts. Hardly anything then disturbed the lovely visual effect of this relatively unspoilt street. Now, because no one seems to care, most of the street is ruined by a proliferation of garish and illuminated signs, 'to let' and 'for sale' notices. The whole appeal, in my view, has been lost.

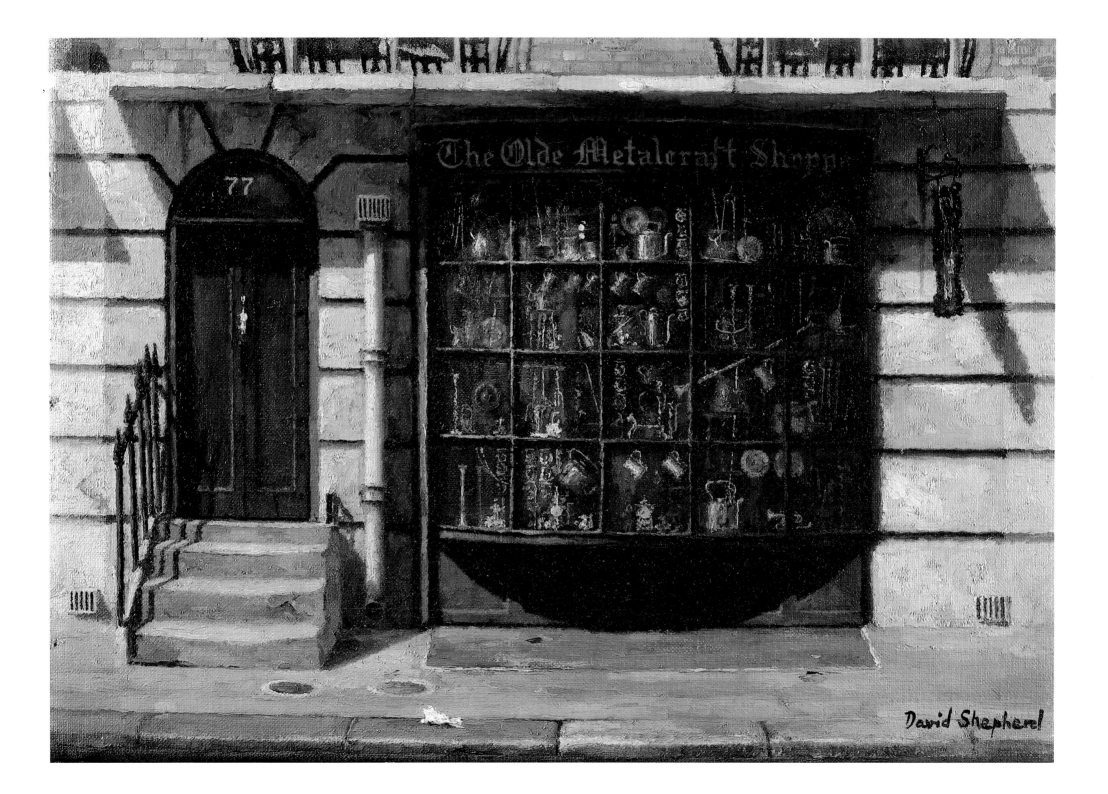

The Olde Metalcraft Shoppe

77

David Shepherd

LONDON
Reproduced by permission of David Wickins Esq

No one, with the exception, possibly, of myself, would be mad enough to undertake a challenge such as painting London from the air on a 2.4m x 1.5m (8ft x 5ft) canvas. The original did not have to be that size, but I felt there was more room to get in all the detail!

The problems were awesome. Obviously, I would have to work from photographs, so I went to a reference library which seemed to specialise in providing this sort of requirement. I found, not surprisingly, that there was no single photograph that would cover the wide angle which I wanted to portray in my picture. There was a large selection of views available, but they were all taken at different heights and different angles, and at different times. Therefore when, for instance, painting the area around Westminster, I had to imagine what it would have looked like if the aircraft had been 30.5m (100ft) higher and 91.5m (100yd) to the left. I knew perfectly well, also, that the painting had to be completely accurate; observant people would be only too pleased to catch me out.

I chose the period when the Festival of Britain site had been cleared on the South Bank and the Shell centre was beginning to go up in a forest of girders and scaffolding. The Royal Festival Hall had been completed but the old and historic shot tower, which was such a feature of that part of the Thames, was yet to be demolished.

At times, the task became quite an effort, so I relieved the pressure by painting a lot of red London buses, which I love. My own car and my sister's horsebox are also in the picture – going round Westminster Square!

After, I suppose, the relatively short period of three weeks, the work was complete. With it still wet on the easel, one of my friends walked in and immediately made the comment, 'You've got one arch too many in Waterloo Bridge.' I was surprised, not only by his apparent ability to so quickly spot a mistake but by the fact that, with all the application that I had put into the painting, I had nevertheless made one. However, I was certainly not going to dismiss this criticism out of hand. I looked at the photographs of that particular stretch of the Thames, and found that he was right! I had to paint the whole bridge out and do it again.

When the painting had been corrected it was exhibited in one of the main windows in a leading department store in Oxford Street. It caused a lot of interest. To stand among a group of people and listen to their comments is usually the only way to get an honest opinion, if they don't realise that you are the artist. There was a small group of boys from Westminster School looking at it and at their school. One of them decided to show off to his friends and he began to point out a whole list of faults – the wrong number of chimneys above that particular school house, the wrong number of windows in another. They did not know that I was standing there until I pointed out that I had painted it, and that I had taken a lot of trouble to get it right. It caused great hilarity and we all parted good friends.

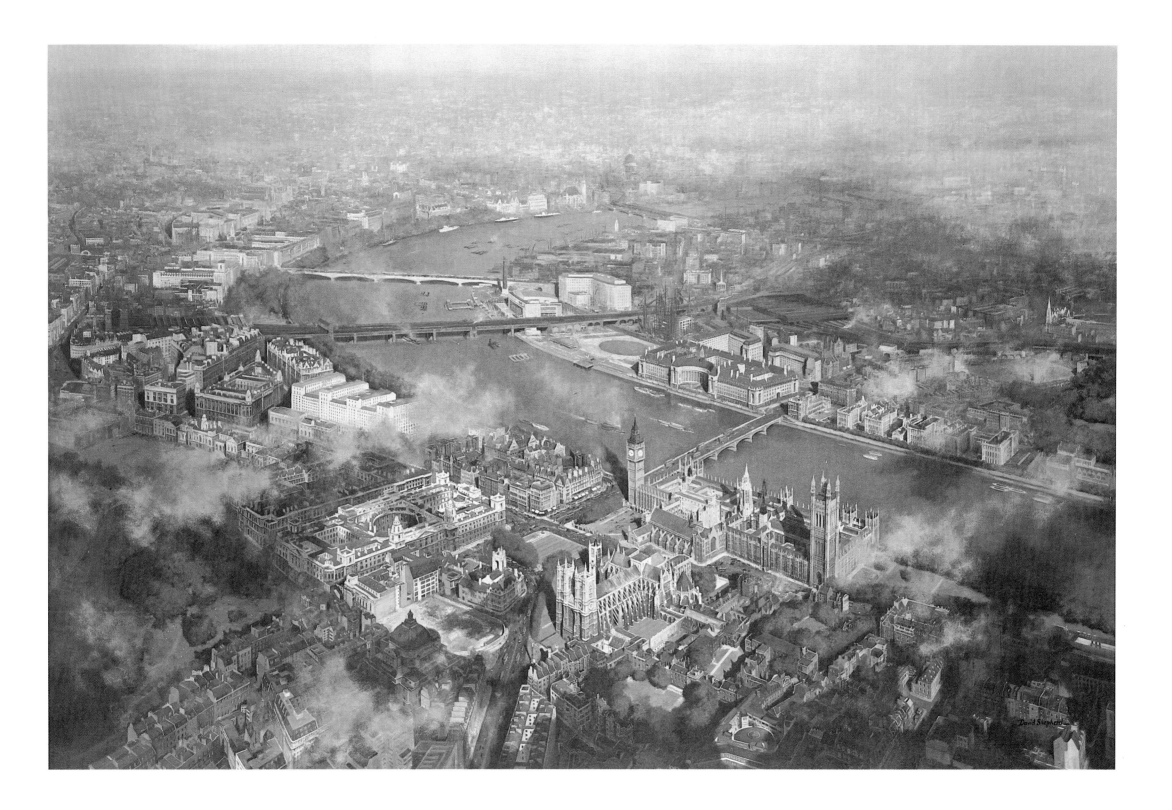

SLAVE ISLAND

From the moment that I set up my easel in this marvellous place, the Arabs who worked in the boatyard were absolutely fascinated by everything that I did. They had never seen oil paint or brushes before, or a canvas. I was lucky, too, because the main subject in the foreground was a brand new dhow waiting to be launched. It was marvellous to witness such old-fashioned woodworking skills which had hardly changed since the days of the Bible. It seemed that the only concession to modern practise was the use of metal nails instead of wooden pegs to join the planks together. The design of the scaffolding around the boat was primitive in the extreme and I was sure that this had already remained the same throughout the centuries too. A network of old poles picked up from here and there were lashed together with bits of string and were erected around the boat. When the finished product was ready to be launched, all the bits of firewood were simply knocked away and the dhow floated out into the harbour on the tide.

This painting changed my whole life overnight: it means so much to me that I have kept it, and the whole story of it is told at the end of this book.

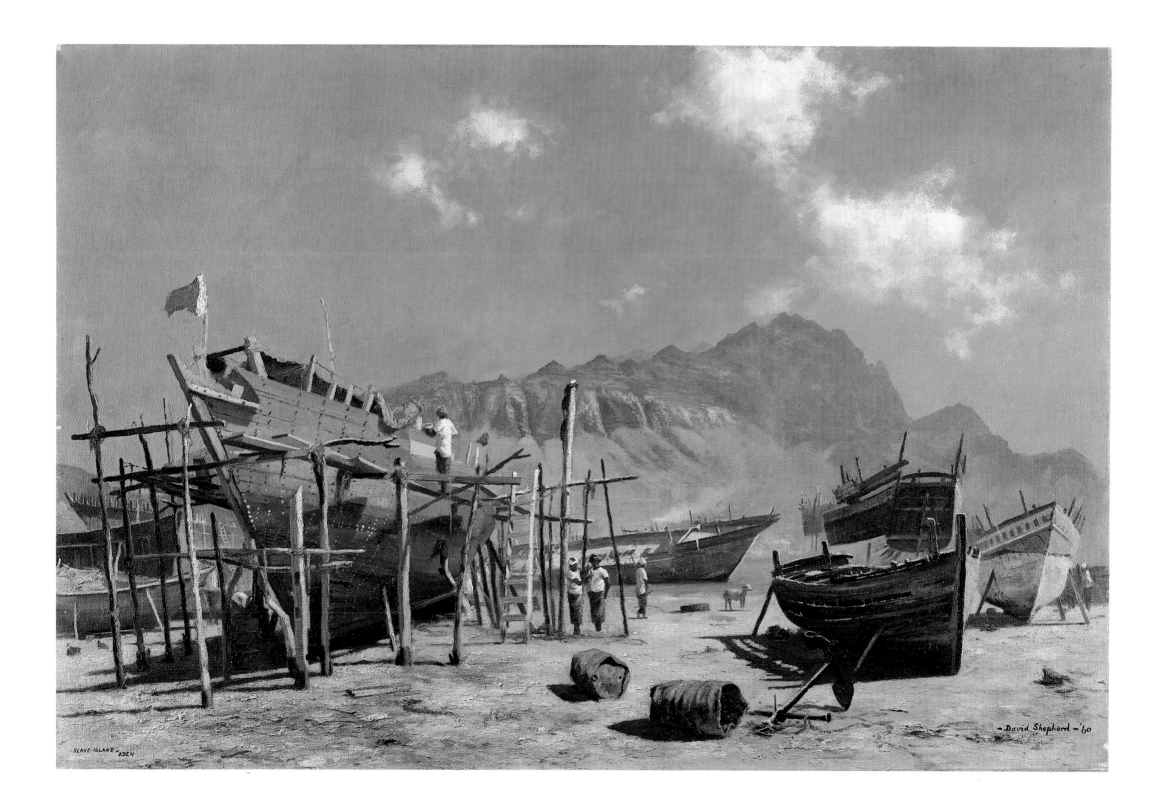

SLAVE ISLAND, ADEN

-David Shepherd -'60

STREET SCENE, ADEN

Reproduced by permission of Whitbread & Co PLC

They say that you can smell Aden from the southern end of the Red Sea. Whether that is true or not, it was certainly an exciting and virile place when the British were there. For an artist like myself who loves atmosphere, it was a paradise of narrow alleyways, smells, goats, camels and all the hustle and bustle of a busy free port. It was fascinating walking among the little shops. I saw a camel push its way into one of the poky little baker shops and grab a loaf. The shopkeeper chased the thief out into the street, picked up the loaf and placed it on the counter. Filth and refuse were everywhere, but it was all a part of the atmosphere. The goats – or shoats as they were known locally because, apparently, they were a mixture of sheep and goats – were eating most of the waste paper. It was probably all they had to eat anyway, but they functioned very well as the town's refuse system.

In the painting, the Arab gentlemen at the open-air stall in the middle of the street are selling vegetables and sticky little cakes. You could only just see these because they were covered in flies, but I was told that they were reasonably edible. I was not prepared to risk the consequences, however!

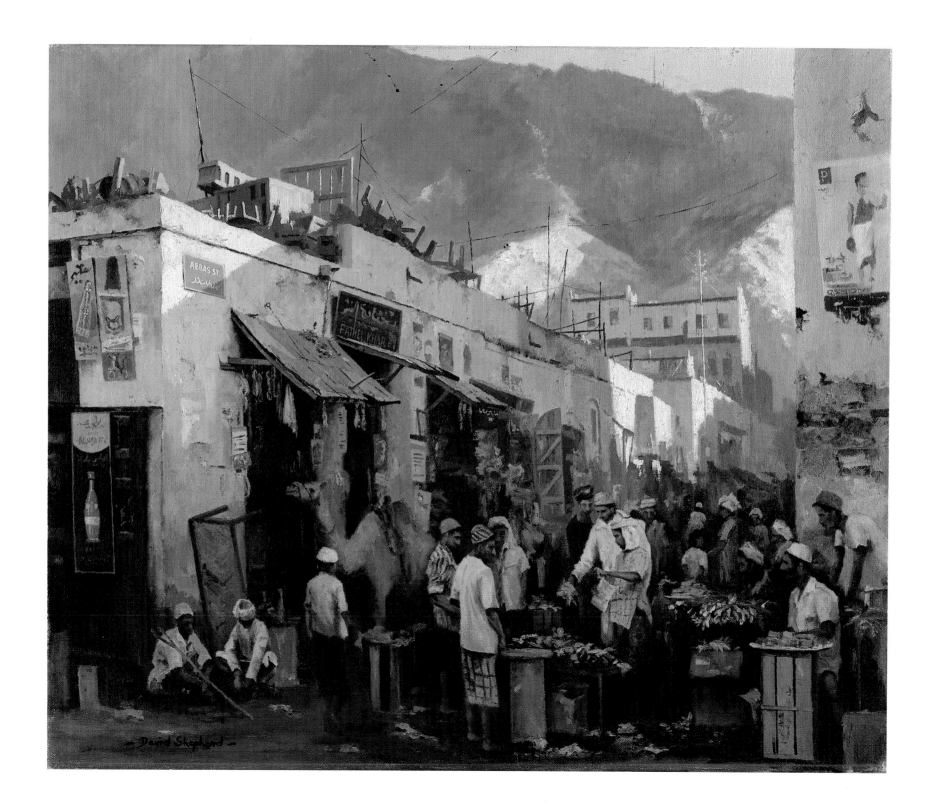

MUKALLA

It is certainly a thrill for an artist to visit a place in this world which he can be fairly sure has never been painted before, and it was due to the Royal Air Force that I managed to get to Mukalla at all.

There was certainly no such thing as a hotel in Mukalla so, if you happened to be one of the rare visiting Englishmen, a signal had to be sent in advance to the political resident to inform him of your coming. You then stayed with him at the 'Official Residence of her Britannic Majesty's Representative to the East Aden Protectorate'. The place was, however, affectionately known as 'Dysentry Hall' because, I was told, if you stayed there long enough you would probably get it! This didn't seem to be particularly polite to the Foreign Office and the building seemed OK to me, in spite of the primitive but effective plumbing arrangements. It was, in fact, a lovely Victorian relic from the days of the great colonial empire; a rambling two-storey affair with a beautiful portico and a white wall all round the property. A couple of very impressive arabs stood on guard on either side of the main entrance and the Union Jack flew proudly from the masthead. At sunset they used to stand smartly to attention and, while the bugle played, the flag was hauled down. In its simply sincerity it was a moving ceremony and I do not mind admitting that tears came to my eyes every time I witnessed it.

There is an amusing anecdote concerning the sale of 'Mukalla'. The painting had just returned from the publishers after they had made a print of it. We had a party that evening, and one of our guests was a farmer from Petersfield in Hampshire. We had all had quite a lot to drink over dinner and, before departing, my farmer friend asked if he could see the studio. The painting of Mukalla, measuring some 3ft x 2ft was on the easel. It was not for sale because I endeavour sometimes to retain the pictures that have been published as prints. 'I'll give you £250 for that.' Before I realised what I had done I had agreed. I have tried since to buy the painting back from his widow at what would be considerable profit to her, but I am pleased that she has told me very firmly that there is no way that she will part with it.

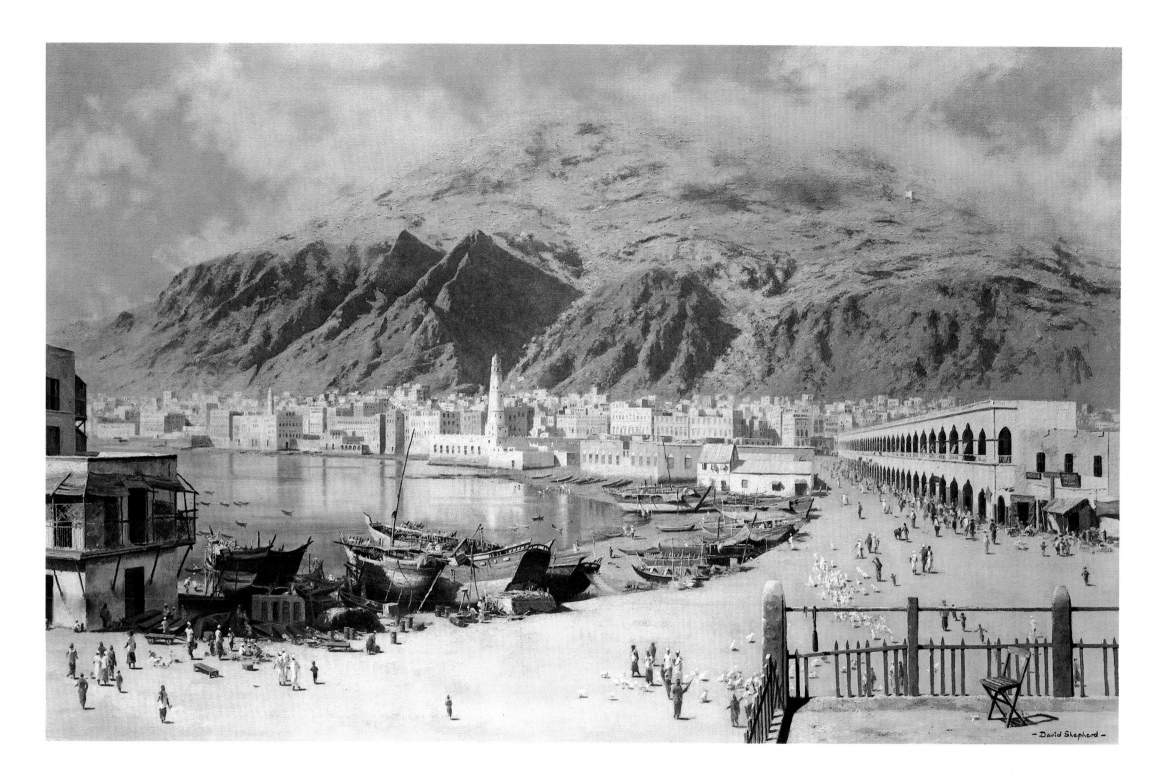
- David Shepherd -

SHIBAM

My visit to Shibam, in the Wadi Hadhramaut, has to be one of the highlights of my life. Somehow, the political agent had managed to 'borrow' one of the six precious land rovers which belonged to the desert locust control people and, after spending the night in his house, I was met the following morning by a splendid Arab who drove me the 70 miles along the Wadi to Shibam. We drove through ancient picturesque villages and then Shibam suddenly appeared in front of us. It may be one of the most written about places in Arabia, but at the same time it is one of the least visited. The centuries-old city is on the floor of the Wadi, its tall mud-brick buildings crowding together, skyscraper fashion, some of them sixteen or more storeys high. It is impossible to drive a vehicle into Shibam, so we left the land rover and walked up a ramp through a massive arched gateway. From the large and busy square in the centre of the town the streets, so narrow that only a couple of people or a pair of donkeys could walk abreast, radiated off in all directions. In fact, walking down these streets was quite a risky business. The sanitation arrangements in such a place were primitive in the extreme. These consisted simply of pipes sticking out from the wall and anything could happen if one was taken unawares. However, all was well; we somehow managed to get a sixth sense and kept to the middle of the alleyways!

In Shibam, there was no electricity, no motor vehicles, and just a few primitive things to buy in the holes in the walls pretending to be shops – although you could buy the inevitable Coca-Cola. This was not delivered to Shibam in shiny yellow lorries; it was brought up on camels. Is there anywhere that you cannot buy it?

I realised as I looked at this place – an absolutely unique collection of mud-brick skyscrapers jostling together and each as old as time – that I had found the ultimate in visual excitement. Here, amongst friendly people, I felt I had stepped back into centuries past. There was nothing to spoil this illusion (except the Coca-Cola) – no extraneous noises such as jet planes and motor bikes. Shibam will remain forever for me one of the most spectacularly beautiful places that I will ever see.

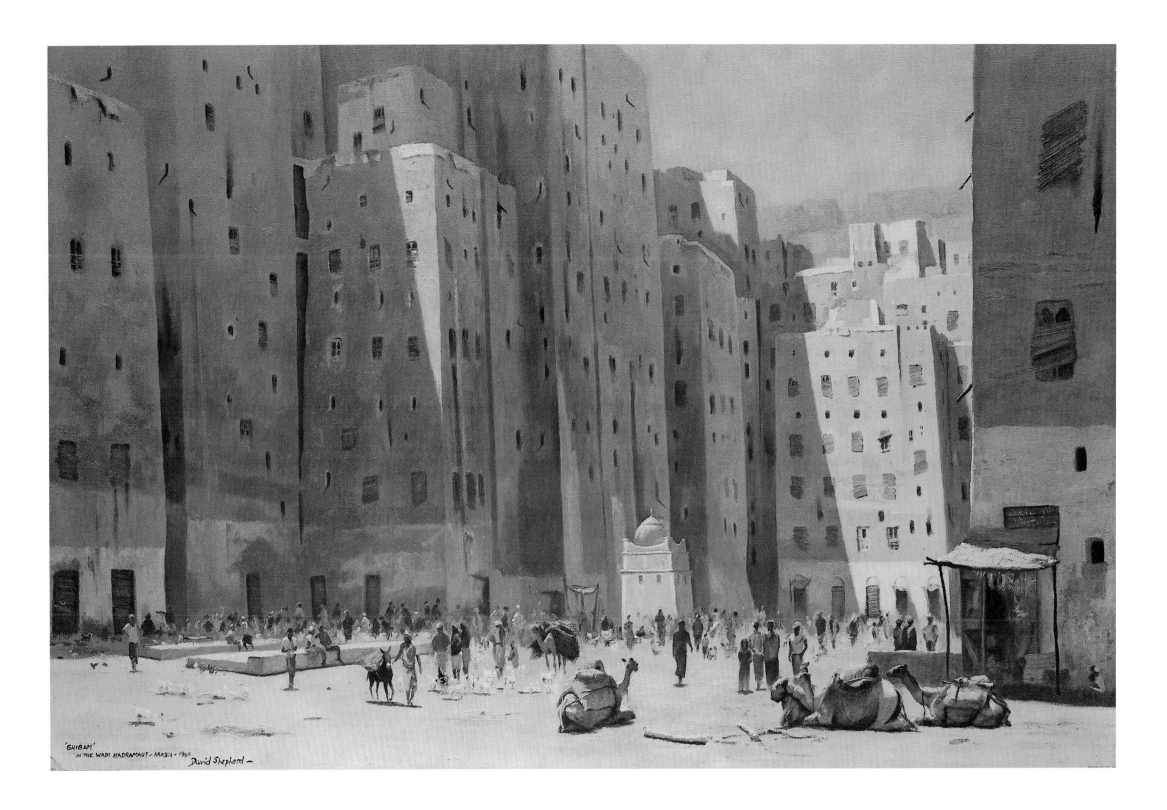

'GHIBAM'
IN THE WADI HADRAMAUT - ARABIA - 1960
David Shepherd -

AUTUMN

I painted many pictures in the 1950s and 1960s, in Windsor
Great Park. Many of the beech trees there must be several
hundred years old, and I found painting the late afternoon sun-
light as it filtered through the autumn tinted leaves particularly
appealing.

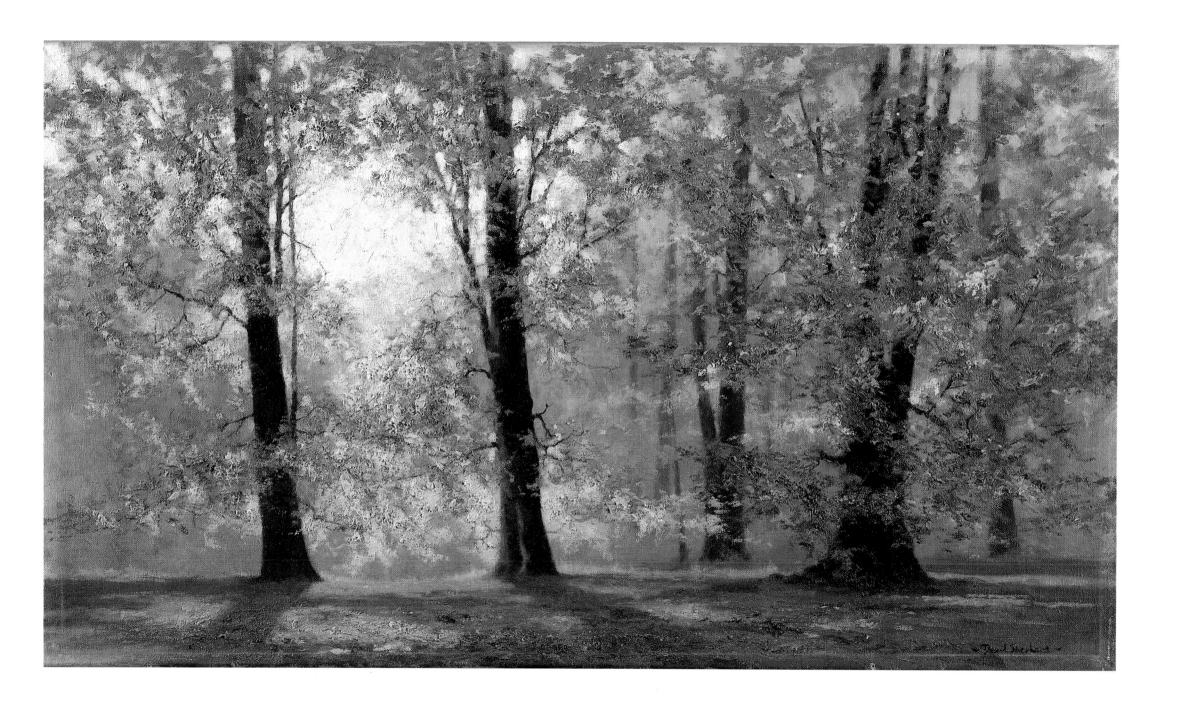

ARNHEM BRIDGE, 5pm, THE SECOND DAY

Reproduced by permission of The 2nd Battalion, The Parachute Regiment

I was just too young to participate in World War II. Nevertheless, the town of Arnhem, its inhabitants, and the whole tragedy of the operation that took place there in 1944 have left a lasting impression on me. I was honoured, therefore, when the 2nd Battalion of the Parachute Regiment asked me if I would paint the operation at the bridge. The intensity of the drama that unfolded during those cliff-hanging few days, when we hung on to that ever-dwindling perimeter around one end of the bridge, ensured that the task would be an exciting one.

When accepting a challenge of such magnitude, it is obviously essential to visit the place where it all happened. I was lucky to go on two of the annual pilgrimages to Arnhem and, perhaps more important still, one private visit with three officers who actually took part in the operation. After all that amount of research, I felt that I had taken part in the operation myself. Indeed, one of the senior officers present told me that he reckoned I probably knew more about the Arnhem operation than almost anyone else. He may have been exaggerating somewhat, but at the same time, when one was taking part in the fighting, one did not have time or inclination to think of history in the making. Getting on with the job as cleanly as possible was far more important than stopping to make notes for the benefit of future historians.

The hospitality and warmth that the people of Arnhem show to British visitors, particularly if they find that they were associated in anyway with the operation, are something that those visitors, myself included, will never forget. This has always struck me as being quite strange because, in fact, the

Dutch really have very little to thank the British for. They suffered enormously during and, particularly, immediately after, the operation. They had to pick up the pieces at the end of the war. Nevertheless, everyone that I met in the town on my three visits was just as keen to help and encourage me in my work as if I had been one of those gallant soldiers to whom they felt they owed so much.

We decided right at the beginning that we would endeavour to portray an actual moment of the battle. We discovered that a RAF Mosquito had flown over the bridge just as a column of German trucks and tanks was coming over it, and had taken a photograph. This was on the second day, at five in the evening. The Germans didn't see the men of the 2nd Battalion dug in on the ramparts of the bridge and the whole column was 'brewed up'. We enlarged the photograph taken by the Mosquito and an amazing amount of detail came to life that had not been previously deciphered. For example, what had just been a blur turned out to be a knocked-out German truck below the bridge, so this detail went into the picture. I tried to portray those incredible hours where hand-to-hand fighting was taking place on and below the bridge, with the British on one side of the approach road and the Germans on the other.

I was flattered when my painting of the bridge was chosen to grace the cover of Cornelius Ryan's book, *A Bridge Too Far*. I had the honour to meet the author shortly before he died and he signed a copy of the print for me. This is not only one of my most treasured possessions but it also reminds me of a most interesting picture to paint.

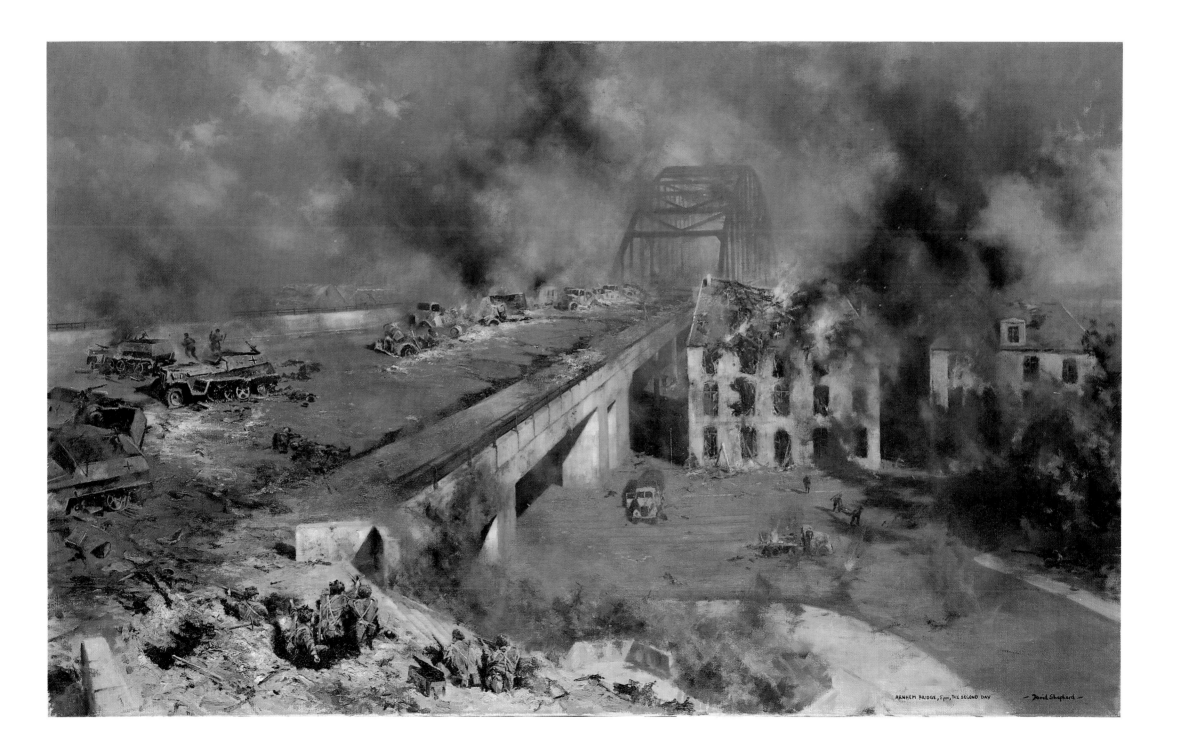

ARNHEM BRIDGE, 5pm, THE SECOND DAY - David Shepherd -

CHRIST
Reproduced by permission of the Chaplain General

Somone once came up to me and said, 'I thought you were dead.' In fact several people have said that over the years – a really tremendous boost for one's morale! I know why they say it. There is still, sadly, a popular fallacy that an artist is only likely to achieve success long after he is dead. Unfortunately, history has, to a degree, proved this to be the case. Of course I care what happens to my reputation and paintings after I have departed, but I would far rather reap the benefit and see the possible enjoyment that some of my pictures give to people while I am alive. If, during my lifetime, I am becoming known to a few people, than I am flattered beyond belief.

If I do occasionally manage to diversify and paint subjects other than wildlife, the usual comment is, 'Oh, I thought, you only painted elephants.' As I have described in this book, I owe an enormous degree of my success to my jumbo paintings. Nevertheless, if by some miracle I am remembered for any of my work after I have departed from this earth, I would dearly like it to be for my painting of Christ. Relatively few members of the public see or even know of this painting, because it hangs in an army garrison church. However, it does mean so much to me and I tell the whole story of the painting at the end of the book.

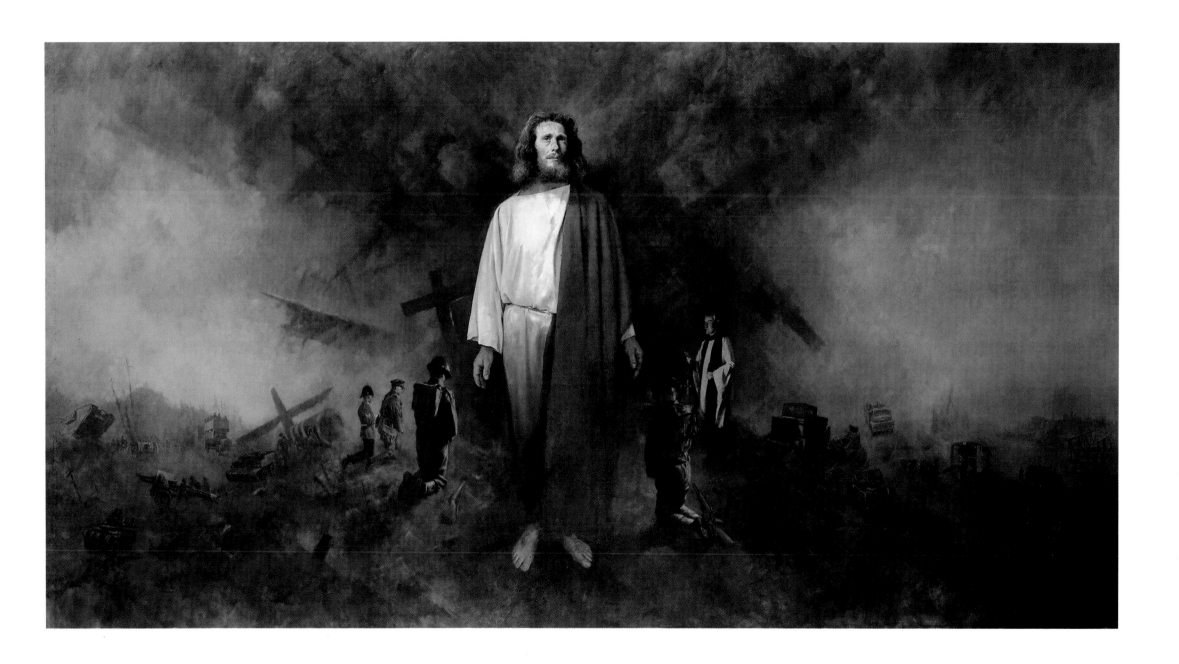

WINTER ELMS

Of all the great English trees, the stately elm is by far my favourite. Tragically, it is now almost a thing of the past, due to the ravages of Dutch Elm disease.

Fortuitously, over the years I have been sketching and photographing elm trees all over England. There is no more beautiful sight, I believe, on a cold winter day than the silhouettes of bare elms, their fine tracery of branches spreading like a fan across a cool grey sky. The rooks' nests in the very uppermost branches of the tree, and the seagulls about to alight on the damp earth below, complete the scene. To me this is the very magic of the everchanging English climate in its subtlest of moods.

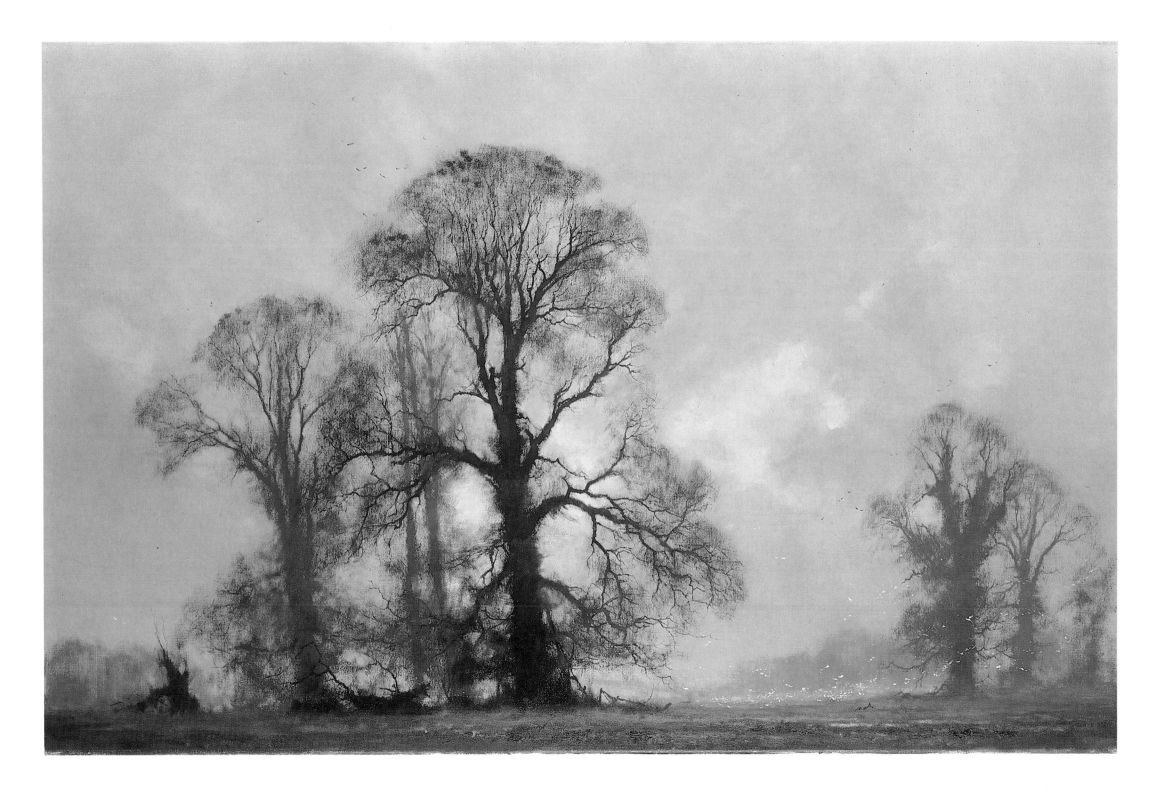

ADEN, CHECKPOINT GOLF – FIRST LIGHT

Reproduced by permission of The 3rd Battalion, The Parachute Regiment

I last went to Aden three weeks before we pulled out, in 1967. By this time, the British were in the middle of what amounted to a full-scale war between two opposing Arab factions, each of whom was attempting fanatically to gain supremacy over the other in order to take over and set up a new government after we had left. It was a weird feeling for a civilian like myself to become embroiled in the middle of such a situation. It was also a fairly risky business to walk around on one's own and, in order to do my research for my painting for the Parachute Regiment, I had to be escorted in an armoured personnel carrier for most of the time; it made me feel very important!

The Parachute Regiment had asked me to do a painting of Checkpoint Golf. This spot was right in the middle of one of the hottest areas, on the road from Aden to Little Aden. A fortified position had been set up in one of the houses beside the road and a sandbag observation post and gun emplacement was built on the roof. In the seering temperatures and humidity of Aden at its hottest, it was not the most pleasant place to spend the best part of a day. However, a certain amount of shade had been rigged up, and the soldiers did their duty looking over the surrounding area to make sure that there were no suspicious movements on the part of the passers-by and the traffic going through the checkpoint; there was always something happening.

It was while I was with the Parachute Regiment at Checkpoint Golf that they decided I had to be looked after very carefully to stop me doing anything stupid – something they remembered very many years later when I did a painting of Northern Ireland, also in this book, for the Green Howards. I really did cause the officer in charge some terrible problems. He had to point out to me very forcibly that the sandbagged wall was built for people's protection and not to stand up on to get a better view. He had good reason, because whenever anything of interest seemed to be happening down below, I would insist on jumping up on the sandbags with my camera! One of the soldiers who happened to have a camera did, in fact, snap me taking my photographs in a somewhat exposed position, with an exasperated officer imploring me to get down otherwise I would probably have my head blown off, I would then have to go home flat on my back, in a coffin, and the Parachute Regiment did not want to face the consequences.

I survived, more by good luck than anything else, and I think the painting has an extra realism about it because I was actually there. Three weeks later, we pulled out, and left Aden to its fate.

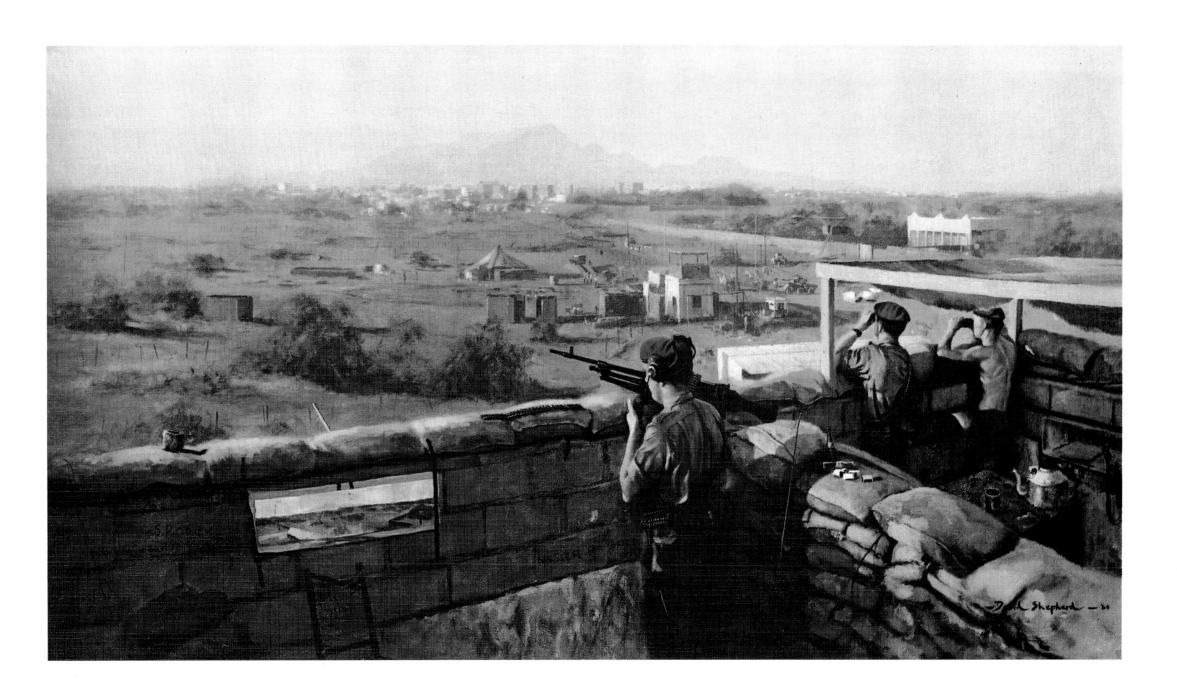

GERMISTON STEAM SHEDS, JOHANNESBURG

I first went to Germiston Sheds on the very day that steam was ending in Great Britain, at the end of 1968. To walk into a steam shed where there were over two hundred locomotives, most of them in steam, was a sight never to be forgotten by any British steam enthusiast. In Britain, we had got rid of our great steam-railway heritage in scenes of squalor and degradation. Here, in South Africa, it was very much alive. I couldn't take it all in, it was so exciting. Wherever I looked, steam locomotives were moving in every direction – shunting, hauling trains, and moving in and out of the shed. The whole area of the depot seemed to be filled with choking smoke which, of course, is part of the glory of steam to someone like me.

The whole place was a hive of activity. The African shed staff were everywhere, pushing wheelbarrows filled with ashes, cleaning out the pits, and washing out the boilers with floods of water gushing in clouds of steam. Many of the engines were filthy, but some were burnished to gleam like jewels in the hot African sun. One engine, the pride of the shed, was cleaned even more than the others. When I hopped up on the cab, I found an African scrubbing the floor! On this first visit, I had the BBC Television camera team with me who were filming my life story, 'The Man Who Loves Giants'. That was a marvellous excuse to be filmed painting, and I set up my easel on two or three occasions in front of the locomotives, surrounded not only by coal dust and smoke but by a lot of hefty Afrikaner locomotive drivers and firemen who were watching everything that I did.

The locomotive on the left is a Class 7, similar to that which President Kaunda of Zambia gave me and which came home to England. On the right is a 15f; this class of engine may well be the last to go at the end of steam in South Africa. Apart from the British Standard 9's (*Black Prince*) I think that the 15f class is perhaps one of the most impressive engines ever built anywhere.

I have been back to Germiston recently and the place is only a shadow of its former self. As in Britain, with years of development still in front of it, steam has been pushed out prematurely in a frenzied and, I believe, highly questionable, desire to dieselise. On my last visit to Germiston there were the familiar scrap lines which I had come to know so well in England in the last few years of steam in the middle sixties – hundreds of locomotives in long lines stretching into the distance, many of them with years of life ahead of them, but with their fires cold, forlorn and neglected. Here, in South Africa, it seemed even more illogical. With more coal than it seems they know what to do with, and cheap labour – two things that make steam economic on any railway system – it is nonetheless going just as fast as it did in Britain and it just seems so senseless.

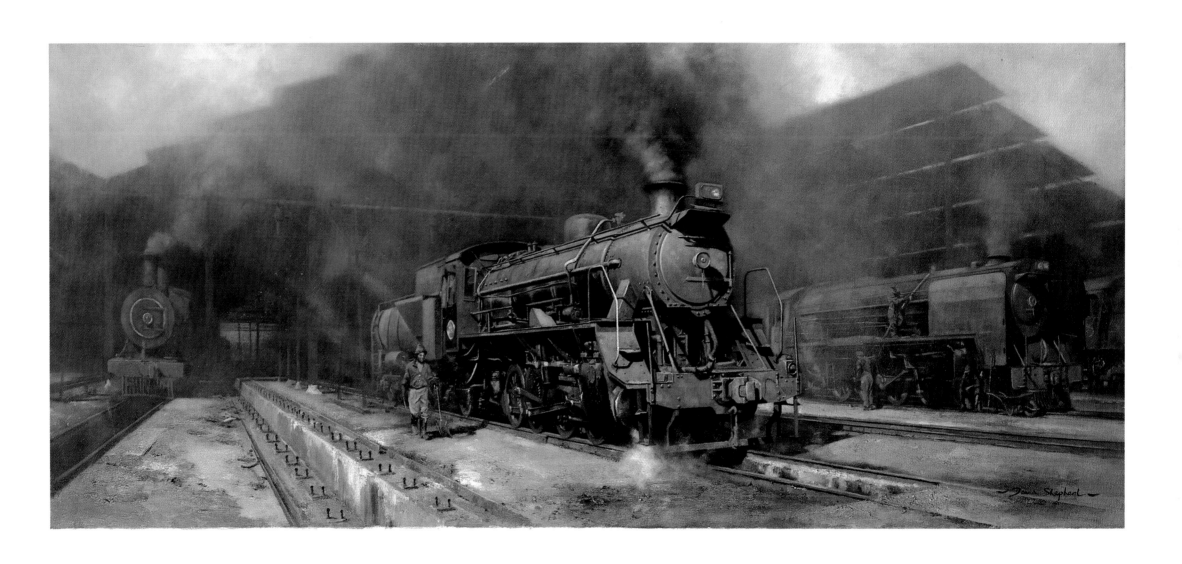

ON SHED – AS WE REMEMBER THEM IN
THE LAST DAYS OF STEAM

In the cathedral atmosphere of the great steam sheds, 92203 and 75029 await their turn on duty.

Towards the end of Britain's great steam age in 1968, the locomotives were grimy work-horses, in the twilight of their years, neglected, forlorn, but still working. Here, in the gloomy depths of a round house, there was intense beauty of the most dramatic kind if you looked for it through the dirt and the grime. Shafts of sunlight penetrated broken panes of soot-caked glass in the roof, pierced through the steam and smoke, and played on pools of green oil on the floor. Lovely harmonies could be found in the cool greys, browns and mauves of the dirty engines; and on the connecting rods one could detect the occasional glimmer of light where wet, slowly dripping, oil caught the sun. All was almost quiet as the great steam engines rested, ready to go out on the road. Only the occasional wisp of steam eddied up into the darkness of the roof, and there was a constant murmur of gentle sound as the engines simmered.

In fact, BR Standard 9F 2–10–0, No 92203, was one of the last steam locomotives to be built in Great Britain in 1959, at Swindon. The Standard 9 could indeed be termed the ultimate in British steam-locomotive design, and the class consisted of 251 engines. I purchased 92203 from Birkenhead in 1967. She spent her short working life on British Rail on, first, the Somerset and Dorset before going north, finally working the massive iron ore trains from Liverpool docks. She was eight years old when I purchased her for £3,000, with spares thrown in for good measure. I have already owned her for more than double her working life on British Rail.

BR Standard 4, number 75029, was one of a class of 79 mixed-traffic locomotives and she also was built in Swindon, in 1954. I purchased her in November 1967 upon her withdrawal from British Rail and she was last stabled at Wrexham, having worked on the Cambrian Coast line.

I have named the two locomotives *Black Prince* and *The Green Knight* respectively, and both are resident on the East Somerset Railway.

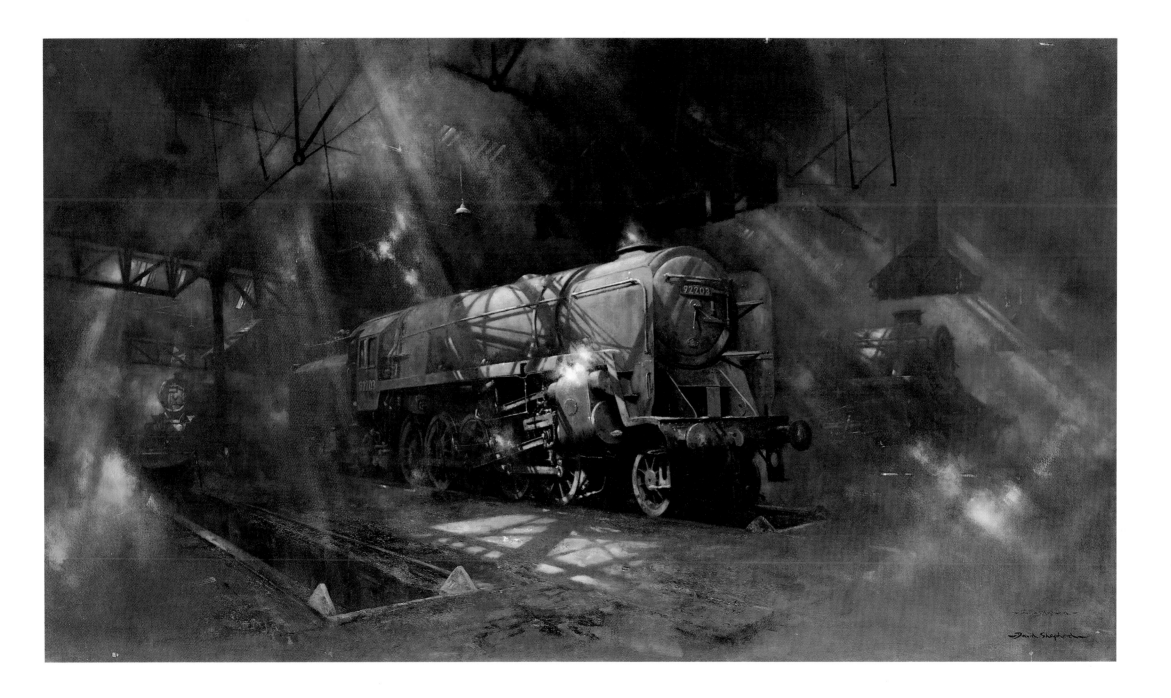

TIGER FIRE

If one judges the success of a particular painting by the amount of money that it raises for charity, then 'Tiger Fire' has to be the most celebrated painting in my career.

There are several sub-species of tiger in the world, but I fear that the only one for which there is any real chance of survival is the Bengal tiger. This magnificent animal was on the brink of extinction in 1973 when the World Wildlife Fund launched Operation Tiger. Since 1947, all but a handful of the 40,000 tigers that were then roaming the Indian jungles had been exterminated through poisoning, trapping and shooting.

That legendary man, Jim Corbet, who many decades ago had the dangerous but necessary job of ridding certain parts of India of man-eating tigers, referred in one of his books to the tiger as a 'jungle gentleman'. I totally agree with that great man, whom I had the privilege to meet just before he died many years ago; the tiger certainly deserves a better fate than to end up as a hearth rug or a fur coat. I have told the story of how 'Tiger Fire' came to be painted at the end of this book.

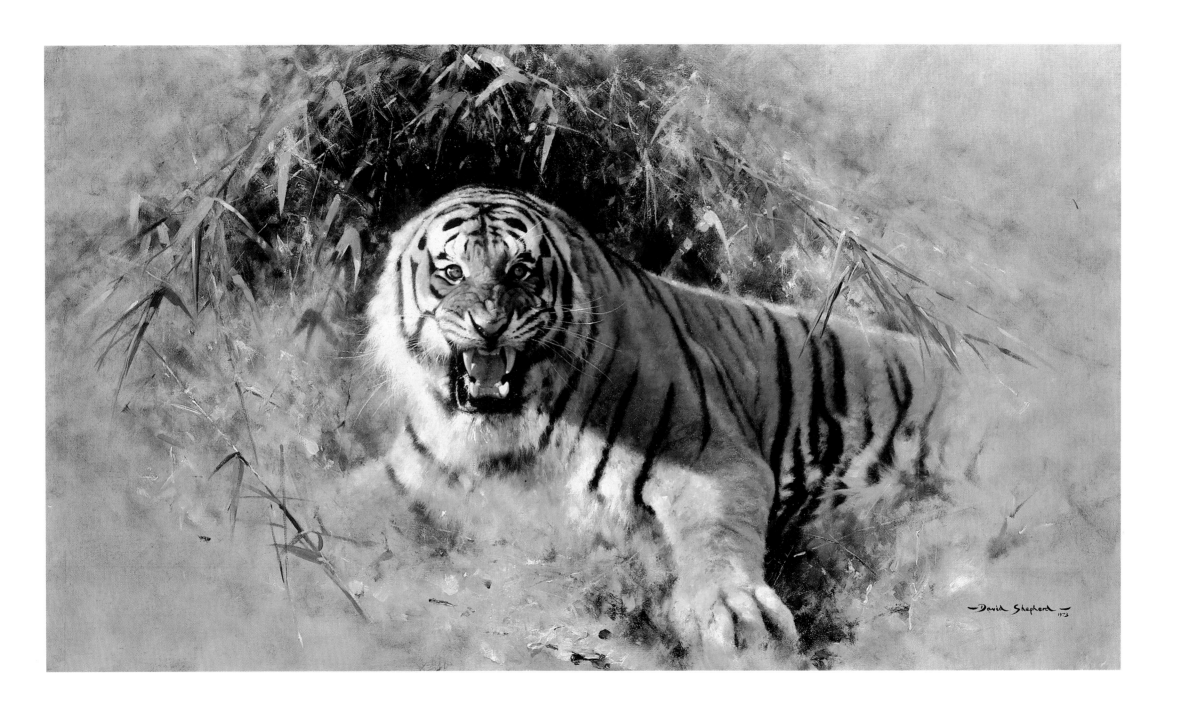

ELEPHANT COUNTRY, TSAVO

Reproduced by permission of Dr & Mrs Irving Dardik

There is a gully that cuts an erratic course for five miles through the red earth of Tsavo. There are always jumbos here for, at intervals, pools of water linger on the surface throughout the year in the otherwise parched landscape.

The destruction that the elephants have wreaked to the trees is appalling – there are parts of this land which have been completely changed in character. However, this is one manifestation of man's influence on the environment. National Parks, however large, are nevertheless artificially created, confined areas. If the animals are left to breed naturally without culling, the larger species, and in particular the elephant who is a most destructive feeder, will inevitably damage their own habitat. All this is a highly contentious issue, but it is man's fault, not the elephant's.

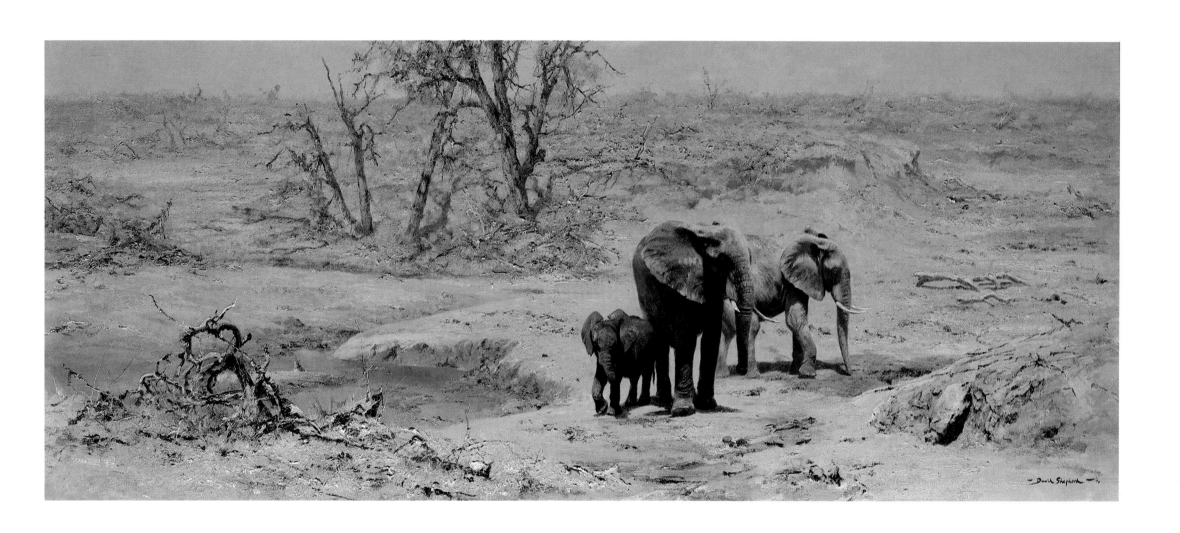

THE ROAD MENDER'S DAUGHTER

I was in India in 1973 looking for tigers for my painting 'Tiger Fire'. My hosts and I were able to get away to some of the remoter parts of the province of Bhutan, in the north-eastern corner of the Indian subcontinent. On one particular day we were driving, it seemed, into the middle of nowhere along a dirt road. We were going fairly fast, because we had a fair distance to travel. Being enthusiastic about almost everything I see that is new and paintable, I was trying to take in as much as I could within the limits of the speed at which the car was going, and as we drove down a gully and up the other side I noticed a bridge that was being repaired. I also noticed that women were humping great loads of stone around on their heads and they had, meanwhile, tied their children up in little wicker baskets. I just had time to notice one particularly attractive little girl, dressed, it appeared, as if she was going off to a party.

On countless occasions in the past, I have missed opportunities to sketch and photograph sights which I knew would make a painting, simply because I felt that there was not enough time to stop. On this particular occasion the compulsion to sketch this little girl was so strong that, although we had by now driven at least a couple of miles further up the road, I insisted that we turn back. It is quite possible that this little girl had never seen a camera or a sketch book before, but she didn't seem to mind in the least.

I took the finished portrait to the publishers who produce fine art prints of my work. It seemed a wonderful subject for a print. The picture had all the ingredients – pathos, and a touch of sentimentality, without overindulging in either of these qualities. The publishers were as enthusiastic as I was about its chances of being a great success. We showed it to the trade and the reaction, to our surprise, was a complete lack of interest. They said the world was sick of Vietnam and, 'We don't want any Vietnamese war orphans.'

If that was the opinion of the trade, who claim they know the market, there was little we could do about it. We pointed out that the picture had nothing whatsoever to do with the Vietnam war, but it made no difference. The print was almost a complete failure, in spite of the fact that it is, I think, one of the more unusual subjects that I have painted. One learns all the time. 'Fashion' and 'taste' change continuously so, now that the Vietnam war is fading into history, perhaps it might be worth considering a re-issue of the print.

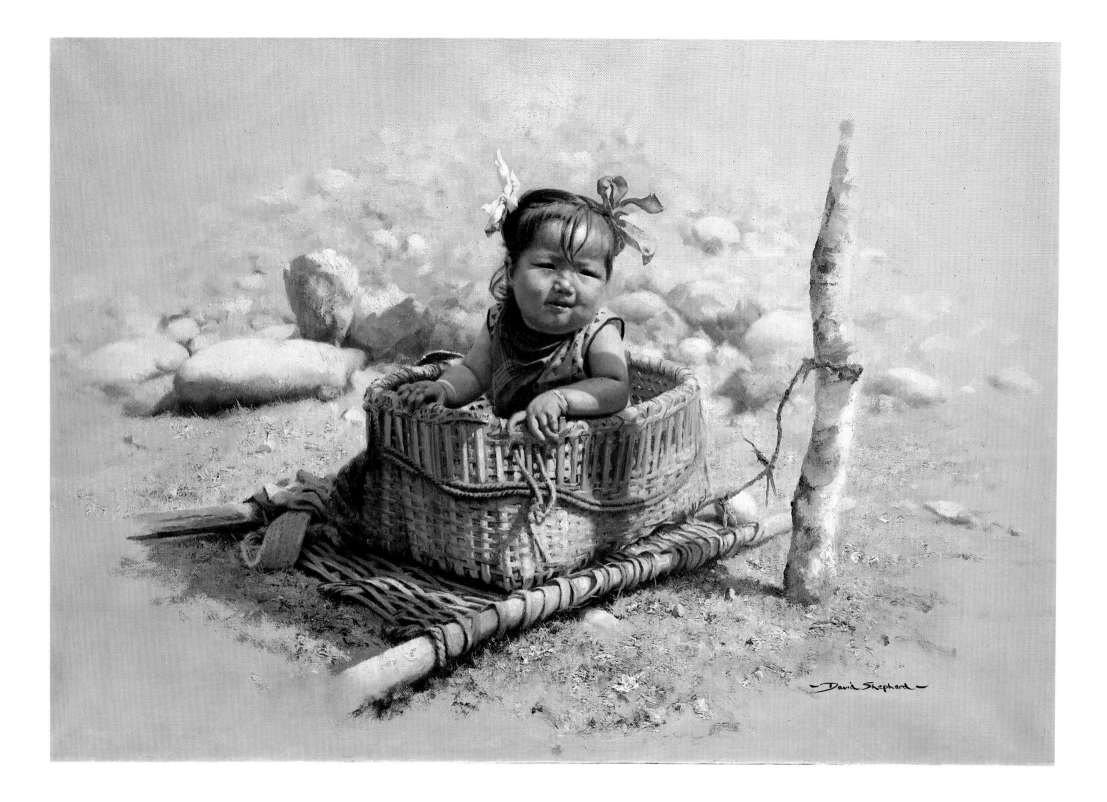

David Shepherd

SPRING PLOUGHING

. . . and blithe afield to ploughing
Against the morning beam
I strode beside my team.

People sometimes ask if I am inspired when I paint, either by music or poetry. In this case it was both. The words of A. E. Housman in 'A Shropshire Lad' seem to fit perfectly the scene that I have painted.

Arthur Butterworth wrote a most beautiful piece of music called 'A Shropshire Lad' which evokes, for me, those days when the sun always seemed to be shining, the fields were full of wild flowers and the larks sang in the clear sky; there were no pesticides to spread their poison, no cars to disturb the tranquility. Tragically, Butterworth was killed in the trenches shortly after; who knows what great music he could have gone on to write, the sort of music that describes the landscape of England that I love to paint so much.

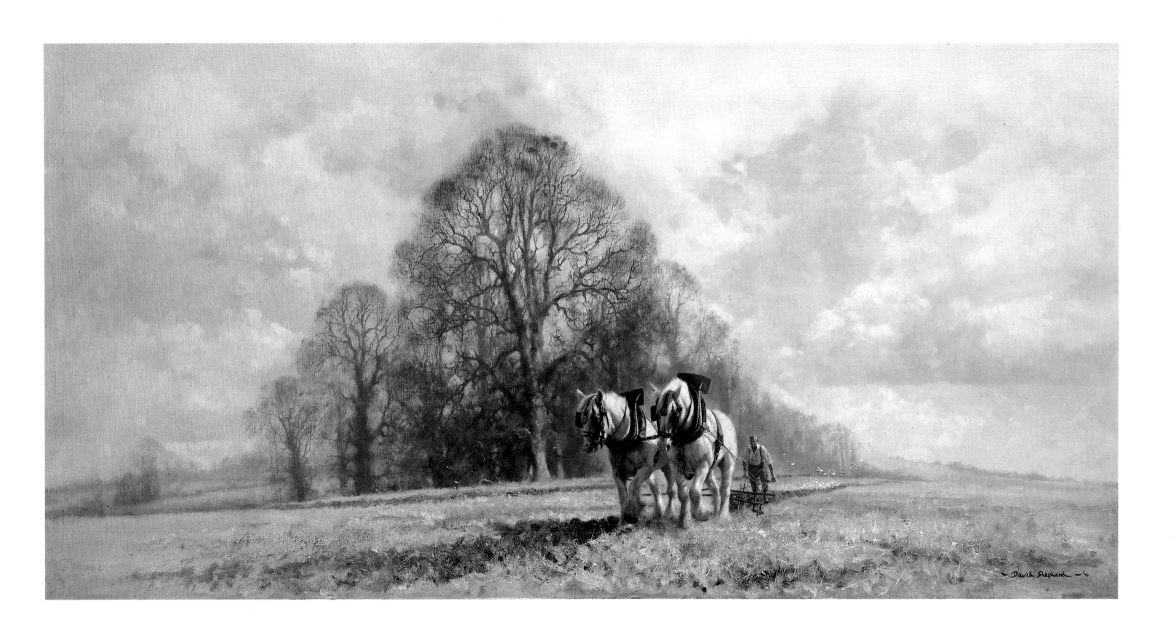

TIGER IN THE SUN

Reproduced by permission of Mr Bill Stremmel

This rare and beautiful animal, so nearly extinct in its wild and natural state, is not the ferocious killer it is often made out to be in the lurid picture book or commercial advertisement.

'He will leave you alone if you leave him alone'; I was told this by a game warden when he was taking me out into the African bush for the very first time to see a real wild elephant. I have always remembered this, and it has given me a much more logical and less sensational approach to the so-called 'dangerous' animals of the world. The elephant, buffalo, lion, leopard, tiger and rhino – all are too much intent on living their lives undisturbed to attack man unless provoked. Unfortunately in this sad age in which we have wreaked such appalling destruction to the world's rich natural resources, they all have ample reason to act otherwise. I went to India to see wild tigers. After three weeks of ceaseless effort, they had still eluded me for good reason; out of 40,000 tigers in India in 1947, over 38,000 had been trapped, shot or poisoned.

For my painting 'Tiger in the Sun', I worked from a captive animal. However, on my visit to India, to the Kanha National Park, I explored and sketched many beautiful settings such as the one in the painting. This is real tiger country and, shortly before my coming on this scene, a tiger had in fact been lying up in the early morning sun on the rock in my painting – the grass was still flattened. So my picture is of an actual scene where tigers can still be found in their natural state; I am one of the privileged few to have been there.

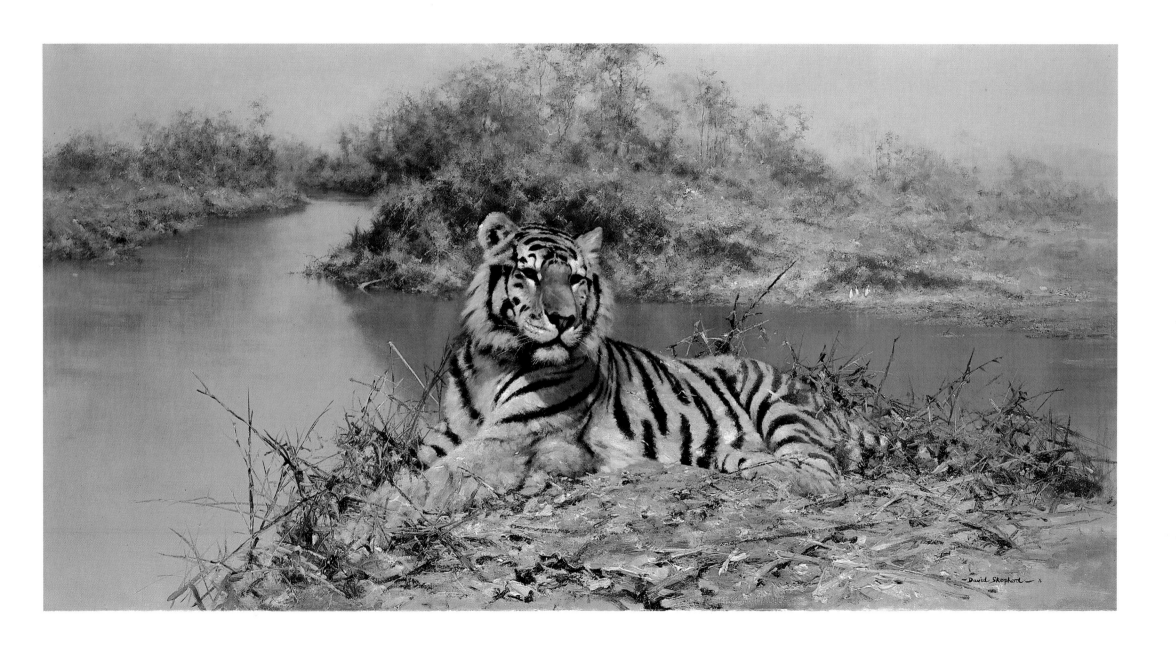

AFRICAN AFTERNOON

Reproduced by permission of Mr & Mrs Martin Hitchins

Of all the examples of the catastrophic damage that man is doing to the environment, perhaps the most significant is that of the tropical rain forests. It is interesting indeed to reflect that, at the time of painting this picture, the estimated rate of destruction of rain forests was 20ha (50 acres) a minute. Now, it is estimated to be 150 acres a minute, which means that an area four times the size of Switzerland is every year being destroyed forever. It was following on the success of my painting 'Tiger Fire', which raised so much money to help save the tiger through the publication of a single limited edition of 850 copies, that I therefore painted 'African Afternoon' specifically in aid of the World Wildlife Fund's tropical rain forest campaign. The picture raised £80,000.

I chose as my subject the beautiful Bongo – a secretive antelope that lives in isolated pockets of deep African forest. This lovely animal seemed to me to represent those countless species that will disappear forever if the progressive destruction of the rain forests continues at such a frightening pace.

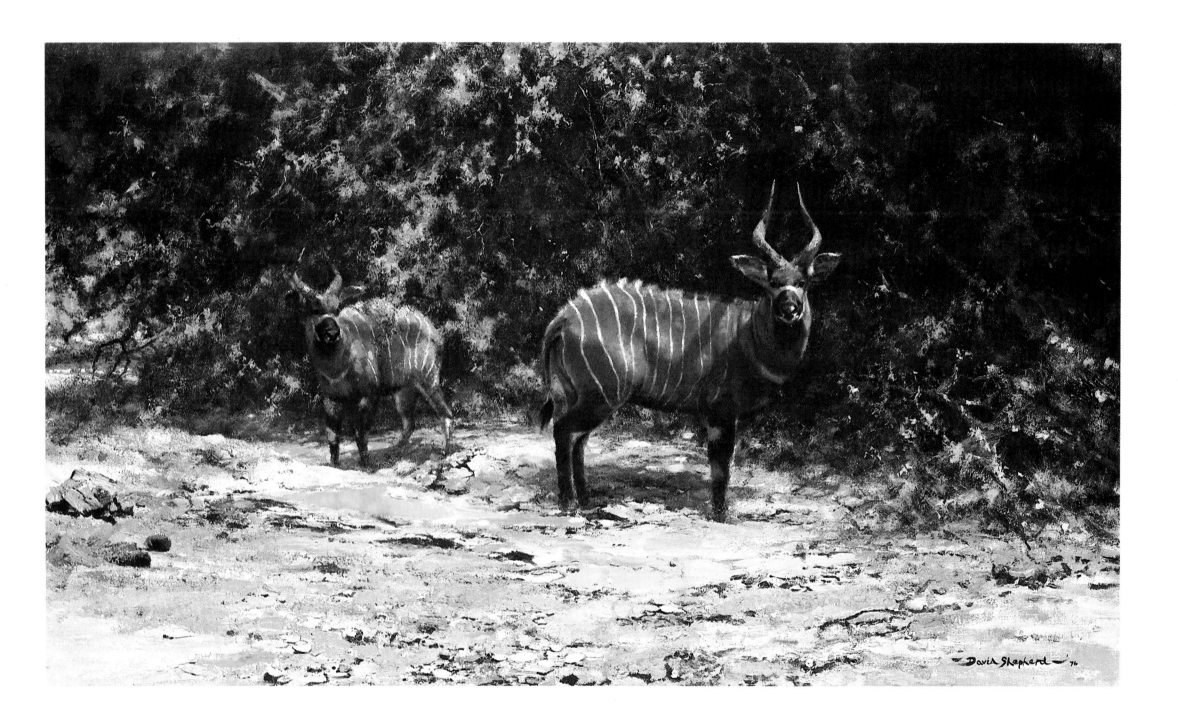

SERENGETI SKIES

Although I generally find most inspiration in the hot, dry, yellow bush of Africa, the Serengeti Plains at their most dramatic have a magic all their own. Surely this is the place for great African skyscapes. With the advent of the rains, bringing the first flush of green grass, the wildebeast, those lovable, comic, but slightly sad, characters of the bush, trek in their tens of thousands – undoubtedly one of the wonders of Africa – and the many varied predators await their turn.

In my painting, two wild dogs are looking at the intruder.

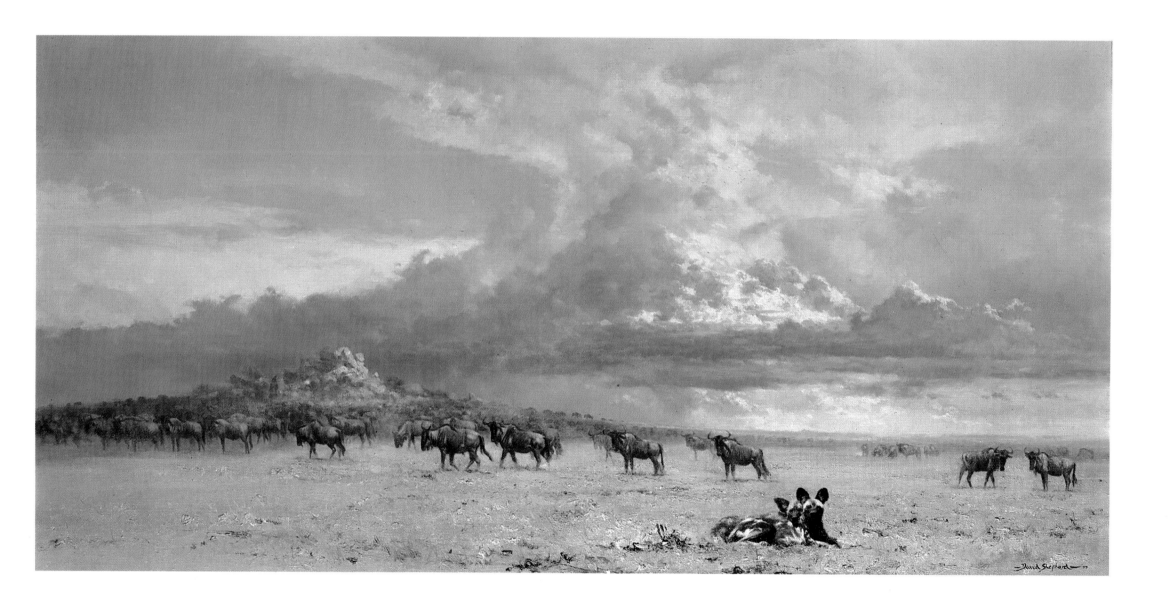

BLACK FIVE COUNTRY

Once in a while, man creates a masterpiece. It may be a great cathedral, or a symphony, or a painting. He can also create a 'classic' machine – that rare achievement when not only are functional requirements more than adequately met, but they are incorporated into a superlative design, born of a designer who is not only an engineer but also an artist. How many times does one hear, 'If it looks right, then it is right.' In the early 1930s, William Stanier, of the London, Midland and Scottish Railway, created just such a 'classic' steam locomotive. There can scarcely be anyone in the legion of devotees of Britain's great and romantic steam-railway age who has not heard of a Black Five – possibly the most successful steam-locomotive design ever.

Stanier's 4–6–0 Class 5 first came into service in 1934, and was at once universally popular with the footplatemen. The Fives were equally at home on express passenger trains as on heavy-freight workings, and they frequently achieved the staggering total of 150,000 miles and more between overhauls. No less than 842 were built, the last emerging from works in 1951.

It was most appropriate that the very last steam-hauled service train on British Railways, on 3 August 1968, was hauled by a Black Five. Until the final days of steam, therefore, these magnificent engines were part of the everyday scene up and down the country and known to, and loved by, countless railway enthusiasts. These were the days when, sadly, everything was running down. Our proud steam heritage was not going out in a blaze of glory as it should have done, proudly; it was going out in degradation and neglect. Locomotives would leave the coaling plant, ready for the road, in appalling external condi-

tion. Some were completely anonymous. Their smoke-box number plates had either been taken off or, much more likely, been stolen by the small minority of railway enthusiasts who spoilt it for everyone else. Even their cabside numbers would be invisible under layers of grime and filth; but such was the perfection of the basic design that they kept running right until the end.

I did the sketches and drawings for this scene at Stoke-on-Trent in the very last weeks of steam. By now, the ground was inches deep in grimy oil and ashes. Nevertheless, for me, this is exciting stuff to paint. I have been criticised many times in the past for rarely painting 'happy', clean engines. This, in my view, is the domain of the photographer; time-worn and neglected locomotives tell far more of a story. After all, this is how we all remember those final months and weeks and this is how I, as an artist, want to portray the scene; sad, but that is how it was, and that is the very stuff of nostalgia.

Now, at Stoke-on-Trent where I spent all those happy final hours sketching and photographing, all has been swept aside in the interests of that awful word 'progress'. The engines have gone to the scrapyard, coaling tower and shed have been flattened by bulldozers in the all too customary fashion, and everything is wasteland. I am a born romantic I know, but I like to reflect, with many others, on the fact that had we left everything exactly as it was on the last day of steam in August 1968 – engines, coaling stage, the shed, all the muck and filth – the place would now be, surely, one of the major tourist attractions in the country! Instead, it is now just a memory, and a faceless collection of modern concrete buildings.

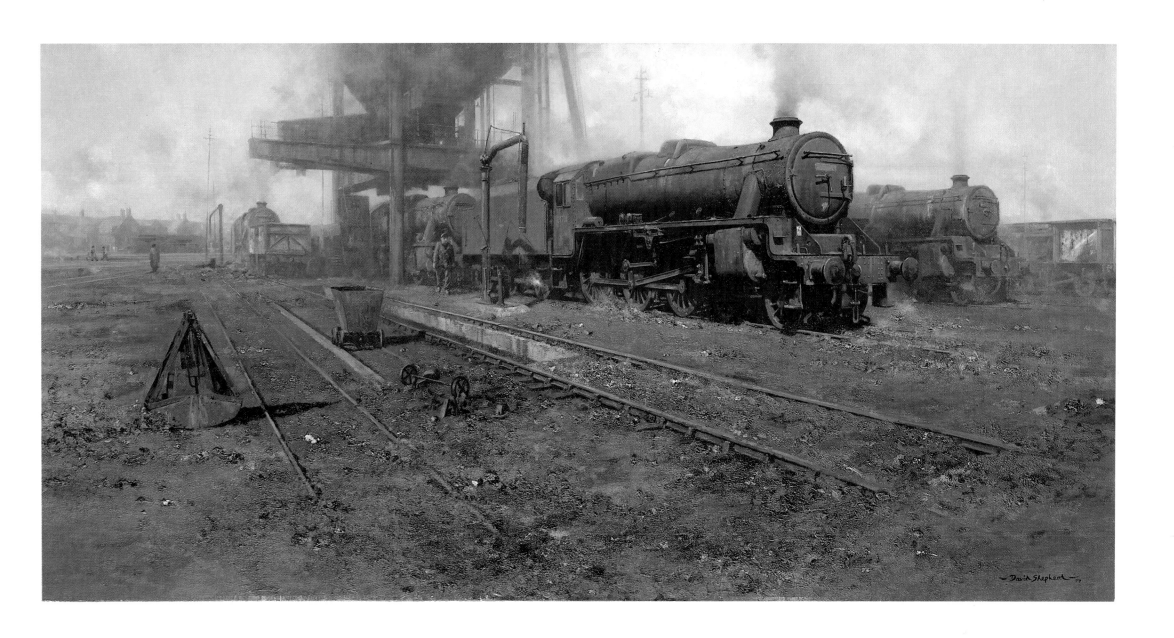

WINTER OF '43, SOMEWHERE IN ENGLAND

I hope that I have been able to evoke, in my painting, the memories and the feelings which must still be fresh in the minds of thousands of ground and aircrew, now dispersed all over the world and who worked on and flew their beloved 'Lancs' with the Royal Air Force during those momentous days of World War II. How many must still remember 'their' Lanc at its far-flung dispersal; a watery sun casting long shadows on a chill autumn evening; the leafless elms of a countryside 'somewhere in England'; the wet runway and the mud; and all the untidy clutter of last-minute preparations before take-off; final adjustments to an engine – 'the revs were a bit low on the port inner last night over Essen, Fred, – it's Cologne tonight, so get 'em right' – and the inevitable bicycles. I hope it is all there; that feeling of those historic times.

I have kept this painting as it means so much to me: not only did it raise such a large amount for the Royal Air Force Benevolent Fund, but I made so many friends while painting it; the whole story is at the end of this book.

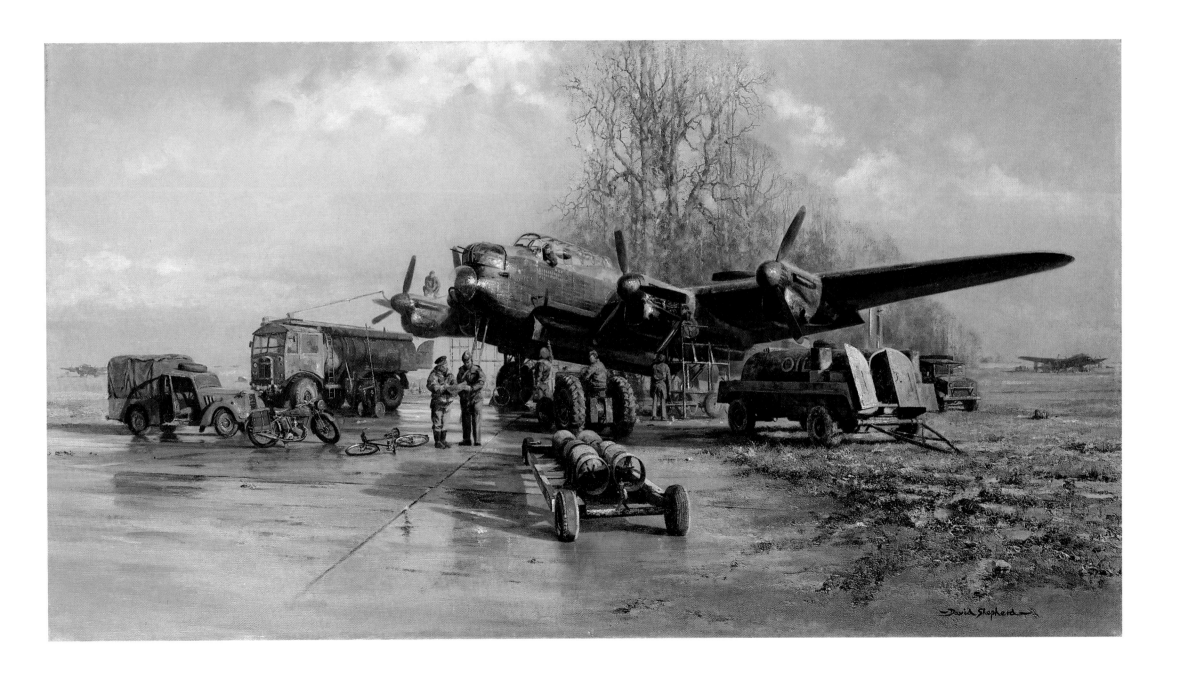

EVENING IN THE LUANGWA

Evening is short in Africa; from daylight to darkness is perhaps just one hour. The burning daytime heat of the Luangwa Valley in Zambia, when nothing seems to stir, gradually gives way to the cool of the evening and the shadows lengthen. Then, quite suddenly, it is dark, and life awakens to the vibrant sounds of the African night.

The lions are content; they have fed well from a previous night's kill, and they will not stir for many an hour. Tonight, the zebra and antelope know that they will be able to graze without fear. All is at peace, in the evening, in the valley.

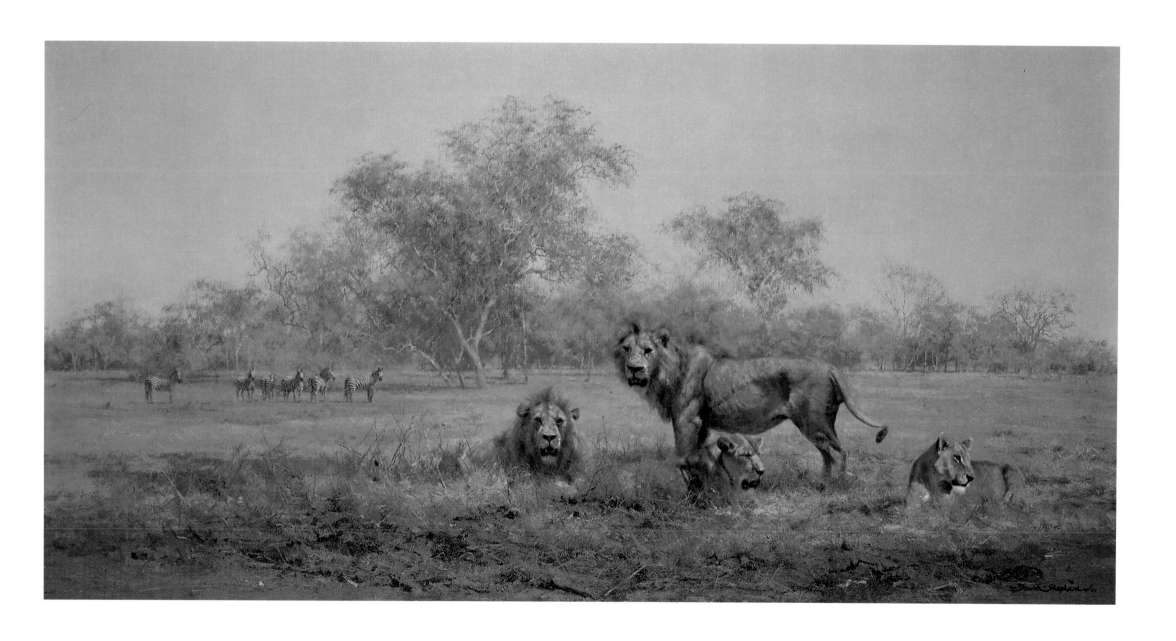

THE CROSSING

Reproduced by permission of Mr & Mrs Peter Miller

The Luangwa Valley National Park in Zambia is, in my opinion, the finest park anywhere in Africa. The magic of this glorious place began to cast its spell over me the first time I went there in 1964, and I have found myself returning time and time again. The North and South parts of the park cover some 31,000km² (12,000sq miles) and the whole area is hot and dry, except at the time of the rains. The Luangwa River, which is the most wonderful feature of the park, slowly twists and turns on a course which frequently changes with the advent of every new rainy season, until finally it runs into the Zambezi River. At the height of the dry season, the waters of the river provide the only drinking places for the teaming wildlife in the park, and possibly greater concentrations of game can be seen here than anywhere else in Africa.

For some considerable part of the river's length in the South Luangwa National Park, the park is on one side and a controlled hunting area is on the other. The elephants have learned that it is perfectly safe to feed in the controlled hunting area at night. Then, at first light, they escape the possibility of being hunted by swimming back across the river into the safety of the National Park. At one or other of these well-defined crossing places, and as the evening shadows lengthen, it is almost certain that one can see up to sixty elephants coming down the river bank to drink. Even at its lowest ebb, the river is still fairly deep in the middle. When they cross, each elephant hangs onto the end of the tail of the one in front. In the middle, in order to breath, the babies, who are by this time completely submerged, have to let go, and their little trunks pop up like periscopes. For me this is the ultimate joy, to watch elephants in such a setting.

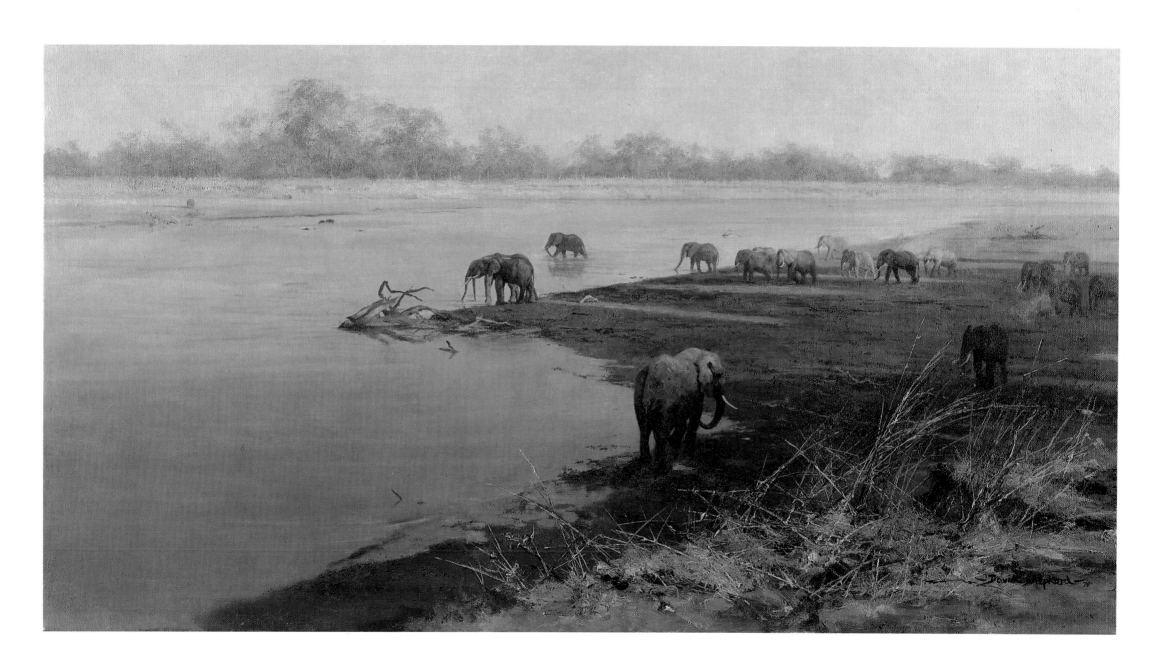

BUFFALO WALLOWS

There is a place in the Tsavo East National Park in Kenya called Buffalo Wallows. Covering many square miles of parched and dry red landscape near the Galana River, it is a landscape of huge rocks jumbled together in chaotic profusion, interspersed with dry gullies. Here, around a corner, one can quite easily be suddenly confronted by either an elephant or a buffalo, of which there are many in the area.

This wild landscape seemed to be an ideal setting in which to portray the African Buffalo. I have seen countless numbers of these magnificent animals over the years, but I never fail to be inspired by them, and by that moment of tension as one suddenly sees a group of them standing gazing at one, their noses sniffing the air and their eyes peering intently at the intruder.

The Tsavo National Park is, or was, a very good place to see rhino. This marvellous animal, who has been with us for sixty million years, is now on the brink of extinction – small wonder when his 'horn' is more valuable pound for pound weight than gold. A wildlife poster to draw attention to the animal's plight features a rhino's portrait and, underneath, it says, 'I'm ugly, nobody loves me.' In fact, he has as much right to exist as the rest of us.

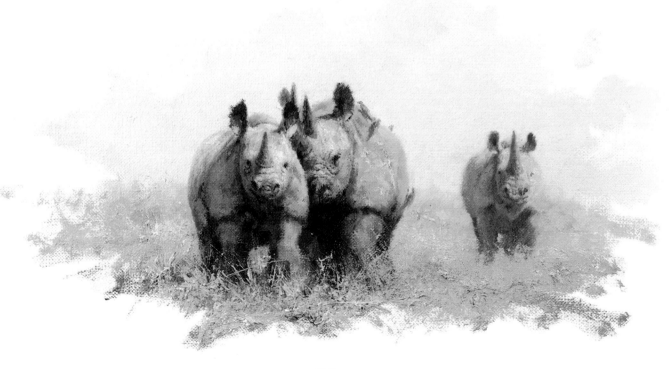

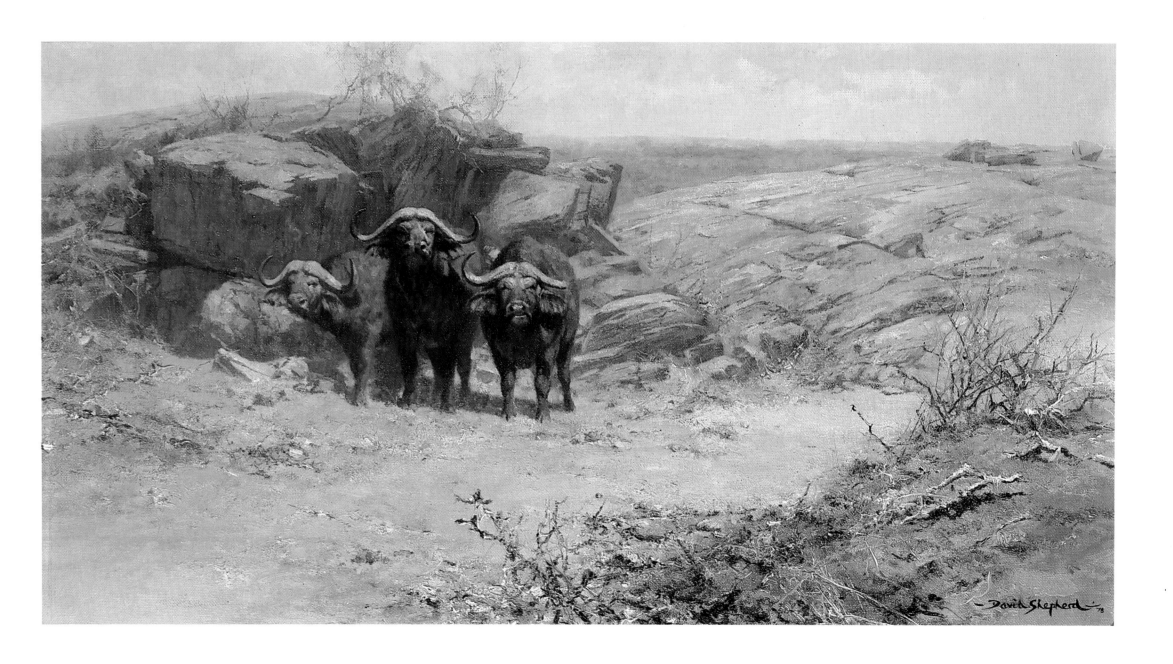

GREATER KUDU
Reproduced by permission of Mr & Mrs Graeme Lamb

The magnificent Greater Kudu roams the open landscape of many African national parks. Some of the finest can be seen in both the Kruger National Park in South Africa and the Luangwa Valley National Park in Zambia. There is scarcely any more impressive sight in Africa than that of a mature kudu bull as he stands, head erect, monarch of all he surveys. Taut as a bow-string, ready to bound away at the slightest hint of alarm, he is a naturally shy animal. A large kudu bull, weighing 295kg (650lb), will be more than a match for his natural enemy the lion. Those beautiful spiral horns stretch upwards for 1.8m (6ft) and are a deterrent to anything except the most determined adversary.

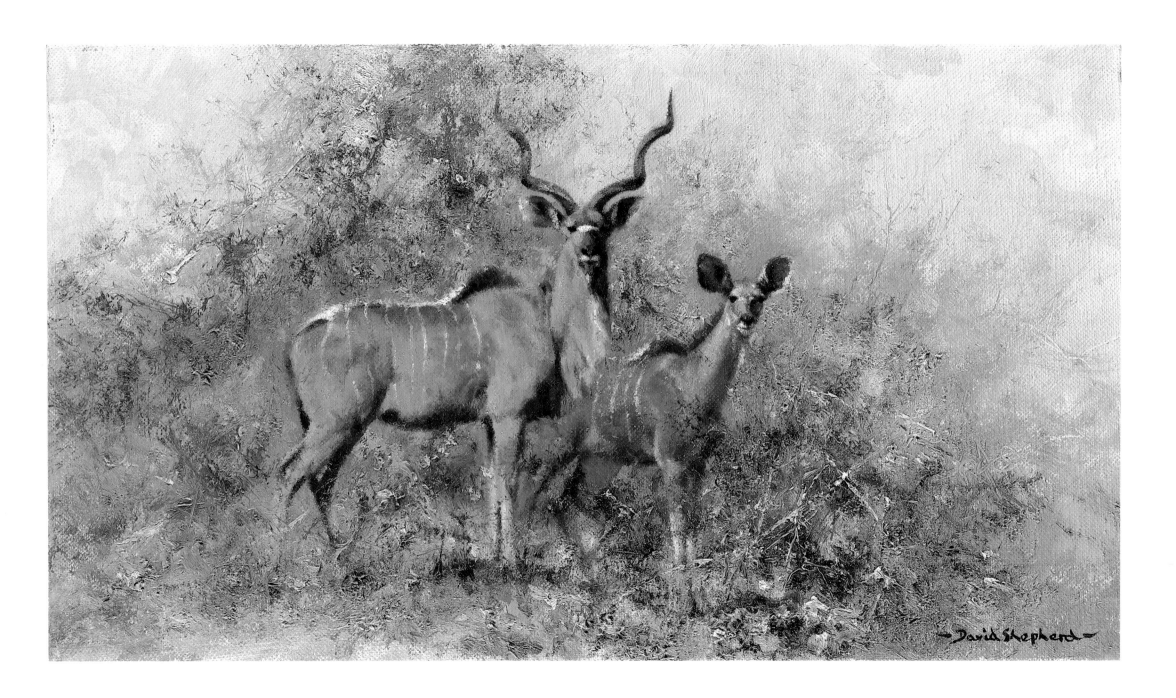

THE LAND OF THE MASAI

In order to obtain the sketches and photographs for this painting, I had to bargain with the local headman for half a day, with the game warden as my interpreter. Sadly, times have changed since the early days. It seemed that the Masai have now got a trade union and I was talking to the shop steward. I was finally allocated five moran – the young warriors of the boma – for an hour, £10 cash, and this had to be paid in advance. However, it was a third of the original asking price! While I was sketching, two or three extras wandered onto the scene in the background and, as these had not been included in the contract, the five that I was sketching immediately refused to co-operate.

I went inside one of the mud and cow-dung huts inside the boma, and the children and old people were friendly, but I felt strongly that I was intruding on their privacy. The Masai are proud and independent, aloof and at times arrogant; but these are surely qualities to be admired in a world of conformity. Sadly, however, some can now earn more money by posing for the tourists' cameras at the local petrol stations than by herding cattle and living their pastoral lives as they have done for centuries. This is the Africa of today!

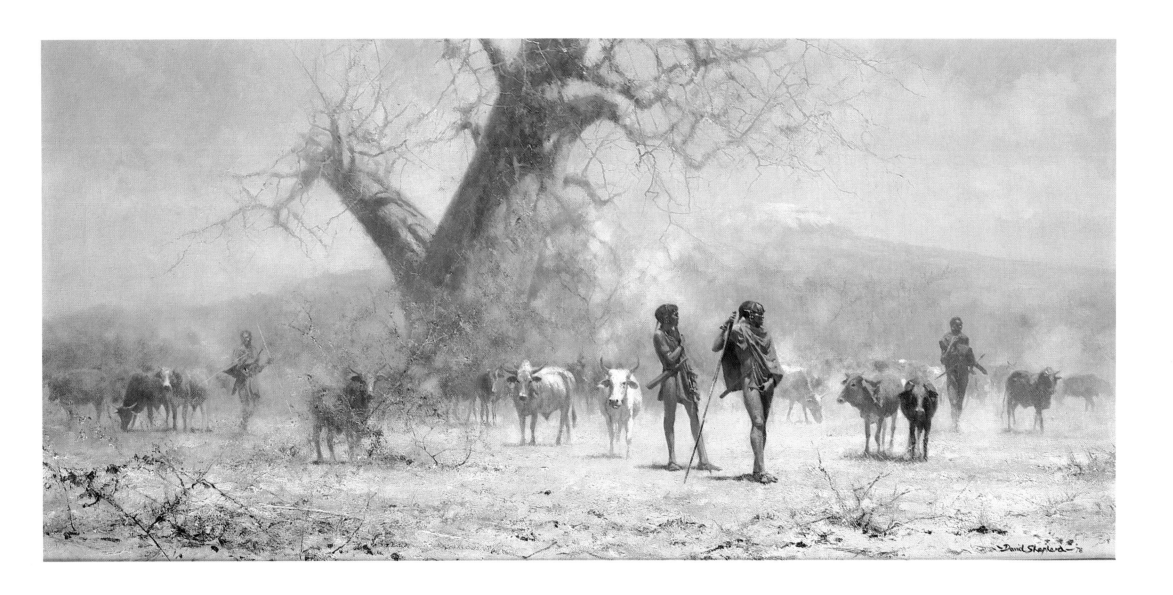

A JUMBO PASSED THIS WAY

Reproduced by permission of Mr & Mrs Donald L. Dell

A few years ago I exhibited a major painting of African elephants in a gallery in Johannesburg. The person who bought it came up to me and said, 'David, why did you put those elephants in the picture, it would have been perfectly OK without them?' He did not in fact realise that he was paying me a very great compliment, by implying that the painting would have stood on its own as a landscape without the animals. I always regard myself as a landscape painter whether the subject happens to be in England, Africa, or anywhere else. It just so happens, that if I paint Africa, I am seldom able to resist the temptation of putting an animal in somewhere.

I have known this area in the Tsavo National Park near the Galana River for many years, and I have painted an exact spot with the rocks, trees and the river exactly as they are. In this particular case, I felt the landscape to be strong enough on its own, without any animals.

My wife and I were out in the park with the game warden and his wife one day and we decided to stop at this lovely place for a picnic. I was excited about the whole area as, wherever I looked, scenes were just begging to be painted. We noticed that an elephant had walked through the gap in the rocks in the foreground, leaving his enormous 'dinner plate' footprints in the red, dry dust. We traced his passage through the gap, down through the rocks and across the river where, in common with a great many of his kind, he left his visiting cards on the dry area of grass right next to the water's edge. He then wandered off into the distance and out of sight. Then there was nothing to disturb the wonderful peace of it all – just the sighing of the wind.

ARDOYNE PATROL

Reproduced by permission of the Officers' Mess, 1st Battalion, The Green Howards

When The Green Howards asked me to paint Northern Ireland, my first reaction was to decline. However, they asked for a painting to portray the day-to-day life of the foot soldier in such a setting and I felt that this would be an interesting challenge, so I was flown out to Belfast to see for myself. On my arrival it was decided that if I was going to go wandering into areas such as the Ardoyne, I would have to be escorted by an army patrol. There was good reason for this. The Parachute Regiment, who would carry out the unenviable task of seeing that I did not do anything stupid, had obviously done their homework. They remembered my last visit to Aden, when I did a painting for them and nearly got my head blown off! They decided that I was probably better off with them to make sure that I didn't get into any trouble. This, in retrospect, was the mistake we possibly made and which led to the problems which were to follow.

The following day I walked in to the Ardoyne from the Crumlin Road. This was an intensely Republican stronghold. I had my camera with me, and within minutes a group of women started spitting at me. It was not a particularly pleasant experience and, not being a trained soldier, who is no doubt used to this sort of thing in Belfast, it took me by surprise. The torrent of filthy language and abuse that was showered on me was not particularly encouraging either. I protested violently. I tried to point out that I was an artist, trying to take photographs for a painting. They were unconvinced; looking at the Parachute Regiment patrol and armoured personnel carrier behind me, one of the women pointed an accusing finger at me and said, 'If you were a f . . . artist you wouldn't need the f . . . Brits behind you; you're f . . . special branch!' It was quite hopeless to try and talk to such people and the situation began to get extremely heated. I reminded them that I was there to do a job, I was going to do it, and that 'it was a free country' (a singularly inappropriate remark, I realised afterwards!).

I wandered further down into the ghettos of the Ardoyne,

and saw scenes of devastation and squalor the likes of which I have never experienced before; rows of gutted houses, with high fences down the middle if that particular street happened to be Catholic on one side and Protestant on the other. It seemed far worse and far more poignant than any scenes of the London Blitz which I remembered. Yet, amongst all this awfulness, with the walls covered in obscene graffiti, I passed a house where, in the open doorway, a lady stood watching me. As I passed she said, 'Come in and have a cup of tea, dear?' Untrained as I was, I did not really know how to react to something so unexpected. I politely declined, pointing out that I had a job to do and did not really have the time. I asked the Parachute Regiment afterwards, whether the old lady's request was some sort of sinister trick to get me into her house and then 'have me done over'. I was told that this was most certainly not the case. This particular person was desperately trying to hang onto a thread of normality in a totally abnormal situation, and she would have been only too keen to welcome me in to have a cup of tea with her.

In the foreground I have portrayed the small child that came up to me and asked if I had any sweets. It seemed particularly tragic to realise that that child and all his friends were growing up in a situation so full of hate and animosity. What would his future be? This was just the sort of touch that I was looking for and it would possibly not have occurred to me had I not actually seen it. I continued my walk further down into the Ardoyne, and was once again surrounded by a group of extremely hostile women. Tempers, including mine, began to get very frayed, and this was the moment when the sergeant in the army personnel carrier decided that it was time to get David Shepherd out. I was bundled into the back of the vehicle and, a few minutes later, was relaxing over a rather stiff drink in the Officers' Mess, in a ramshackle and desolate converted mill a few hundred yards away.

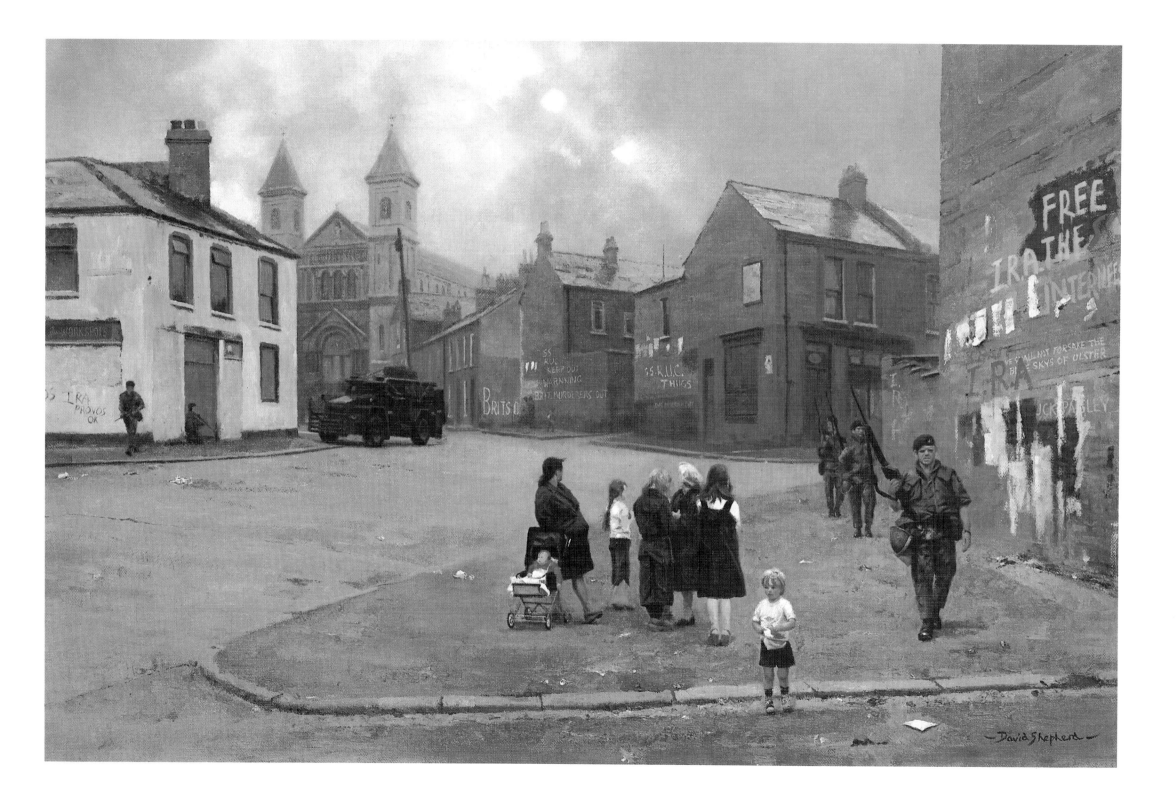

ZEBRAS AND COLONY WEAVERS

Reproduced by permission of Mr Frederico Riojas

The Etosha National Park in South West Africa is more inaccessible than most other National Parks and has an individual beauty all its own. A remote harsh, dry and dusty landscape of rock and glistening white salt pans, even the sky is a different hue of blue. The waterholes team with wildlife. Etosha has some of the largest concentrations of zebra and gemsbok to be seen anywhere in Africa.

One of the most interesting features of the park is the huge nests built in the acacia trees by the Colony, or Sociable, Weavers. These attractive yellow birds live in many hundreds in the huge masses of twigs and grass knotted together in the branches of the trees and which are their nests. Some of these communal 'cities' measure 3.7m (12ft) and more across, and can be 1.5m (5ft) thick. Many have been built up over a period of thirty years or more, attaining such a size that the host tree eventually collapses under the weight of the nests built in its branches. This is my favourite sort of country and Etosha and places like it call me back again and again.

THE ARK, TURNING INTO WIND

Reproduced by permission of The Fleet Air Arm Museum, Yeovilton

'Stand clear of propellers, jet pipes and intakes'; Lieutenant Commander Flying has just made this 'pipe' over the flight-deck communications system.

The flight deck of an aircraft carrier at sea has been termed 'the most dangerous place on earth'. To an artist who's emotions are stirred by almost anything big, dramatic and exciting, such a place is almost beyond contemplation. Wherever I looked there was activity of a kind that would have produced a thousand paintings. Gannet aircraft were being towed with their wings folded looking like praying mantis, Buccaneers and Phantoms were coming up from the inner depths of the ship on lifts and taxying to the catapult for take-off. The sight of a 20-ton Buccaneer with its twin Spey engines at full throttle generating as much power as a destroyer, rearing up like a pre-historic monster and straining for release from the catapult and then accelerating from standstill to 130 miles an hour in a couple of seconds, was almost too much for me!

I have written further about the great success of this painting at the end of this book. It is one of three or four which are landmarks in my career, if for no other reason than that they have raised very large sums of money for charity and other worthy causes.

SERENGETI
Reproduced by permission of Mr Bill Parson

The cheetah is the fastest animal on four legs over a short distance, able to attain speeds of up to 96km (60 miles) an hour. When moving fast, these animals often take up the most unpaintable anatomical positions. They make a much better painting when still, but alert, peering into the distance.

The Serengeti National Park in Tanzania is one of the finest places to see cheetah close. On one occasion, my wife and I were out with the warden; it had been raining heavily and there was a lot of mud on the windscreen of the land rover. We came across a small group of cheetah and one jumped onto the front of the vehicle, possibly mistaking it for an anthill from which it would get a better view of the surrounding landscape. Before I quite realised what I was seeing, the warden had wound the window down and, putting his arm around the front of the windscreen, caught hold of the cheetah's tail and wiped the windscreen clean. The cheetah seemed totally oblivious of what was happening and took not the slightest notice!

Tourism is a vital element in the long-term survival of Africa's game. There is nothing wrong with mass tourism if it is properly controlled. However, there are national parks in Africa where the large numbers of tourist buses packed with people is not only having a major effect, physically, on the environment, but it is also affecting the social behaviour of the very animals that these people are paying money to go and see. The cheetah in the Serengeti are, it seems, a good example of this. Whenever a cheetah is seen hunting, in full flight, it will quite possibly have several buses driving flat out just behind it, full of people, with their movie cameras whirring, chasing the cheetah. The animal cannot hunt in these circumstances and it will quite possibly go hungry. I have been told that the cheetah have now managed to adapt their hunting habits to cope with this disturbance from man – they now know that the only chance they can hunt undisturbed is during the afternoon when all the tourists have gone back to their safari lodges for lunch and an afternoon siesta. Tourism must play its part in the survival of wildlife, but it must be controlled.

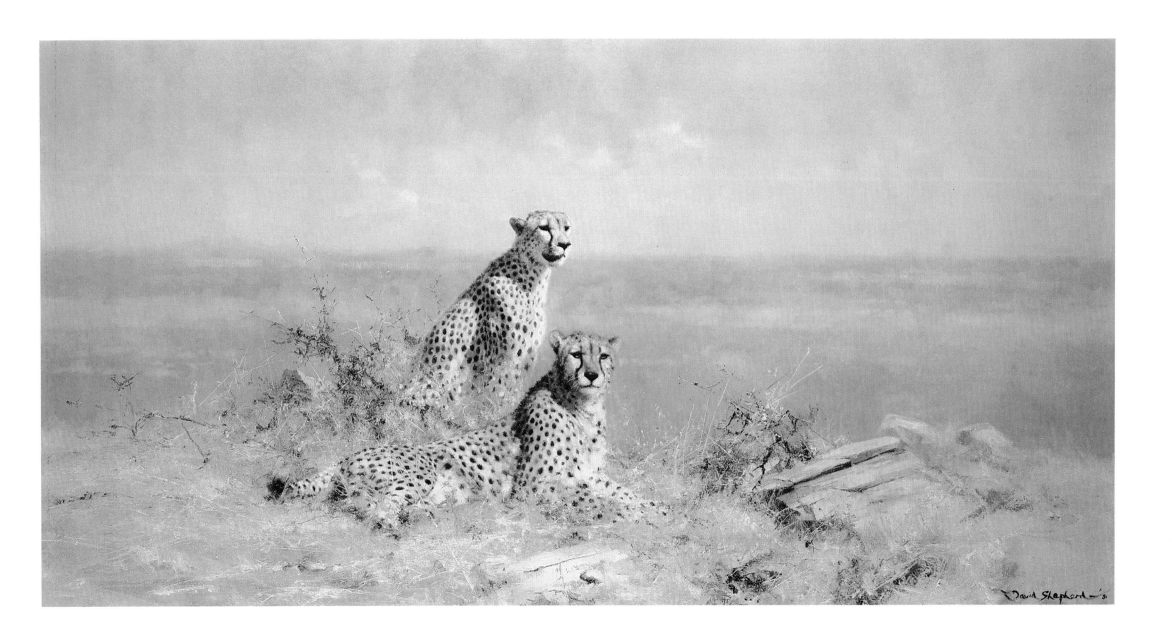

THE WELCOME STORM

Reproduced by permission of Mr George Montgomery

Towering and dramatic skyscapes are so much a part of the vastness of Africa. With a hush of expectancy, the parched land is awaiting the coming of a new season's rain. The grass has been scarce for many months since the last rain fell, and the wildlife is thirsty and restless; but the days of endless blue sky and searing sun are gradually giving way to threatening thunder clouds. Soon, the heavens will open and the landscape will be born anew.

The scene is the Luangwa Valley in Zambia, one of the finest National Parks in the world and one of the last strongholds of the African elephant.

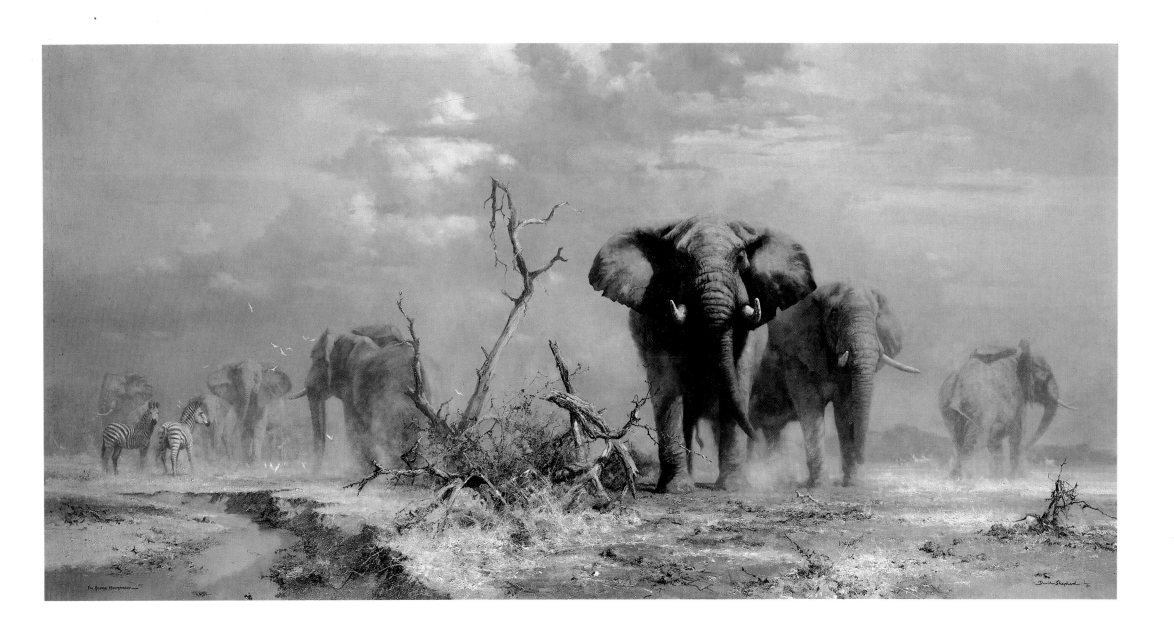

For George Montgomery — David Shepherd

THE OLD FORGE

With his dog always with him as his inseparable companion, the village farrier had arrived for another hard day's work. So often now, I want to return to the past. I wonder if this great hunger for nostalgia and memories of a bygone age, when life seemed to move just that little bit slower, is an antidote to the functional and materialistic age in which we now live – an age when built-in obsolescence and push-button entertainment seem to count for everything. People are turning to country crafts, in which skills and working with one's hands meant something, to an increasing degree; and more and more people are looking back to those days when simpler things in life mattered just a little more.

For my painting of the Old Forge, I visited the Devon Shire Horse Centre near Plymouth, which is open to the public. This is a working farm; heavy horses are used throughout the year for all the farm work, and at least once a week some are taken into the forge to be shod. There is only one concession to modern practice; the old bellows have given way to electricity. Otherwise everything is as it was in days gone by – the ringing tones of hammer on anvil, that characteristic smell of singed hair as a new shoe is tried and fitted in clouds of smoke, and the light of the fire dancing among the cobwebbed beams of the ancient roof.

Princess was the subject for my painting. She stood as quiet and as placid as a lamb, as her new shoes were fitted. The only problem was that she would not look towards me so we had all the while to rattle the food bucket. She fared very well that morning!

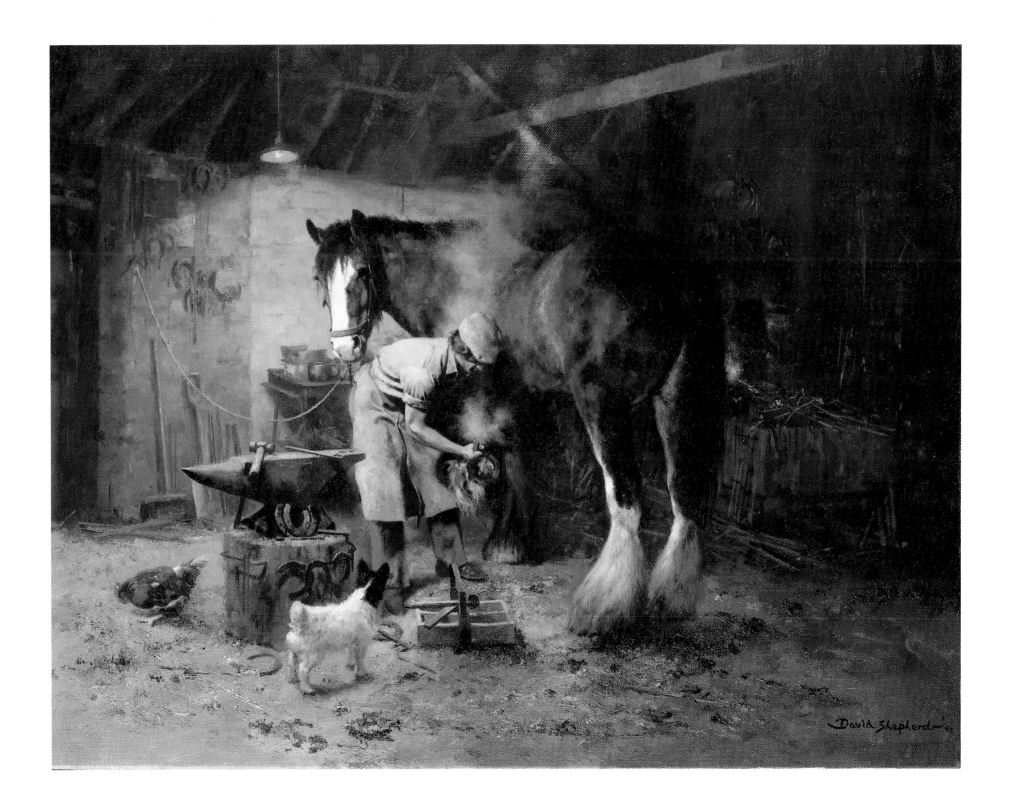

David Shepherd

THE LUNCH BREAK

In the heat of a high summer noon, after a hard morning's toil loading up the harvest, both farm workers and horses pause for a well-deserved break. This is the time to bring out the freshly baked bread, the cheese and the local brew, then to talk of local farming happenings.

My painting is set in the 1920s. This was an age of few cars, and there is nothing to shatter the summer tranquillity; against the background of noble English elms, just the sounds of bees buzzing in the poppies and larks singing their song far above in the blue sky provide that timeless magic of a true summer's day.

The pace of life was that much slower but, for the workers on the farm, life was not always easy. The pay was low, and the hours very long; on occasions, the farm machinery was deliberately left unoiled because if the boss could hear the wheels squeaking he knew his labourers were working! Nevertheless, in those days of a now distant age, perhaps the real value of life meant just a little more – companionship and satisfaction in a job worth doing and well done.

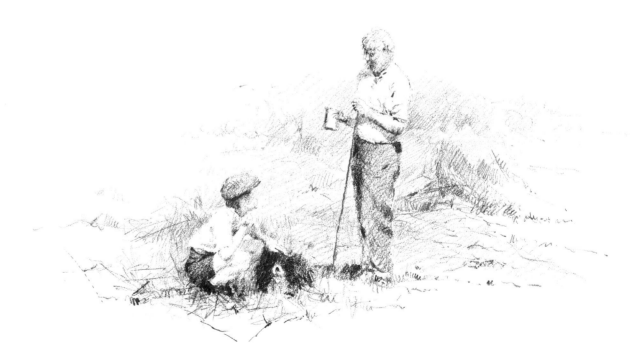

WATERSTONE'S

BOOKSELLERS

114-116 GEORGE STREET
EDINBURGH EH2 4LX
Telephone: 031-225 3436
AND
LONDON

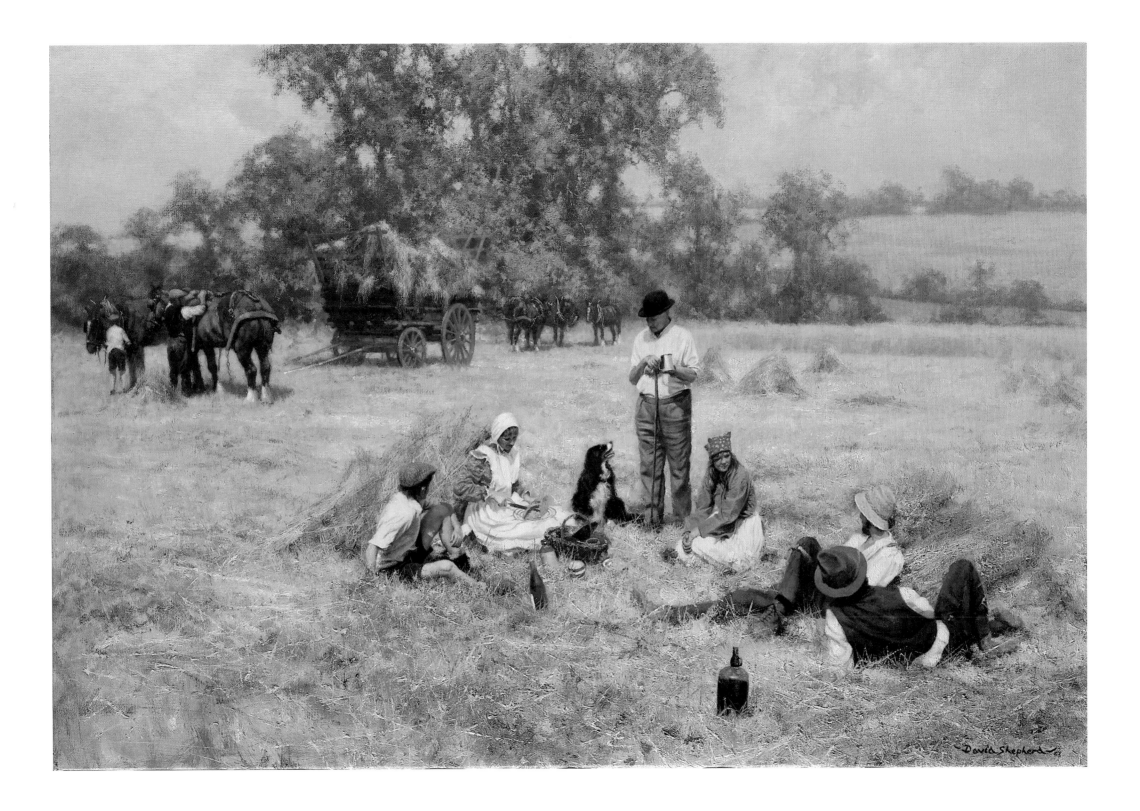

GRANDPA'S WORKSHOP

I have wanted to paint a subject like this for many years, bringing together my love of model making and my passion for steam locomotives. After much help from friends and quite a lot of detective work, we tracked Bert Perriman down near Lancing in Sussex.

Model makers are a very special breed of people and there will always be those who hope to catch me out. I was advised that there were many essentials that I must put in the painting to make it authentic – the Oxo tin full of bits and pieces, jam jars full of nails and other paraphernalia which may seem rubbish, but to the model maker will, one day, perhaps be of some use. Moreover, I was told that I would probably notice things which did not, at first sight, seem to have anything to do with model making – a clock, a lawn mower, an electric fire and other such things.

Sure enough, it was all there. Typically, Bert had hidden himself away in his tiny workshop at the bottom of the garden. There, amongst the orderly chaos of the tools and bits and pieces that are so much a part of a model maker's world, he was able to relax. There was, sure enough, a clock on the shelf. He should have been attending to this at the urgent request of his Mrs Perriman. It had stopped ticking many months ago. She had kept on at him to repair it, but it could stay on the shelf for a little longer. Bert had something much more important to get on with; he must finish the model of his favourite steam locomotive – a London, Brighton and South Coast Railway Atlantic. The lawn mower could wait too.

Young Andrew lives next door to his Grandpa. He's crazy about steam trains too. Having run back from school and paused only to grab a packet of crisps from the larder, he rushed round to lend a hand. He should be getting on with his homework but, like the clock, that too could wait.

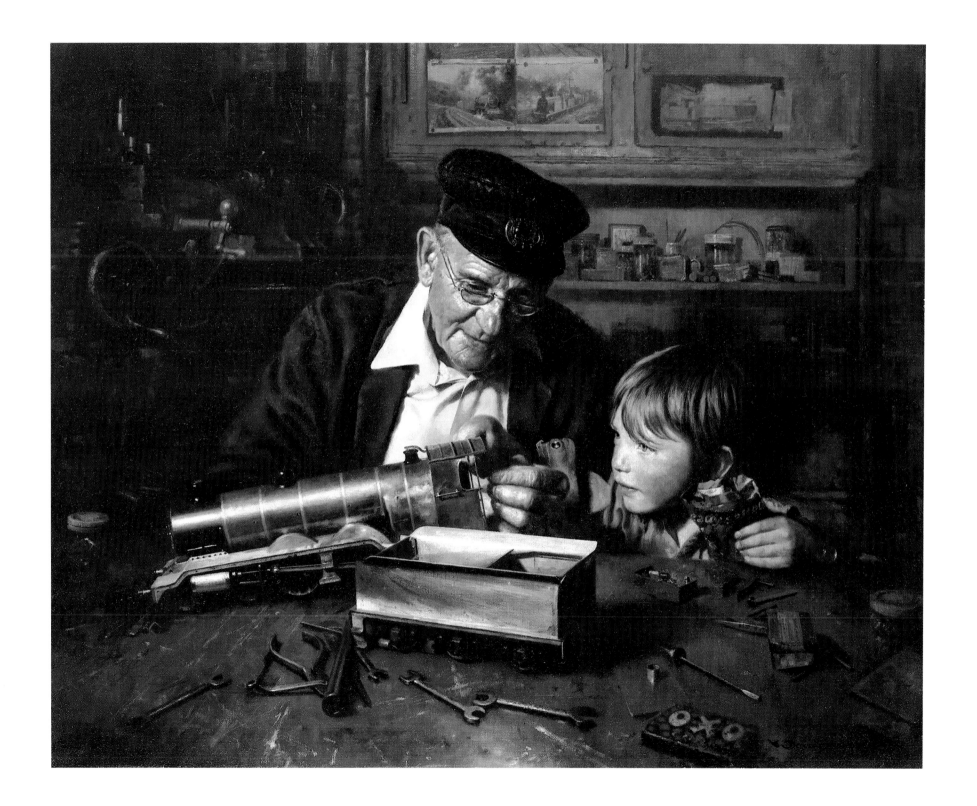

MUFFIN'S PUPS

In her first litter, Muffin, our bearded collie, produced eight glorious puppies. They all began very quickly to develop their own special and diverse characters. At the time of the painting, they were seven weeks old and getting to the point where the mayhem and pandemonium at feeding time was such that they were not only a burden to their mother but to everyone else concerned. Also, perhaps, they were at their most irresistible. The tears flowed when the day came that they all had to be taken away to their new homes.

JUST CATS

Reproduced by permission of Mr & Mrs Anthony Athaide

I love sketching the heads of the big cats. Lions and tigers all have different personalities, which definitely show in their faces. Some have nice wide generous expressions, and others always seem to have a mean look about them. I know one thing; no two lions or tigers are the same.

When painting any of the big cats, it is an easy trap to fall into to resort to painting zoo animals. Here, the animals are indolent. They are regularly fed and are lazy, and they tend to lose that lithe muscular look. In contrast, lions in their natural environment often look scraggy. They are scratched and very often have warts and scars as a result of fights; their manes, far from being of the impossible size usually seen in a zoo, have an unkempt and torn look about them caused by the harsh environment in which they live.

'Just Cats' is the first painting that I have worked in monochrome as well as in colour, and it made an interesting exercise.

David Shepherd

ELEPHANTS' PLAYTIME

Elephants adore mud. After a cool few minutes sploshing around, during which time they get themselves into impossible positions to ensure that the mud reaches every square inch of their rather large bodies, they come out and have a good dust down in the sand – the elephant equivalent of talcum powder. This is an essential part of the daily routine of an elephant. Then, if there is a convenient tree nearby – and there usually is – the next thing to do is to have a really good scratch to complete the whole blissful experience; the ticks in the heavy folds of the jumbo's skin don't like this treatment very much but then that's the whole idea. Around many a waterhole in Africa it is possible to see many trees have been worn as smooth as glass by this treatment.

In such settings, over the years, I have seen many unforgettable sights. Elephants, if left undisturbed, always seem to be doing something funny. On one occasion, a really tiny baby had got stuck in the mud on the edge of the lagoon. The mother kneeled down on the bank and put her tusks under the baby and pulled it up out of the mud. It popped up like a cork out of a bottle; she was using her tusks like a forklift truck.

On another occasion, I sat up in the remains of an old platform in a very dead tree – the platform had been built for a film that my friend who was with me had made many years previously. There were only a few planks left in the platform and the tree was, it seemed, in imminent danger of toppling over altogether. However, we climbed up and, for the next three hours, I enjoyed one of the most thrilling experiences in Africa. 300 elephants came down to drink. Several times they came right under the platform and if I had wanted to, I could have stretched my leg over the edge and touched the tops of their backs. The only possible danger would have been if one of the stroppy young bulls had decided to scratch himself against our particular tree – then, anything could have happened! I watched enthralled as young elephants dug into the banks with their trunks and sploshed wet slime under their bodies. Baby elephants, only a matter of weeks old, were cavorting in the sand and mud, wobbling in all directions not quite knowing what to do with their little rubber trunks. All the while, the elephants' tummies were rumbling like a motorbike rally; they had no manners.

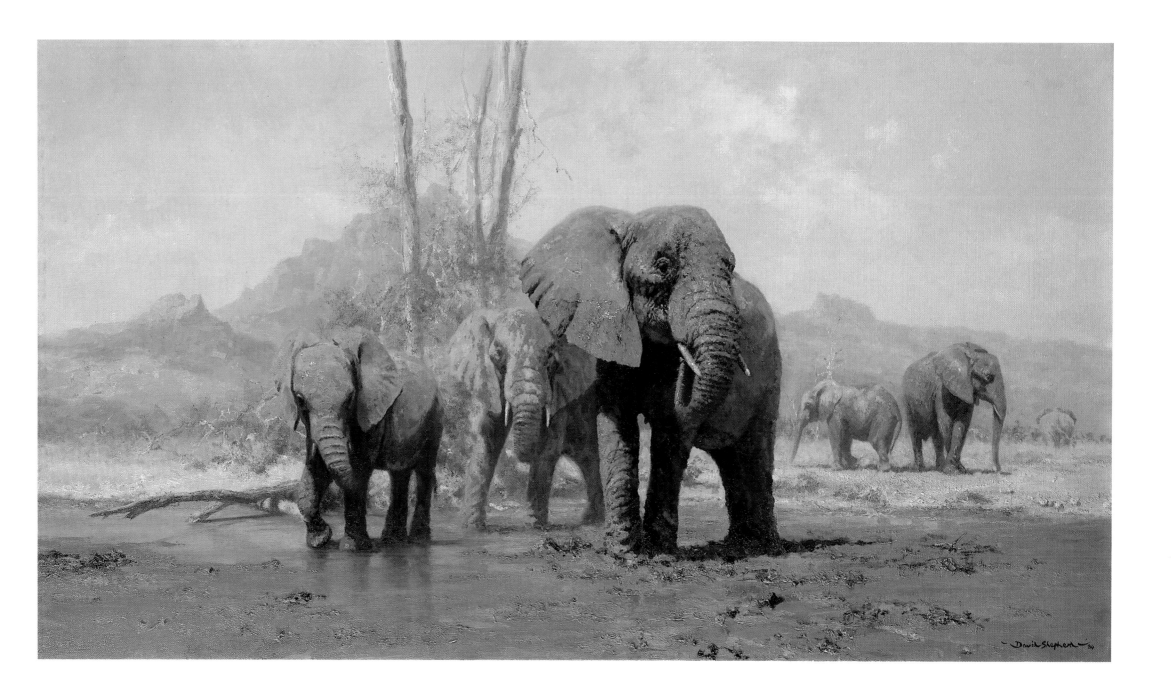

PLAYTIME

Surely, some of the happiest moments in a small child's life are playtime with the boisterous pups of a beloved dog. The three children are completely and utterly absorbed in these fascinating new playthings who responded so readily to the slightest suggestion of a game, and who belonged to Muffin, our bearded collie.

I love Victorian clothes. The painting would surely have had much less appeal if I had painted the children in T-shirts and jeans. At the theatrical costumier's where I went for the clothes, I noticed, on a shelf at the back of the shop, a row of teddy bears. I was advised to be careful because, at the turn of the century, teddy bears changed a great deal in design and in the picture everything must be correct. One rather special bear, and obviously the shop's favourite, was over eighty years old. 'He doesn't go out very often because he is getting on a bit, but if you look after him, we are sure that he would love a weekend in the country.'

Teddy, like the clothes, was mine for the weekend, together with a beautiful original porcelain doll. On returning the items to the shop I was asked, 'Has teddy enjoyed his weekend in the country? We do hope so.' I know one thing: I couldn't really have done the painting without him.

OVER THE FORTH

Everything about the Forth Bridge is impressive. Apart from its sheer size, it was the most marvellous experience to drive across it in the cab of a locomotive many years ago; only then was I able to appreciate the majesty of this monument to late Victorian engineering. It reminded me strongly of going down the aisle of a great cathedral, as the intricate tracery of the girders passed over and around me.

By modern standards, no doubt this beautiful bridge is out of date, but the statistics impressed me as much as the bridge itself. It took only 7 years to build, nevertheless 5,000 men worked on the job and it cost £3,000,000. Over 2.4km (1½ miles) long, it consists of 145 acres of steel work which has to be painted every 4 years by 20 men, using 17 tons of paint at a time. When British Railways showed me over the bridge, I refrained from asking them how many rivets were used in its construction. The estimate is 6½ million, or 4,200 tons. The last one was placed in position by HRH The Prince of Wales in March 1890.

My locomotive crossing the bridge is an LNER A2 Pacific on, for such an engine, humble freight duty towards the end of steam. The bridge is no doubt still in fine fettle but, apart from the occasional steam special, the trains crossing it are now diesel-hauled, and these don't quite seem to suit such a magnificent and appropriate setting for the majesty of steam.

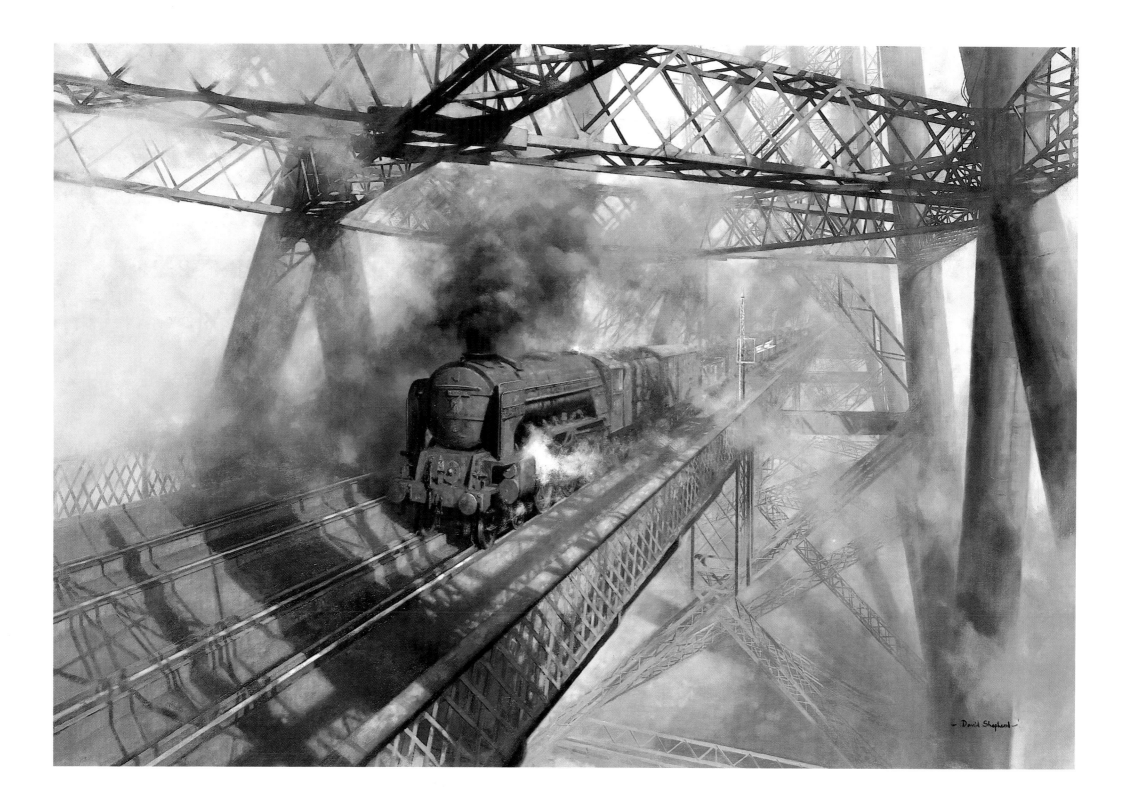

David Shepherd

COTTAGE COMPANIONS

I have turned once again to the early Victorian past, an era of dimly lit inglenook fireplaces in smokey cottages.

Barbara posed for this picture with Muffin, our bearded collie. While Barbara was trying to get on with the spinning, Muffin was trying to persuade her that going for a walk would be far more fun.

The fireplace in my painting is in our own home, an Elizabethan farmhouse dating from 1560. In those days so long ago the family would quite possibly sit inside the fireplace and draw a curtain right across for warmth. The original hooks to hold the curtain back are still in the brickwork and when I was preparing the fireplace for my picture, hanging the small curtain inside the old oak beam, I found some of the material of the original curtain still in place.

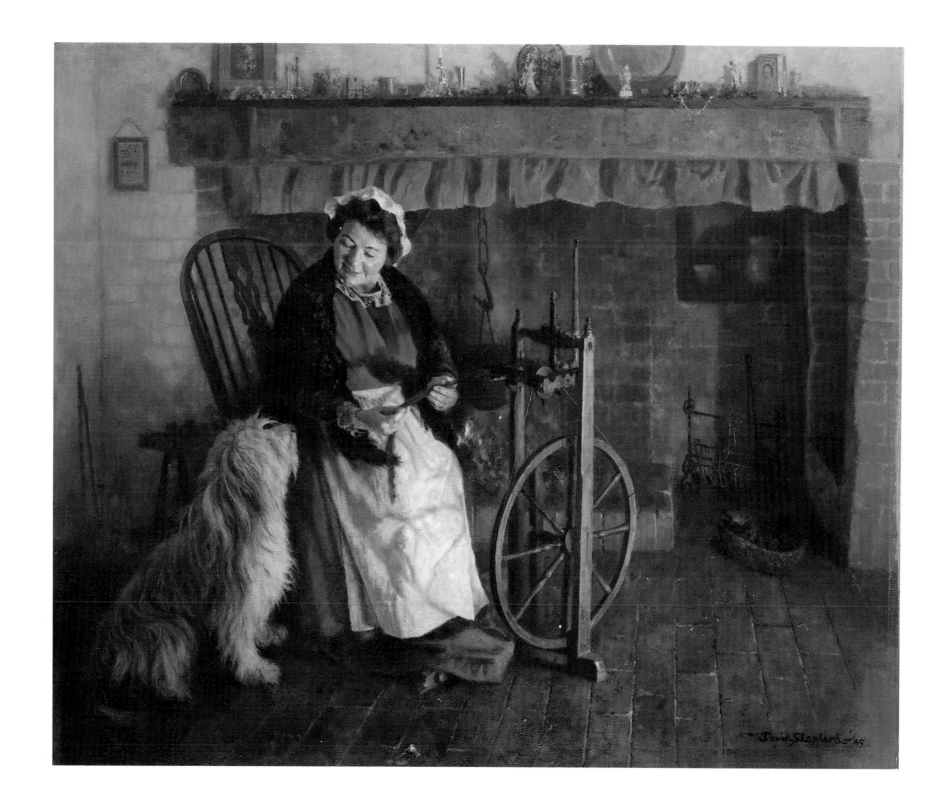

MR THOMAS AND MAJOR RICHARD LEVESON GOWER

In days gone by, many of the great masters were commissioned to paint conversation pieces and murals on huge areas of canvas, sponsored by wealthy families or industrial organisations. The finished work would hang in a stately home. In this much more materialistic age, this sort of sponsorship could be said to be almost a thing of the past. A contemporary painter is a lucky man indeed if he gets such a commission. Once in my career so far, and only once, have I had the honour to paint such a canvas.

I was commissioned to paint these two splendid gentlemen living in their beautiful home. This painting already hangs in the hall which eventually will be open to the public. It was the greatest joy to paint this picture, on a canvas measuring 8ft x 5ft. On this scale, the artist really has the chance to endulge himself.

Meeting Mr Thomas and Major Richard was a great pleasure. I was fearful of their reaction when they saw the finished portrait – this is always a sobering moment as I know because I have been painted myself and it is a very strange feeling to be looking at oneself in paint instead of in the mirror. When the painting was completed, we took it over in a removal van and hung it on the panelling in the great dining hall. It was then professionally lit and when this work had been done, we invited the two gentlemen to come in, sit down, and open their eyes. There was silence for a few minutes, but it was perfectly obvious from their reaction that I had succeeded in giving them what they had hoped for.

I was honoured to have this painting accepted by the Royal Society of Portrait Painters 1983 exhibition in London. I am not a member of this august body and felt that I had almost no hope of getting the portrait in, particularly bearing in mind its size. However, I was amazed when, telephoning the society to ask if I could come to collect the painting after its rejection, they told me that I could not have it because it had in fact been accepted. On the private view day, I am proud to say that it caused a great deal of interest and comment, particularly the gorgeous mature brown leather shoes worn by Major Richard. It was quite amazing the number of people who said 'You don't get shoes like that anymore!'

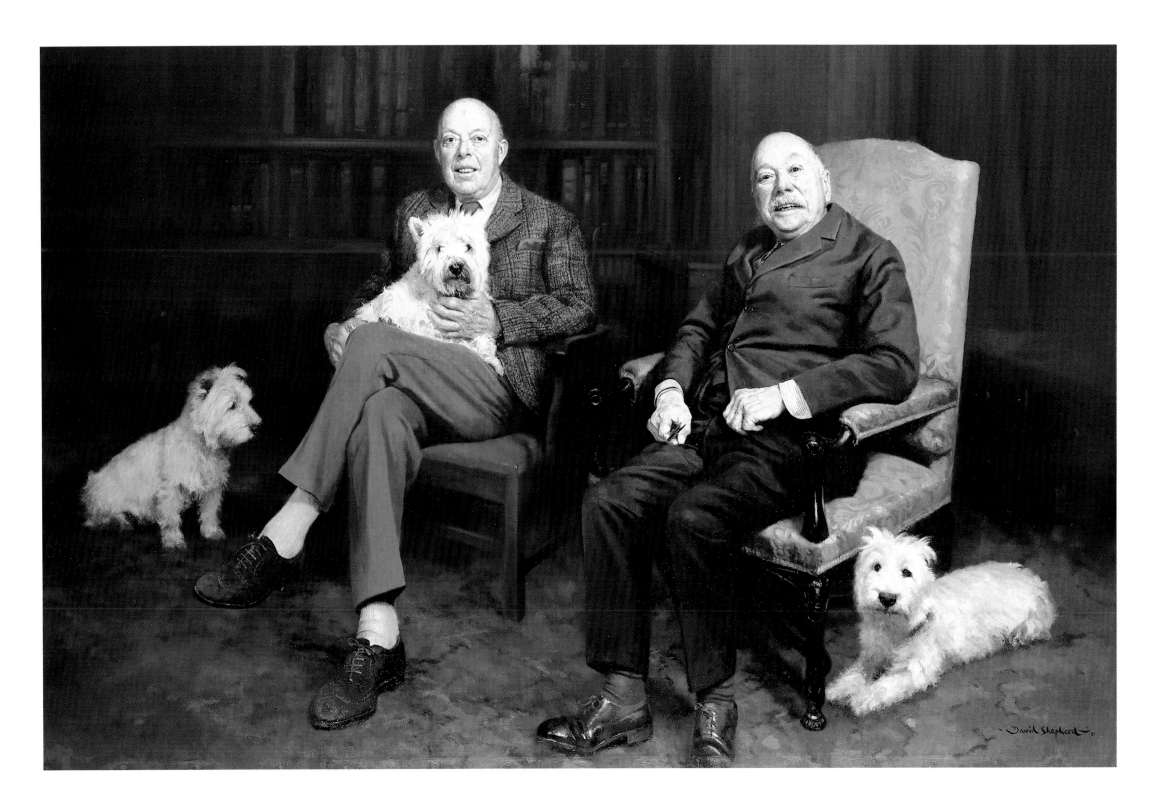

WINTER SUNSHINE

There is a time of the year when the English landscape takes on a mantle of the very subtlest of hues and tones which, I believe, makes our country scene unique.

It is just before spring bursts forth in all its glory; there is still a chill in the air but, when the sun does come out, the fields and trees are washed by a lovely soft, fresh green and brown tint – particularly the great and mature elm, that most majestic of trees which to me will always remain so peculiarly British. Tragically the elm now seems to be a thing of the past.

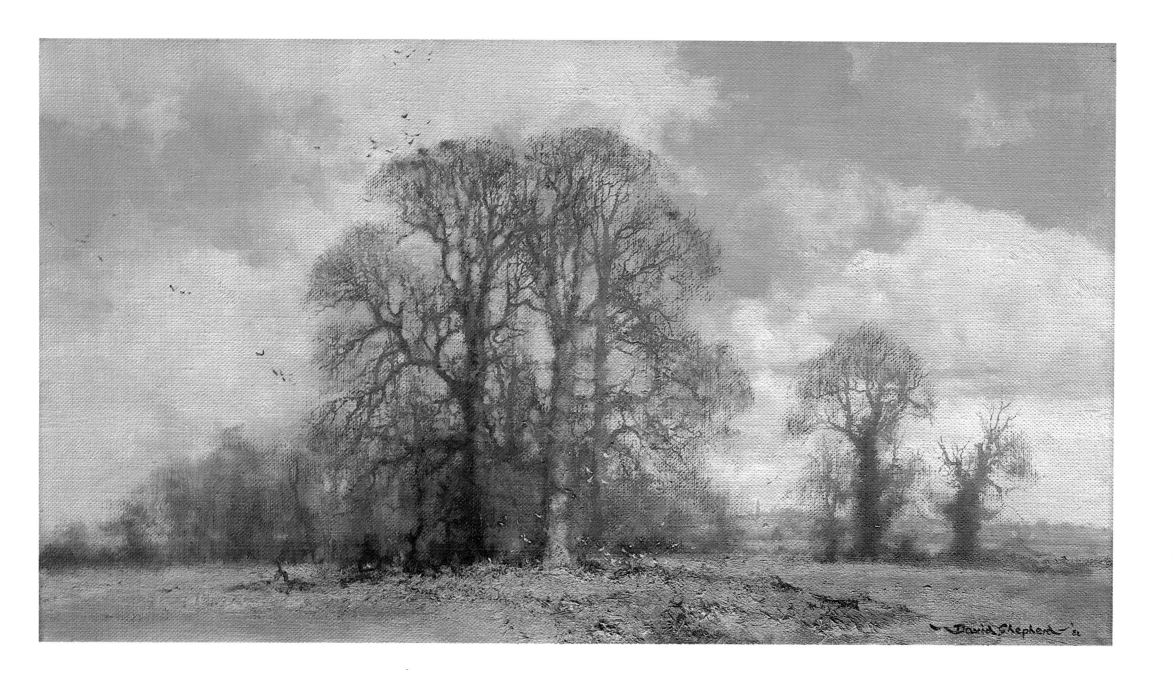

LUANGWA EVENING

One of the most wonderful ways to relax is to watch, perhaps, a herd of over thirty or forty elephants just minding their own business and getting on with the daily routine of being elephants. Over the last thirty years I have witnessed many such timeless scenes, but each time the experience is a new one.

My family and I have sat for hours by one of the lagoons in the Luangwa Valley with our very special friends – those who do not chatter all the time. While such a memorable scene unfolds the human voice is completely out of context.

As the sun goes down and the shadows lengthen, all we hear is the gentle sound of the water, the occasional plop of a diving bird or a fish jumping, or the obscene grunts of a hippo. These great river horses remind me so much of people. When they are asleep on a river bank, I always think of a lot of old colonels in a London club, asleep in the library after lunch. In the Luangwa Valley many of the lagoons are covered in the vivid green Nile cabbage and when a hippo surfaces from the depths, it reminds me of a lot of women going off to a spring meeting of a women's institute – wearing their best floral spring hats.

As we sit and marvel at this wonderful scene, a fish eagle calls – perhaps one of the loveliest sounds in Africa. Over on the far bank, we strain our eyes. What was that tiny movement we saw in the shadows? Zebra and impala are barking. There is a tension in the air. Was that little speck of colour which appeared and then vanished again a lion, or perhaps a leopard? Then peace returns. The animals are drinking. They are safe, for the moment. A gentle breeze sends a ripple across the waters of the lagoon. All these are the natural sounds of Africa. Then, the peace and tranquility may be suddenly disturbed, perhaps by two young teenage elephants beating each other up playfully.

Somehow, whenever I watch a scene like this, I feel it is just possible to begin to sort my priorities out. Are we, in fact, all that much better off for being 'civilised' as we call it, with all its multitude of problems? I only hope and pray that the sight of sixty elephants playing in the river will be available for all time for others to enjoy as I have.

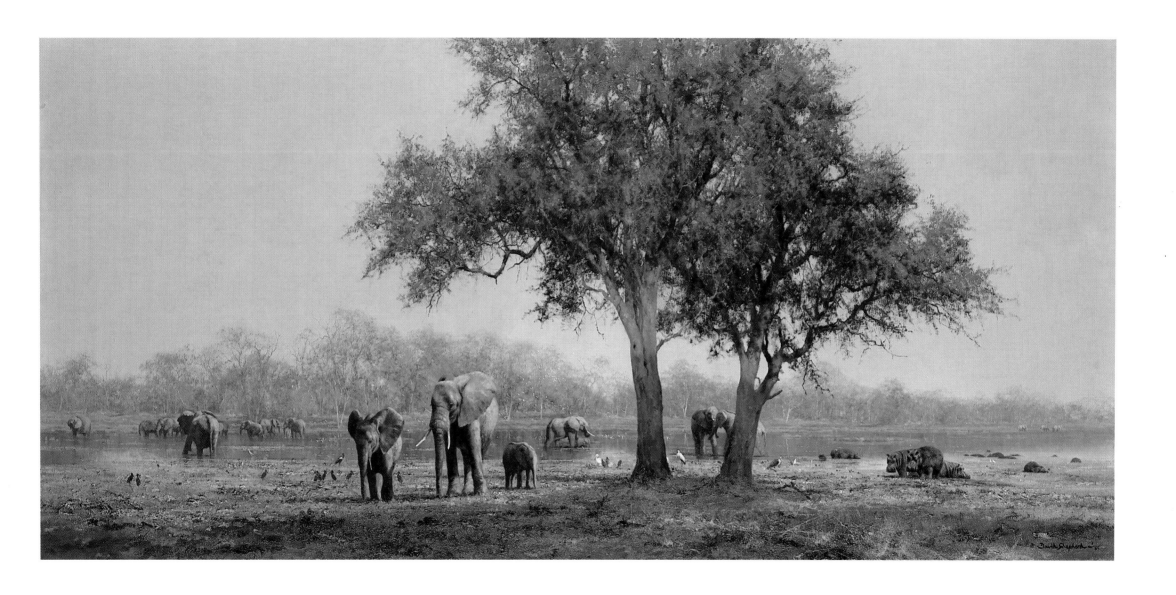

SHIRES ON HOLIDAY

A detail from a painting reproduced by permission of Whitbread & Co PLC

Undertaking a commission from Whitbread to paint a picture of their hop farm in Kent, I wanted to see three of their beautiful shires 'released' for their summer holiday in the countryside.

Living and working for almost the entire year in the City of London, this 'get away from it all' in the fresh green fields of Kent is obviously a great moment in the lives of these horses. The horse box arrived and backed up to the gate – down came the ramps and three one-ton horses went wild with joy; for nearly half an hour, they couldn't contain their exuberance at their freedom and galloped around the field.

One member of the Whitbread staff told me that he was driving his tractor across the field on a previous occasion when one of the horses came thundering towards him; he suddenly realised that it wasn't going to stop, and it jumped right over him and the tractor. He got quite a shock: he hadn't realised that shires were showjumpers!

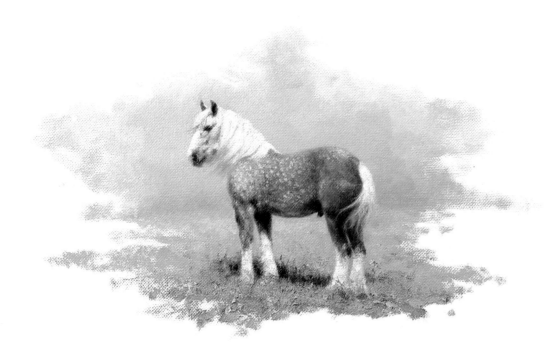

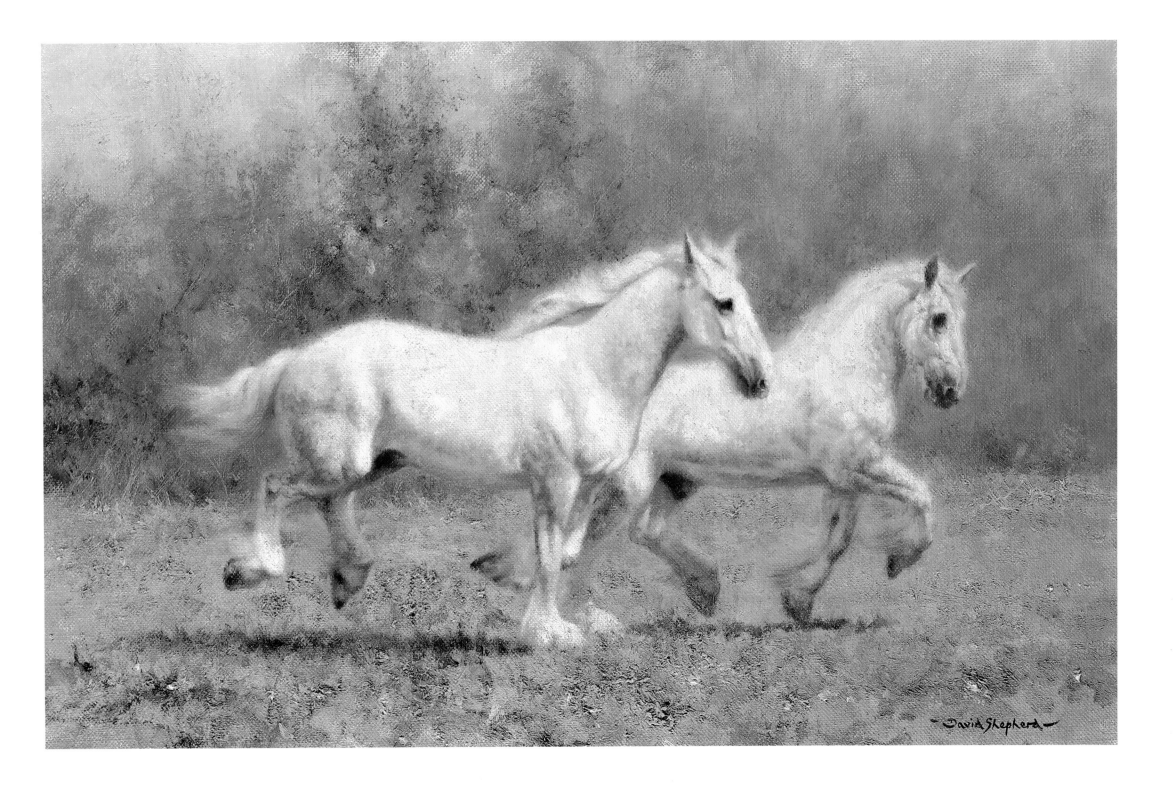

NINE ELMS, THE LAST HOURS

In the half-demolished shed, it's the end of the line for 73155 and she now stands forlorn and rusting. Merchant Navy 35030 is in steam for the last time – she has just run the final steam train into Waterloo and together, chalked with corny but sincere slogans of affection, they await their last journey, hauled by diesel to the breaker's yard and the cutter's torch.

Inspection pits are filling with ashes from fires now cold. Old buckets, rubbish and twisted firing irons are everywhere – all the squalid impedimenta that mark the end of an era.

Nine Elms is still a 'wasteland' – of modern concrete in the form of the new Covent Garden Market. What a tourist attraction it would be, had we left it exactly as it was on 7 July 1967.

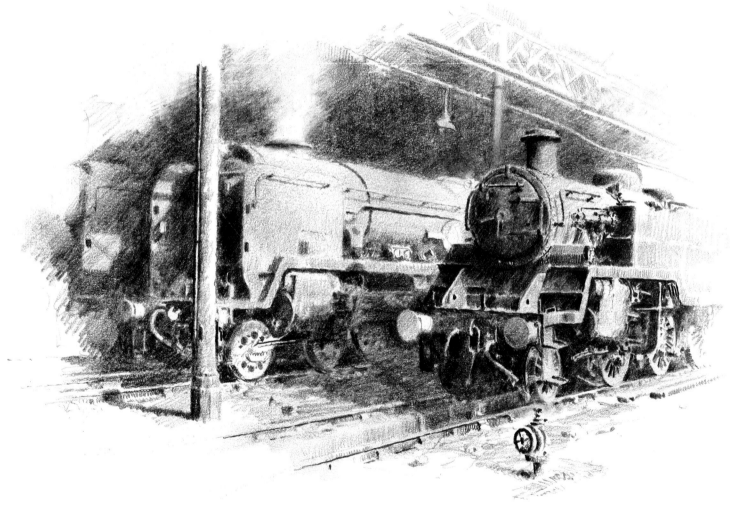

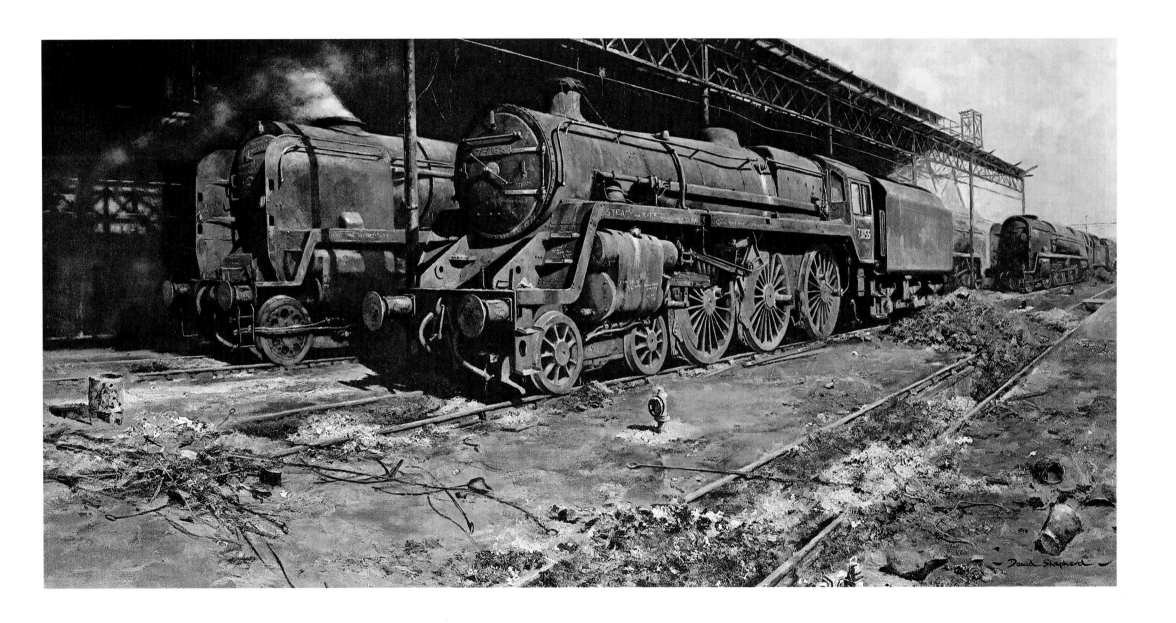

THE ZAMBEZI SAWMILLS RAILWAY

The client from Texas was hot on the trail of 'his' lion. He had paid the usual not inconsiderable sum for his game license and was now on the safari of a lifetime with his professional hunter. He had 'bagged' everything else that he was allowed and he now only had to get the magnificent black maned lion that he dreamed of for so long.

The two men were alone, many miles from even the nearest land-rover track, where only the professional hunter, with that uncanny sense of bushcraft coming from years of experience could avoid getting lost in a matter of minutes in those vast tracks of featureless African bush.

The excitement was mounting by the minute. The two men moved together, silently through the trees, ever nearer to the unsuspecting lion, which was always enticingly just ahead of them. The trees were thinner now; suddenly they came into a clearing, and there it was. The American's heart was thumping and the adrenalin was flowing. Picture the scene in all its remoteness; an area seemingly untrodden by man, the bush clearing, and, all by itself, an old steam engine. Shafts of sunlight filtered through the tree tops and caught the burnished copper and wisps of steam from an 1896 vintage 4–8–0 ex-South African Railways, ex-Rhodesia Railways steam locomotive. It was gently simmering away in the heat of an African afternoon and not a living soul was to be seen.

Our American friend was speechless with amazement at the incongruity of the scene. Yet the old steam engine seemed to fit into this timeless picture and become part of it. The lion was at once forgotten and for the rest of the day our friend clambered all over the engine taking photographs. The old locomotive was one of many which were ending their long working lives in Africa, operated by the Zambezi Sawmills Railway in the forests of Zambia.

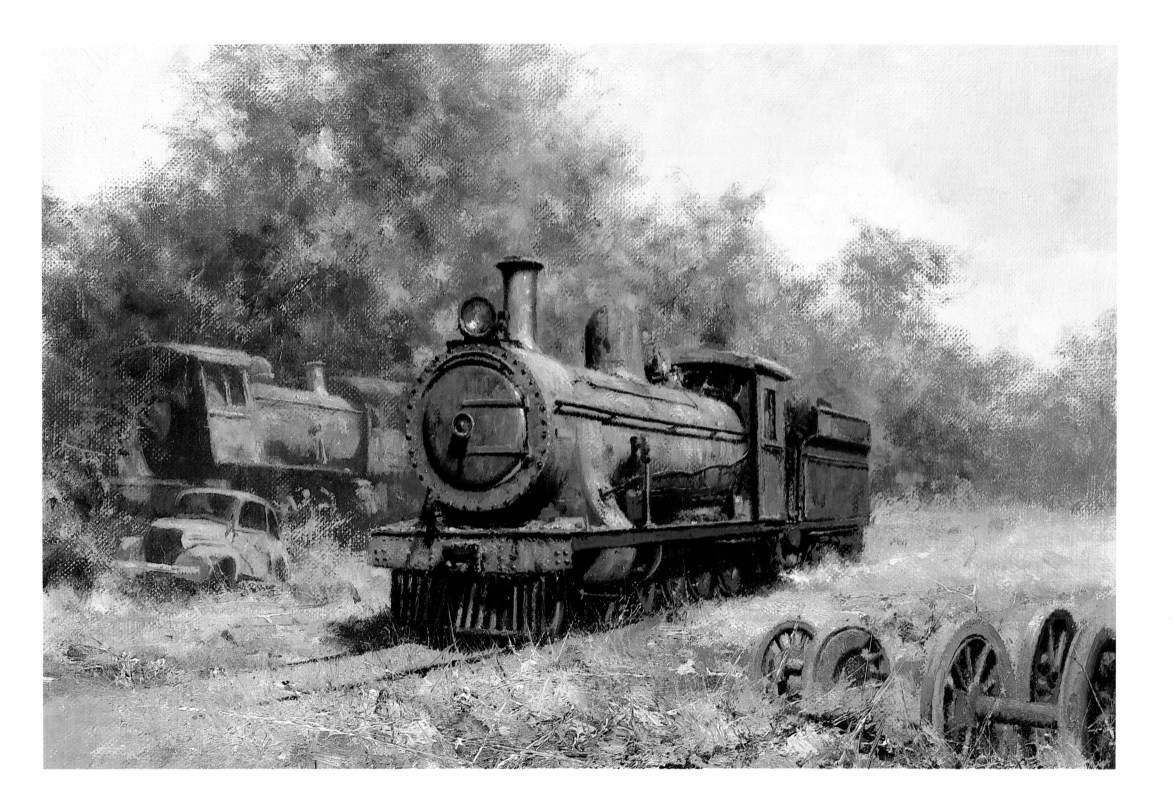

PORKERS
Reproduced by permission of Mr & Mrs Peter Dorey

Piglets seem to be everywhere, hundreds of them from many different litters, rooting around and playing in the warm spring sunshine. I selected five little characters from the crowd and put them into a box and waited to see what would happen. Their immediate attempts to escape from their temporary confinement resulted in some splendid piggy expressions.

Nearby a sow grunted in blissful contentment as she wallowed in a cool mudbath with her family.

David Shepherd

SCOTSMAN '34

Reproduced by permission of the Hon W. H. McAlpine

LNER Flying Scotsman is surely the most famous steam locomotive in the world. Built in 1923, she was saved from the scrapyard in 1963 and is today in running order.

I am often asked, 'Why don't you ever paint clean locomotives?'. To prove that I do, I have included my painting of 4472 at Kings Cross shed in this book. However, I get as much satisfaction in painting locomotives as so many of us remember them, in appalling external condition. Somehow, this represented the ignominious end to our great steam age.

In the last few weeks and days of steam in the South of England in July 1967, I managed to do some twenty lightning sketches from life at Guildford and Nine Elms Shed. Every spare moment was spent recording something on canvas for future painting before it was too late. On one particular evening, 76069 had just come in on a ballast train from Aldershot, probably one of her last duties. The sun was shining but the engine was half in shadow. It was an interesting exercise in recording the subtlest of colours to be found in such a scene.

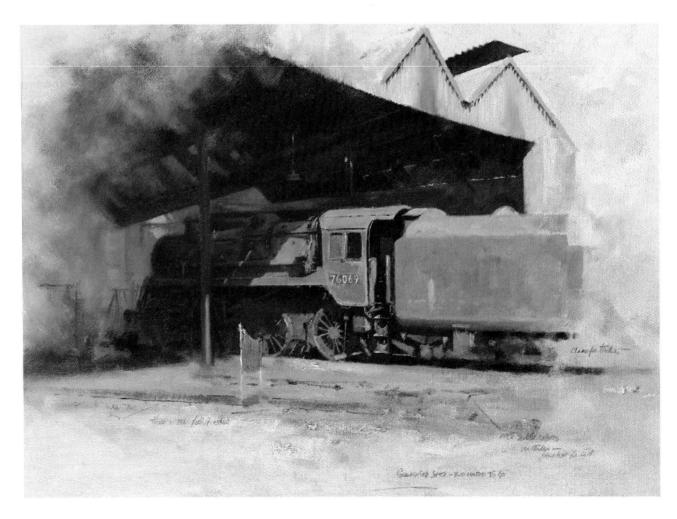

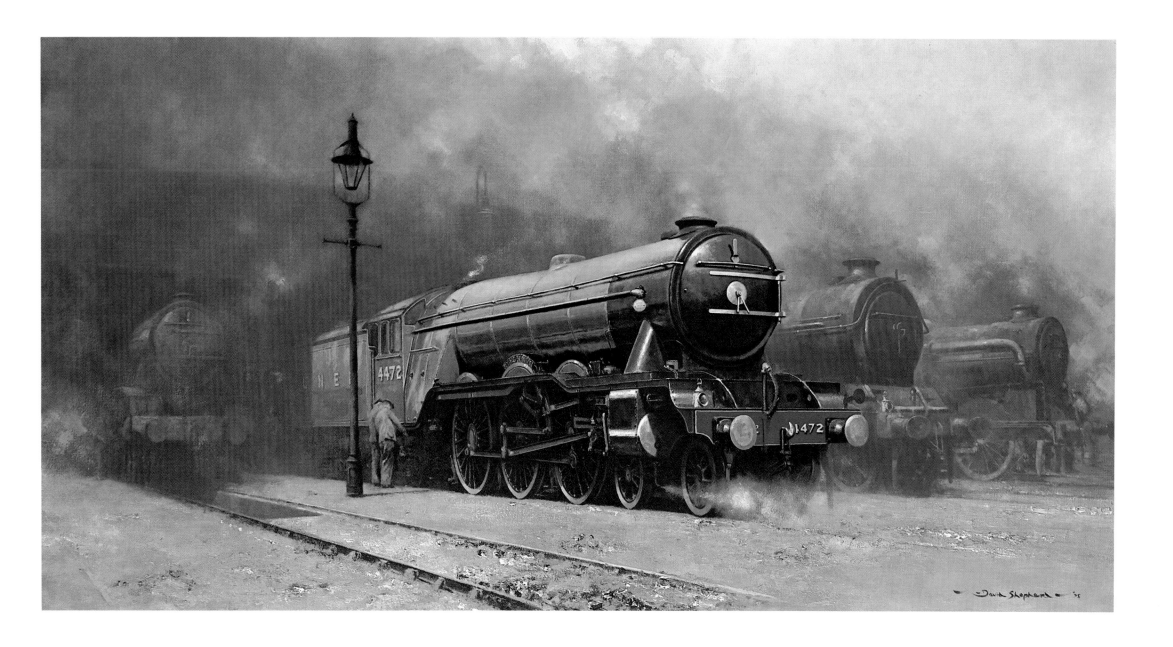

AUSTER 9 IN MALAYA

Reproduced by permission of Headquarters, Army Air Corps Officers' Mess

It was over a chance meeting in a pub, with a friend of mine who worked for the Blue Funnel Line in Liverpool, that this painting came about. My reader may wonder at the connection. All I can say is that anything can happen in my crazy and diverse life.

It was as a result of that informal meeting over a couple of beers that a very exciting trip for myself and my wife evolved. 'If you would like to paint us a couple of paintings of our ships in the Far East, we will give you and your wife a free trip around Japan, Thailand, and anywhere else where the ships may happen to be going.' It was an offer too exciting to refuse. Coincidentally, at this time, in 1962, I was beginning to paint a series of pictures for my friends in the Army Air Corps who wanted me to record, over the years, on canvas, every aircraft and helicopter that they would operate. (I am still doing them.) They heard that I was going to be in the Far East so they saw this as an ideal opportunity for me to paint an Auster 9 in Malaya.

I flew out on a Comet of 216 Squadron from Royal Air Force Lyneham. It was an interesting journey and just about every disaster that could happen did; so much so that at the end of the trip, my friends in 216 had almost decided that they would never fly me again; they claimed that I had a jinx on their aircraft. Undercarriage failure, fuel system failure, an engine flameout; we were stuck at El Adem, near Tobruk, for five days, for a complete engine change and El Adem is no place to be stuck for five days! After various other problems, we arrived in Hong Kong nearly a week late. I was supposed to arrive at the same time as my wife who had flown on BOAC and we were to meet the Blue Funnel Line ship there, to go on our journey round the various ports of call. By the time I arrived, the ship was half way round Japan and I had to catch it up, but that is another story.

My hosts in Malaya were the Army Air Corps and the Royal Air Force, and I enjoyed many exciting and adventurous flights all over the country in their aircraft. They asked me to portray a scene typical of the sometimes slightly hazardous forest landings on remote airstrips, some of which had been literally carved out of the jungle. Sumpitan was certainly one of these. I do not think that even the pilot quite realised just how dodgy it was. After an hour's flying below the tree tops and round the bends of a river on one wing tip and then the other, we found the airstrip. It was at this point that the pilot told me that this particular one had not been used for many months! (The jungle grows up very quickly in Malaya.) However, I am a trusting sort of fellow with every confidence in the skill of my pilot friends in the Army and Air Force. We did a dummy run. The excitement mounted as we dipped down below the trees and skimmed the grass on the strip – there was also a man herding some buffalo as an additional hazard! However, after two or three sorties to reconnoitre, my friend Chris decided that it was worth a try and we got down safely. I then stayed on the airstrip while he did a couple of circuits and bumps for me to record the scene and it certainly made an interesting picture.

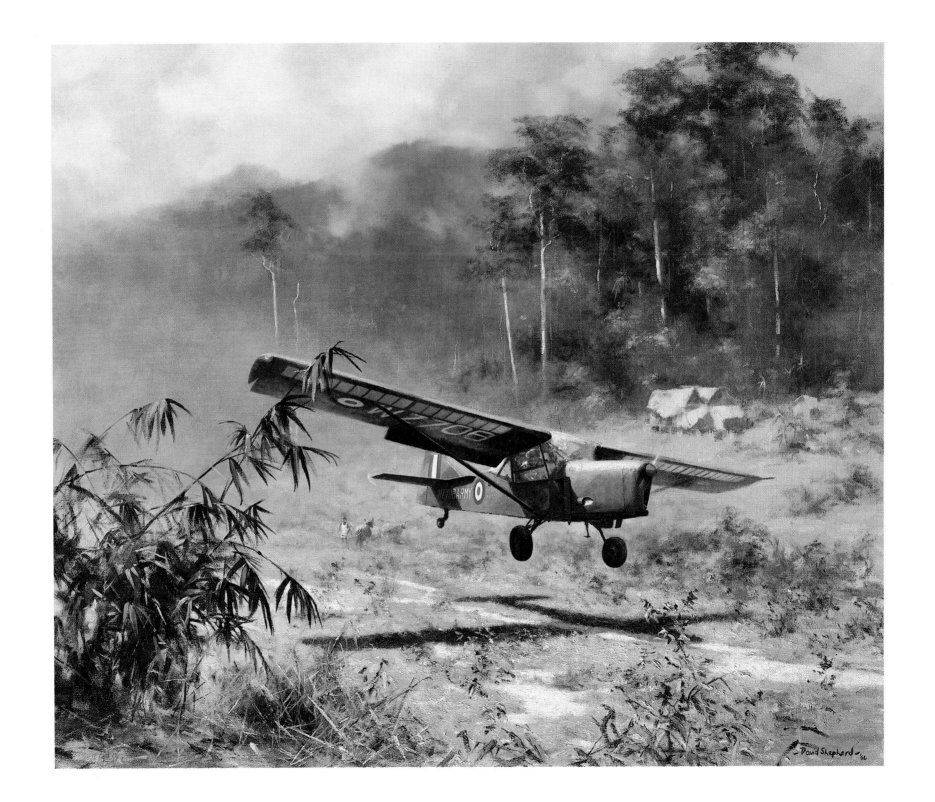

THE FOUR GENTLEMEN OF TSAVO

It was on my very first visit to Kenya in 1949 and my abortive attempt to become a game warden that I saw my very first elephants in the wild. The initial impression, and one that has gained strength over the years as I have seen more and more of these magnificent animals in their natural environment, is of one's own complete insignificance. If armed with a gun, man is powerful, but alone, unarmed, he is nothing. The lion has been termed 'The King of the Beasts' and, impressive though he can be, I really cannot quite understand why!

The elephant is a gentle giant. The warden, who showed me my very first elephant, said 'If you leave them alone, they will leave you alone.' Man is the elephant's only enemy. I can never think of elephant's as dangerous. Why should I? They are only dangerous when man has given them reason to be.

Tsavo, where the earth is red, will always be one of the finest places to see African elephants. Here, they have a massive stature, far more heavily built than their cousins in, for example, the Luangwa Valley in Zambia. Tragically, though, it is now becoming increasingly difficult to see a really fine bull carrying big ivory. They have all but gone. Isn't it amazing that man, who can paint a Mona Lisa or write a great symphony, can at the same time completely exterminates so many of the wild creatures around him? One can always recreate a man-made object, however valuable, but once the great elephants have gone, they can never be re-created. The days are over when one could see elephants carrying ivory so huge that they would have to lift their heads when walking. It is our loss.

However, a mounting number of people all over the world are now becoming more and more concerned. I can count myself lucky that I have been able to go to such places as Tsavo and see, as in my painting, a group of magnificent bull elephants – animals to which I owe so much.

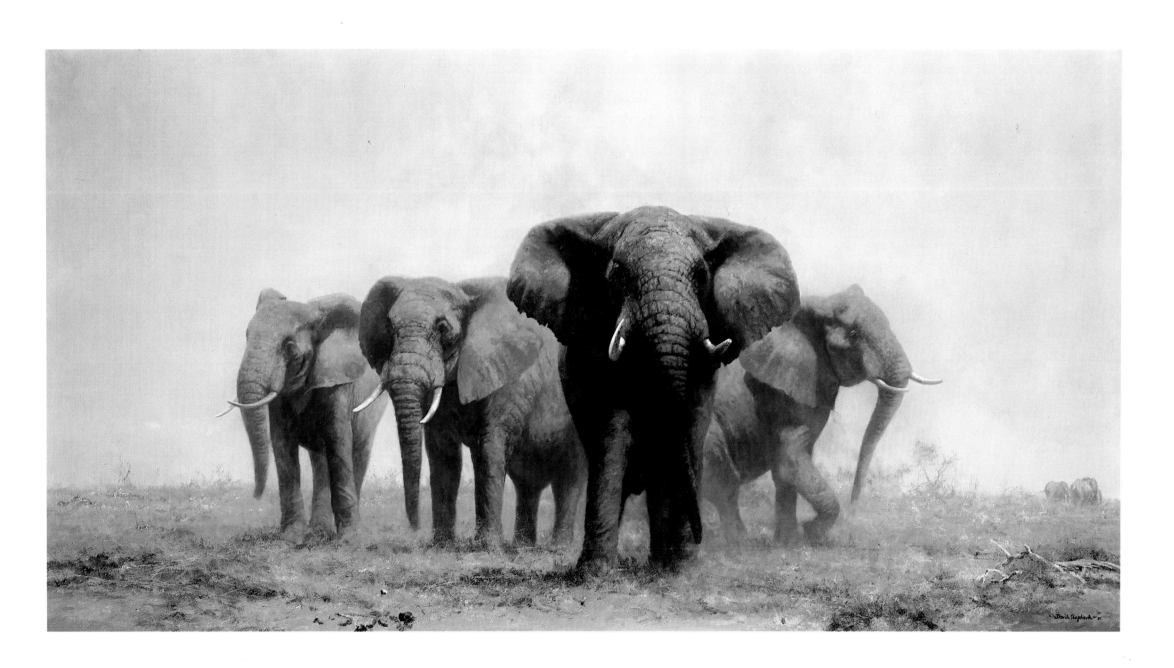

'Highlands' —
near Drumbeck — June 82
rocks in bracken and tufty grass

with draggett hair over face —

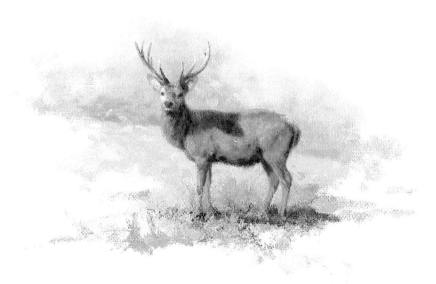

AN APPRECIATION OF DAVID SHEPHERD

BY CYRIL LITTLEWOOD MBE

Founder & Director, Young People's Trust
for Endangered Species

I am reminded of David Shepherd whenever I see an orang-utan!

This is no reflection on David's physical appearance or eating habits; it is simply that I first met him as a result of his wish to paint a picture of a young orang-utan for a special charity Christmas card in aid of conservation.

As his time was totally committed to painting during that late Spring more than twenty years ago, I was asked if I could pop along to London Zoo and take a series of pictures of a delightful baby orang-utan who, at that time, was drawing large crowds round her glass-fronted cage each day to watch her antics.

As photography is one of my few hobbies I was only too pleased to have this opportunity to visit the Zoo and take a few pictures – but who was David Shepherd anyway? I was vaguely aware that I had seen a painting entitled 'Wise Old Elephant' attributed to him and sold as a print in Boots the Chemist or somewhere, but I knew nothing about the man except that I felt grateful to him for this 'official assignment' as it would make a nice change from school lecturing and all my other educational work.

On the appointed day I presented myself at London Zoo armed with a Press Pass, a Microcord twin-lens reflex camera and one of the revolutionary new Pentax Spotmatic SLR cameras – my latest pride and joy.

All this took place in the early 1960s when the apes and monkeys were still contained in the old Primate House. To obtain the photographs required by this man Shepherd (whoever he was) I would need to be on the wrong side of the safety barrier with my camera lens held close to the glass to avoid reflections – including those of the weirder members of the animal-loving British Public who feel it is essential when looking at apes and monkeys to screw up the face, scratch the armpits and emit strange and unintelligible vocal sounds . . . much to the embarrassment of the unfortunate inmates!

Now, thanks to the greatly increased entrance fees, there are fewer of the face-pullers, scratchers and cat-callers visiting the Zoo. It is my firm belief that most of them went into politics if transmissions from The House of Commons are anything to go by!

Meanwhile, back at the Zoo, I introduced myself to the Keeper of Primates (whose title these days might well suggest something ecclesiastical!) – who proved to be a friendly and most helpful chap.

My first few minutes in front of the safety barrier caused great excitement among a troop of twittering, chattering capuchin monkeys who were housed in the cage next to the young orang-utan. On the other side, far from being in any way excited – but quietly and intently interested – was Guy the gorilla, a past master at keeping his thoughts and emotions firmly under control whatever might be going on inside that great head and behind those watchful eyes.

The baby orang-utan was fast asleep, so for the next couple of hours I found myself under the constant and rather sneaky gaze of Guy the gorilla. The capuchins were quite pally by this time so the Keeper gave me a supply of titbits to pass to these inquisitive South American monkeys . . . to their obvious pleasure and delight.

Meanwhile, the baby orang slept on and on despite the confident assurances of the Keeper that she would wake up 'any

time now' and begin to play. The hours were passing slowly now – with the orang still sleeping, the capuchins chattering and eating and Guy the gorilla still watching me slyly from under his frowning and slightly bowed forehead.

I began to understand just what the cage-dwellers had to put up with after a third obnoxious child had pointed at me and yelled derisively 'look Mum, one of 'em has got out of his cage' or words to that effect. This child was just within my reach – and thoughts of homicide entered my head. Now, I firmly believe to this day that Guy the gorilla read my mind at that moment because he got up and moved a little closer to the front of his cage – for a better view of the impending mayhem perhaps. I could swear that he actually smiled at me and nodded encouragement.

However, retribution came from a rather unexpected quarter, as 'Mum' seized her offensive offspring firmly by the ear, muttered an apology to me and then, with a hand about the size of a Dover sole, gave the child a resounding slap which won Guy's instant approval – mine too! But the orang slept on.

Who *was* this wretched David Shepherd whom I now blamed unreservedly for my discomfort!

The capuchin monkeys, by now fed to the gills, were actually offering *me* titbits from the floor of their cage. I considered this to be a charming gesture on their part – if not a particularly appetising one. Amazingly the now elderly boss of that troop of capuchins is still alive at the time of writing and he never fails to greet me whenever I visit the Zoo, even if many months pass between visits.

As lunchtime came and went and the day wore on into mid-afternoon I began to feel that I was wasting my valuable time. Guy the gorilla still watched me intently, but in a friendlier fashion now that we understood each other; the capuchins went about their business – and the orang slept on and on.

By now, the atmosphere in the Primate House was hot, humid and quite stifling and I began to curse the name of David Shepherd! Quite apart from anything else, I was now almost ankle deep in fruit and certain other things that my capuchin friends kept pushing in my direction. At least I suffered no pangs of hunger during the long vigil. The smell was enough to put anyone off the thought of eating for days!

At one stage I suggested to the Keeper that his star performer might have died in her sleep – at which he looked rather hurt so I stuck (almost literally) to my post determined to give David Shepherd a piece of my mind at the earliest possible opportunity.

Then, at long last, the baby orang-utan stirred and I hastily prepared to take the photographs that had caused me to spend so many long, sticky hours of waiting – during which I had been obliged to watch the antics of the capuchins (many of which were quite obscene and practically all of them unsavoury), to say nothing of Guy the gorilla's unswerving gaze and the insults of ill-mannered human offspring.

After all the waiting though, the baby orang did not perform that day. Well, that is not entirely true, as something had upset her digestive system and this resulted in a quite spectacular but not particularly photogenic bout of diarrhoea! The capuchins were disgusted at this display and turned their backs while poor Guy the gorilla turned green and looked the other way. My sympathies were with my distant cousins and I decided it was time to leave. At this rate David Shepherd would be using only one colour for his painting – a sort of yellow ochre not usually associated with this (or any other) species of ape!

I packed up my equipment, bade farewell to the capuchins, Guy the gorilla and the friendly Keeper – and I acknowledged the waves of other residents who seemed quite sad to see me go. Then, tired and sticky and feeling distinctly irritable, I travelled homeward – with a strong feeling that I was going to dislike this David Shepherd character *whoever* he was!

Even as I drove home through the chaos of London's rush-hour traffic (roundly cursing traffic jams, capuchin monkeys, gazing gorillas, very unco-operative orang-utans, cheeky little boys and David Shepherd . . . *especially* David Shepherd) he had already changed his mind about the orang and decided to paint an elephant instead! Fortunately for me – and, under the circumstances, for him – I did not hear of this change until a few days later.

Not long after the foregoing events had taken place I met David for the first time. Far from wanting to strangle him on the

spot I discovered to my intense surprise that I liked the man immensely and we struck up an immediate friendship.

Later still, I met David's lovely wife Avril and their four charming little daughters Melinda, Mandy, Melanie and Wendy. Since that first meeting I have had the pleasure of watching the girls grow up into striking and still very charming young women.

A strong bond of friendship has developed between our two families over the past twenty years – and I now feel well qualified to answer the question which kept nagging at me all those years ago at London Zoo . . . 'who is this David Shepherd anyway?'

Born in 1931, he was eight years old at the outbreak of World War II in 1939 which meant that he had little influence on its outcome one way or the other! He lived in London during the Blitz, but then so did about eight million others, so there was nothing remarkable about that episode in his life except perhaps that it fostered a keen interest in aircraft. This was in no way unusual either as most children, especially boys, developed this fascination for aeroplanes of all kinds during the war years. After all, from the point of view of self-preservation if nothing else, it was always handy to know when an approaching aircraft was 'one of theirs' or 'one of ours'. As I too lived in London during that period I suspect that, like me, David could identify many aircraft from the sound of their engines alone. It wasn't too difficult to do that in those days of propeller-driven fighters, bombers and transports. The advent of the jet engine has made aural identification a much more difficult game to play.

Despite the fact that David's interest in aircraft was typical of any youngsters of that period, it was to play a vital role in his future career as we shall see.

He was educated at Stowe School in Buckinghamshire. Founded in 1923 as a 'modern Public school for boys' and situated in a lovely part of southern England, the school made a deep and lasting impression on David Shepherd. So much so, in fact, that he sent his youngest daughter Wendy to follow in his footsteps! As with so many Public schools now, Stowe has opened its Sixth Form studies to girls as well as boys. I think that David Shepherd gained great satisfaction from the fact that Wendy completed her schooling at his old school. Incidentally, David Niven was also a pupil at this school and he too remembered it with great affection.

It would seem that David Shepherd was an adequate rather than a brilliant scholar, as he left school in 1949 without a burning desire to become Prime Minister, Merchant Banker or Bishop (another David Shepherd evidently had the latter ambition!).

He did not go on to university and at that time he had no thought of becoming an artist, although his interest in wildlife had taken over from his boyhood love of aircraft – at least for the present.

There was a very good reason for this total lack of academic ambition – although I doubt if his parents fully appreciated what must have seemed to them a waste of a first-class education. David wanted, above anything else in the world, to become a game warden in Africa!

This is by no means an unusual ambition even today, although back in 1949 it was probably easier to achieve that ambition with the right qualifications. David, of course, had none of these academic requirements; he just knew that he could 'do great things' for African wildlife – even if he himself was not exactly certain how! Fate obviously knew how he could be of very special service to the animals of Africa . . . and elsewhere too, but Fate decided to play one or two tricks on David first.

So, with the eventual, if reluctant, blessing of his parents this nineteen-year-old callow youth (and photographs of the period confirm that he really was a rather callow youth) travelled by flying boat to Kenya.

On reaching Nairobi he wasted no time in presenting himself to the Chief Game Warden. I can somehow imagine David standing there with all the exuberant confidence of youth (however callow) and saying to the slightly bemused game warden 'Here I am; I've come to be a game warden; where do I start?' This is where Fate played one of those nasty tricks – because the Chief Warden, far from being delighted and relieved to see this saviour of wild creatures great and small on his doorstep, more or less told him to push off . . . and that even if there were any jobs going, he wouldn't give one to such an un-

trained, untried and slightly arrogant (to say nothing of callow) youth!

It must have seemed like the end of the world to David – and a time of great emotional upheaval. Perhaps Fate was just beginning to stir up the first of the artistic traits that gradually developed in the years to follow. David returned to England feeling that all was lost. Whatever could he do with his life now? Here he was, not yet twenty-one years of age and finished . . . or so it must have seemed.

There seemed just one glimmer of hope. At school, David had taken an interest in art – largely, as he freely admits, to avoid getting involved in any rough sports such as rugby football (after all, a chap could break things in organised mayhem of that kind). He understood a little about art, so perhaps he could take up painting.

Quite convinced that most artists starved to death and enjoying good food as he did, he had some second thoughts about this distinctly hazardous means of earning a crust. In fact, he was worried in case a crust was all he would earn!

It occurred to him then that he might become a bus driver. After all, they got paid regularly and it was certainly a job with plenty of travel involved. His parents evidently did not fancy the idea of their son in bus driver's uniform – even the game warden's khaki shorts and shirt would have been more acceptable than that – so David's father came to his help and gave him the encouragement to become an artist, or at least learn how to become one.

It seemed that The Slade School of Fine Art was just what David needed – or was it the other way round? – so he submitted his application together with the required examples of his work. His six bird paintings were received with less than enthusiasm, much less! Whether or not the Chief Game Warden in Nairobi had relatives among the faculty of The Slade School we may never know, but their treatment of David bore an uncanny similarity. 'Push off,' they said, 'you have no talent for painting and frankly, you are not worth teaching.'

It seemed inevitable now that David Shepherd would have to make his mark on the world as a bus driver. In view of the real train set he plays with these days one wonders why he never seems to have considered becoming an engine driver!

At last Fate, who had not been too kind to date, did something constructive for a change by arranging for David to attend a party in London at which he was introduced to another guest by the name of Robin Goodwin. In the course of conversation it transpired that this man was a successful artist – which is possibly why David had never heard of him in view of his firm belief that all artists starved in garrets or wherever.

David told of his spectacular lack of success in getting a place at The Slade and his resulting disappointment. Robin Goodwin did little to heal the would-be artist's wounds by telling him that if The Slade didn't take him then he must be totally without talent. In spite of this apparent lack of encouragement, Goodwin suggested that David might go round to his studio next day and take some of his work along. On seeing David's avian efforts the artist quickly confirmed the views expressed by the Chief Game Warden's relatives at The Slade to the effect that David Shepherd was blessed with a quite spectacular lack of artistic talent!

Was it Fate who suddenly put a ridiculous idea at the back of Goodwin's mind? It seems highly probable, because Robin Goodwin suddenly suggested that he would be willing to attempt to teach David to paint properly, although he held out little or no hope of any success with such an untalented pupil. So now, after two heartbreaking and quite shattering failures David was being given a chance to prove himself. At this point Fate probably nipped smartly across to David and whispered 'say yes you fool, before he changes his mind'. David said yes quite fervently. He had taken the first real step towards fame.

It would have been nice to relate at this point that everything ran smoothly for David from that moment, but this was far from being the case. He now had three long hard years of training to undergo before entertaining the slightest hope of earning his living as an artist.

Robin Goodwin proved to be a hard taskmaster and there were often times when David must have been at breaking point, but under Goodwin's skilful tuition and guidance and to the amazement of his family and friend's David's previously well hidden artistic talen began to blossom.

Unfortunately, one of the problems with this world of ours is that there are too many people competing for recognition in every field . . . game wardens and artists included. It was now up to the totally unknown young artist David Shepherd to start earning that crust or, better still, the complete loaf!

At this stage he might have tried for a job with an advertising agency and disappeared without trace. David needed help very badly and a rescue operation was called for. It was David's father who emulated the Seventh Cavalry and came to the rescue by telling his son that he could live at home for a year and not have to worry about making a living if this would help him to achieve something in life. This fatherly help and encouragement was probably just as important to David's future career as Robin Goodwin's willingness to teach him to paint.

Now it was up to the young Shepherd to make something of his life . . . and this is where his boyhood interest in aircraft was rekindled in a very positive way, for David found that not only did he enjoy painting aircraft, but that he painted them rather well. He managed to obtain a special pass which allowed him access to the rapidly expanding Heathrow Airport where he revelled in painting pictures of Lockheed Constellations, Boeing Stratocruisers and De Havilland Comets – the airliners of the period.

The Chairman of the British Overseas Airways Corporation saw some of his paintings and later held an exhibition of David Shepherd's work. He even arranged for him to fly in a Comet airliner in order to improve his skyscapes. David, rather cleverly, gave a number of his paintings to different airlines in the hope that they might eventually commission him to produce further works of aviation art. Which they did!

Fate decided to do the young artist another favour during his early days as an aviation artist by helping him to get acquainted with a delightful secretary who worked in England for Capital Airlines of Washington. Those of us who know David well would agree that this was the best thing Fate could possibly have done for him – and this good deed far outweighed the dirty tricks previously played on the lad – for now he had met his future wife Avril.

Meanwhile, back on the runway so to speak David was achieving recognition to the extent that the Royal Air Force gave him a number of commissions and flew him to various parts of the world in their aircraft. He was in his element.

The RAF now asked him to undertake a couple of painting commissions in Kenya . . . and so Fate, by courtesy of the Royal Air Force, steered the one time would-be game warden back to the scene of his first heartbreak and disillusionment.

Somewhat to his surprise, David discovered that the RAF in Kenya didn't want paintings of aircraft; they had enough to do with those things every day. No, what they wanted was something that would help to symbolise Kenya . . . in fact, what about painting elephants for a change?

That first elephant painting was sold to the RAF for the princely sum of £25. After that, commissions for wildlife paintings began to increase in number. David Shepherd had wanted to become a game warden so that he could do something for wildlife – and he had failed. He was now on the point of finding out that his newly discovered talent for painting wild animals would soon enable him to help them on a scale beyond his wildest hopes and dreams . . . but not for a little while yet.

Someone once said that the best thing that ever happened to African wildlife was when David Shepherd failed to become a game warden. This statement was, I think, intended as a compliment to David rather than an indication of the narrow escape the wildlife of Africa had experienced!

As he gained confidence, recognition and experience he began to undertake commissions which allowed him to paint many different kinds of subject, although steam locomotives and elephants gave him a special feeling of satisfaction and achievement.

In 1962 David Shepherd did an elephant painting which he entitled 'Wise Old Elephant'. This was produced as an unlimited print edition by Solomon & Whitehead and it became a best seller almost immediately. This painting is now in its ninth printing and it has sold more than 100,000 copies! David Shepherd was becoming a household name at last.

His growing list of commissions included those from the armed services for battle scenes of World War II. These commissions enabled him to fly to many parts of the world. He has

since flown in V-bombers, fighters, helicopters, has sailed on HMS *Ark Royal* and even flown in a Lancaster bomber.

The year 1962 saw David's first one-man exhibition in London's Tyron Gallery. It was a sell-out, as were other exhibitions in New York and South Africa. Our failed game warden and one-time potential bus driver was legging it up the ladder of fame!

In 1967, following a sell-out of his pictures at the New York exhibition, David decided to buy a train set. He telephoned British Rail and bought two main-line steam locomotives; the first weighing some 120 tons and named *The Green Knight* and the second even larger at 140 tons *Black Prince*. Now, of course, he needed a track, a station and all the other nice little accessories to go with the set. In the end, and after a long and agonising series of meetings and legal problems, David Shepherd founded the East Somerset Railway at Cranmore, near Shepton Mallet in Somerset.

Over the past few years and thanks chiefly to the dedication of a loyal band of helpers, the East Somerset Railway has developed from a muddled collection of rolling stock into an extremely well organised private railway visited by steam train enthusiasts from all over Britain – and quite a few from overseas too.

There have been times when David has felt that he had his two locomotives hanging like millstones round his neck, because running a railway – even a small private line – can cost a vast amount of money. The railway is now run as a charity and it has become one of the most successful private railways in the country thanks to David's generosity and the superhuman efforts of his volunteer team.

In 1977 he repaid a special debt of gratitude to the Royal Air Force when he painted a picture of a Lancaster bomber at dispersal and entitled it 'Winter of '43, Somewhere in England'. The 850 copies of this painting which he donated to the Royal Air Force Benevolent Fund raised £95,000 for that charity.

It was in 1962 that David Shepherd became involved in wildlife conservation and began to realise his potential ability to help wild animals through the medium of his paintings. He would now be able to make a real and lasting contribution to conservation on a worldwide scale – even though his first donation of a painting for this purpose raised only £250.

Since those early days of involvement his generous efforts have raised over £1,000,000 for conservation projects. In 1974 alone, his painting 'Tiger Fire' resulted in £127,000 being raised for the World Wildlife Fund's campaign 'Project Tiger'. His work in this field was recognised in 1974 when he was awarded the Order of the Golden Ark by Prince Bernhard of the Netherlands and again in 1980 when he received the OBE in The Queen's New Year Honours list. There have been several lesser awards made by organisations and institutes denoting further recognition of his services to heritage and conservation.

These days, the first announcement of a forthcoming David Shepherd exhibition automatically produces an immediate rush of potential buyers for the pictures. Although he does hold regular exhibitions in the United States and elsewhere overseas it is no longer *necessary* for him to do so. His American clients are perfectly willing to hop aboard Concorde just to make certain of a chance to bid for paintings. In fact, such is the popularity of his work that, at a recent exhibition, all seventy-six of his pictures were sold by ballot in just twenty minutes . . . with one enthusiastic American wanting to buy the lot! Limited edition prints signed by David Shepherd are not only a joy to behold; they can prove to be something of an asset too, as they rapidly appreciate in value. It is not at all unusual to hear of signed prints exchanging hands at five or six times their original price!

With several books already to his credit and the probability of more to come after this volume has been published our artist has also established himself as a successful author and writer.

Three or four major television programmes on David Shepherd the artist, conservationist and railway enthusiast have already been screened here in Britain and in many other parts of the world. No doubt there will be more of these to come in the future.

I believe that David has now reached the pinnacle of his career, so what a far cry it must seen from those early days around the runways and hangars at the infant Heathrow (which grew up into a monster of a place) when he was happily

painting those Constellations, Stratocruisers and Comets – and actually giving the results away!

Has he ever stopped to wonder what would have happened if he had turned down that party invitation a quarter of a century ago? What if Robin Goodwin hadn't turned up – or he and David had not been introduced? Perhaps David would by now have become Inspector Shepherd of London Transport buses . . . the scourge of route 88! Did Fate do David Shepherd a good turn that night in 1950 – or was it intended as a good turn for wildlife instead? Either way, it seems to have turned out very nicely for both parties on the whole!

As all benefactors know to their cost (quite literally in many cases) one generous gesture in aid of a good cause could be likened to throwing a little snowball on a mountainside only to bring an avalanche down on one's head! The good Shepherd has already, through his personal efforts, raised around £1,000,000 for conservation plus hundreds of thousands of pounds for heritage and other causes which, he felt, merited his help. This generosity opened the floodgates to a tidal wave of appeals . . . and even *demands* for paintings, prints and money. The situation soon grew into a problem which caused David and his family great concern. It is extremely difficult to say no to a request from a charity which is obviously doing a splendid job in its own particular field. It is much easier to reject the more arrogant demands made on his time and generosity.

By 1983 he realised that if he tried to grant all the requests for help he would be working twenty-four hours a day non-stop for charity – and not earning his keep. Good artists may not starve in garrets, but they need to pay the bills and look after their families just like everyone else. The situation was becoming desperate and it was beginning to affect David's routine commissions. As in days of old David Shepherd was in need of some speedy assistance as he slowly disappeared under the avalanche of appeals. Would it be Fate – or possibly a St Bernard – who came to the rescue this time? In fact, it would seem that Fate was busy elsewhere on this occasion so she deputised some of David's closest friends to provide the solution.

The cause of David's problem was that he was trying to deal with all the appeals and requests personally – and suffering per-sonal remorse and regret whenever he had to say no. The answer to this situation, as proposed by his friends, was quite simple. 'Let us channel your charitable efforts in a sensible way by creating a David Shepherd Charitable Foundation' they said. In this way all requests for grants, pictures or help of any kind could be received by the Foundation instead of going to David personally. Trustees of the Foundation could form themselves into an allocations committee to study applications for grants and make their recommendations concerning the merits of each case.

The idea developed into full discussions – including all the legal implications – and then application was made for the Foundation to be registered by the Charity Commissioners as a recognised British charitable trust. The David Shepherd Charitable Foundation was officially registered in 1984 and began to develop and function during 1985. The aim is to develop the Foundation slowly and steadily, keeping its salaried staff to the absolute minimum – costs too.

Two charities will become the main beneficiaries of the Foundation: the World Wildlife Fund and the Young People's Trust for Endangered Species – both of which are close to David's heart. Many other worthwhile causes will also benefit as a result of the formation of the charitable trust . . . and David too will benefit in his own way as a result of having so much worry lifted from his shoulders.

David and Avril Shepherd live in a beautiful sixteenth-century farmhouse near the village of Hascombe in Surrey. The name Hascombe means 'valley of the witch' in the old language of the Anglo-Saxons, but I suspect that any witch still knocking about in that valley must be of the 'white' or good variety as David and Avril and their family have been blessed with happiness and contentment in their home. In fact, the house itself is rich in character and has the 'feel' of a dwelling that has been the centre of a great deal of joy and contentment throughout its four hundred years of existence.

Do not imagine for one moment that the Shepherd household is as tranquil as the preceding paragraph may suggest. All professors, scientists, artists and bug-hunters are, by tradition, supposed to be absent-minded, emotional, petulant and, at

times, hysterical!! David is no exception to the rule – and he manages to combine all these traits with such skill and perfection that one could be forgiven for gaining the impression that they were the result of years of training and study!

This is where Avril Shepherd proves to be David's perfect partner, for while David crashes around the house like a rogue elephant with toothache looking for a letter or some other object which he is certain somebody has deliberately hidden – but which invariably turns up in his pocket – Avril goes quietly about the business of running the house, charming her guests and generally ignoring the crashes and thumps, the curses and ravings and slamming of doors.

David is quite magnificently flappable. Avril is supremely unflappable – and somehow this balance works wonderfully, as I have witnessed on so many occasions. The more nervous guests have been known to dive under the table or leap into cupboards as the roaring rogue elephant comes crashing into the room – only to settle in a chair, giggle like a naughty schoolboy and admit that whatever it was he was looking for was in his pocket all the time. As the trembling guests emerge from the cupboards and come up from under the table they will almost certainly find Avril waiting to welcome them with a tray of (much needed) drinks at the ready and radiating that same brightness and tranquility we experience when sunshine follows a thunderstorm!

Generally speaking, the young Shepherdesses have more of their mother's qualities than those of their father (thank God), except perhaps for Mandy Shepherd, who at the age of fourteen was turning out better art work than her Dad could achieve at 21! I will not dwell on Mandy's potential as an artist now, as I believe that she will quickly establish herself as an artist of renown and follow in David's footsteps by having her own books published in years to come.

When David Shepherd invited me to write this introduction I was mildly surprised, for whilst we are the best of friends I, as a typical native of Yorkshire, tend to be blunt and 'call a spade a spade' (what else would you call the wretched thing anyway), so David and I may not always agree with each other's views. Even so, we always manage to settle our differences amicably and cheerfully, so that's what counts.

The public image of David Shepherd is often that of a rather noisy and egotistical extrovert who must be absolute hell to live with. In fact, the *real* David is a surprisingly gentle and very genuine man who is quietly grateful for the wonderful gifts bestowed upon him . . . and grateful too, to those who helped to develop and bring out those creative talents which set him on the road to success. His story is not one of overnight success. It is a twenty-five-year history of sheer hard work and dedication, with a liberal sprinkling of disappointments and setbacks – and a wonderful wife and family to share his successes and rally round whenever the rogue elephant has the toothache!

David Shepherd has so many acquaintances and friends that a wise man said of him 'we may soon need his enemies to rally round and save him from his friends . . . or he will become an endangered species'.

Fortunately for David, Avril, the young Shepherdesses and posterity, there are enough of David's real friends around to make sure that he does not become an endangered species.

But he must be absolute hell to live with!

CYRIL LITTLEWOOD
Cranleigh, Surrey
May 1985

David Shepherd

BY HIMSELF

Luck plays a part, I believe, in anyone's success and I am certain that I have had more than my share of it. In fact, in the formative years of my life the indications were that I was not going to have much success in anything. I failed to be a game warden which is what I first wanted and very nearly failed to be an artist as well.

My ambition as a child to be a game warden in Africa was undoubtedly kindled by the books that I collected and read, by the so-called 'pioneers' who 'opened up the dark continent'. It is interesting, now that I have opened my eyes and have learned a great deal about what we are doing to our wildlife and to our world, to reread these books. Most of them leave me with a strong feeling of disgust and revulsion, as they seem to be one long tale of slaughter from cover to cover. 'This morning I was confronted by a herd of elephants unexpectedly – I downed six of the brutes before they took off'; 'Had a bad morning today, shot only three rhino'. It is surely because of these people, who seemed to shoot everything that moved without a second thought, that we now have to think so desperately of wildlife conservation.

Anyway, my Dad did nothing to discourage me from being a game warden in Africa, adopting the general philosophy that if that was what I wanted to be, he would not stand in my way. An uncle of mine, a coffee farmer, had been told about me and for some reason had decided to take me under his wing. I am appalled now to think back. Nobody seemed to ask me if I was interested in coffee farming, which I wasn't – I was going to Kenya to become a game warden! The coffee farmer was a fairly hard man and I was totally useless to him; he told me in no uncertain terms that I was a square peg in a very round hole. I knew nothing about coffee. I was miserable. Up until now the thought of homesickness had never occurred to me but within twelve hours of arriving on this remote farm, it hit me. I had no mobility and felt imprisoned, and I remember at once writing hysterical letters to my Dad pleading to come home, then counting the minutes until the reply came. I almost made myself ill. In the meantime, my baggage arrived. I had left England fully prepared to spend five years in Kenya and the thing which fills me with horror and pain was that my father willingly paid the bill to fly out all my worldly possessions. While the bewildered farmer looked on, the enormous crate which had been flown out by air was off-loaded from the truck. I had irresponsibly packed my bicycle and all sorts of other extraordinary things. I wonder if it ever occurred to any of us that there are bicycles in Africa, plenty of them. I had even imported a motheaten lion skin which I bought for a pound in a junk shop in Buckingham! I have learned since those days.

After a month on the coffee farm, I finally arrived in Nairobi. I had the incredibly arrogant idea that I was God's gift to the Kenya National Parks and that all I had to do would be to knock on the door of the head game warden's office and say 'Here I am, I've come to be a game warden.' He would then say 'How wonderful, welcome to the Kenya National Parks.' He didn't. He pointed out as diplomatically as he could that there were no vacancies and if there were, he wouldn't have given one to me – I didn't know one end of an animal from the other. It was the shock that I deserved, and my world was in ruins.

However, I did meet some wonderful people on my visit. I was taken down to Amboseli by one of the game wardens and shown my very first herd of elephants in front of Mount Kilimanjaro; though I didn't realise it at that moment, my life would never be quite the same again. Meanwhile my father, in

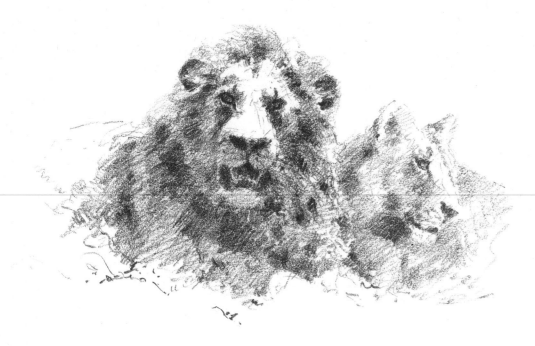

response to my now even more frantic pleas to come home, said quite rightly that he had paid my air fare and I would have to stay and earn my keep and pay for my own passage back to England. I had to do something, so I applied for a position as a receptionist in a hotel on the Kenya coast. Incredibly, I got the job. I was paid one pound a week, which I have since been told was a lousy deal for the hotel. But, while there, I painted ten bird paintings on plaster board and sold them all at ten pounds each to the gullible or culture-starved (or both) public. These paid my passage home on a Union Castle steamer.

With my one ambition in ruins, I decided I would have to turn to art, the only other thing that I had been remotely interested in. When I was at school, this manifested itself only to the extent of being an excuse to get off the rugger field – painting in the art school at Stowe was infinitely preferable to being squashed under a heap of writhing bodies in a sea of mud, having my collar bone broken, in what was supposed to be a game. I could not quite see the point or the fun of it. But if I was going to be a professional painter, then obviously I would have to have some training. I showed one of my rather strange bird pictures to the Slade School of Fine Art, as an entrance exami-

nation. They took one look at it and decided that I was not worth teaching. Another door was firmly shut in my face. Things were, by now, beginning to look a bit grim.

I do believe in miracles, for one now happened. I was just on the point of getting a job with the Aldershot and District Traction Co, driving buses around the Surrey countryside, when I went to a cocktail party in London. Generally speaking, I don't like these sort of parties, but that one changed my life. I was introduced to a professional artist called Robin Goodwin, who I had never heard of; he had certainly never heard of me. I started pouring out all my tale of woe about failing to become a game warden, and failing to become an artist. It didn't help my sagging morale when he said, 'Well, I am not going to teach you, I don't need the money, I don't have the time, and I don't particularly like students anyway.' However, he did say, in a rash moment, that he would be prepared to look at my bird pictures if I was prepared to drive up the following morning to his studio in Chelsea. He could then confirm what the Slade School of Art had said. I did just that and, unbelievably, he said, 'Do you want me to teach you?'

To this day, I have never understood what Robin saw in my work, but he must have seen some flicker of talent somewhere in the bird paintings that I showed him. It has, I believe, been a case of 1 per cent talent and 99 per cent training, and I owe all my success to him. He took me on for three years. I believe one either has the gift to teach or not, and that this is particularly relevant in the business of teaching any of the creative arts. It is awfully easy to break the spirit of a student. It is equally dangerous to praise him all the time, as that would be totally counterproductive. Somehow, Robin struck the perfect balance.

The first few hours on the first day with Robin were traumatic. He metaphorically shook me by the scruff of the neck and instilled a few first principles into my extremely immature and untrained head. 'I am going to tell you a few basic things now and if you are not prepared to accept them you can shove off out of my studio for good. First of all, because you are an artist, you have no right to assume that you are any different from anybody else. You are not. An artist, or a pianist, is no different from a farmer, an electrician or an engineer. The world does not owe

creative people a living any more than it owes a living to anyone else. If by some miracle you are going to earn your living by your painting, you are going to be working seven days a week, in every hour that God gives, including Sundays. You have got to get into your studio at nine o'clock in the morning in November when it is so dark that you can't see the canvas, and paint for the Inland Revenue, and the school fees.' To pile on the agony he continued, 'I am never going to say anything good about anything that you do for the next three years because I am going to assume that you know the good things – I am only going to tell you the bad things.' This was absolutely terrible and I seem to remember almost bursting into floods of tears. All my illusions had been shattered in one blow – I did think that painters were different, that painters could only work when they felt like it, that you had to be Bohemian in order to be a successful artist. How right Robin was, and how wrong I was.

When this short sharp session of verbal torture was over, Robin said 'I've got a commission to paint Westminster Bridge; come on, you're coming with me.' We both hopped on a bus. Robin had his easel, covered in paint from years of hard work; I had my shiny brand new one. We alighted and, within a matter of minutes, Robin was painting away quite happily right by the bus stop, completely oblivious to the crowds around him. I was paralysed with fear. I had never even painted in the middle of a field; here I was in the middle of London. I tried to pretend that it was a better composition down the steps, behind the wall, in front of County Hall. In fact, down there I couldn't see anything anyway and, of course, Robin saw through this straight away. 'Come on up here and paint beside me.' For the first three days, I don't think that I touched the brush on to the canvas. Every time a bus went by, every few seconds, about thirty people craned their necks to see what we were doing.

Robin was primarily a marine and portrait painter. During the years that I was with him, he had a large number of portrait commissions to undertake and I painted these alongside him. I also experienced just how hard such painting is from the sitter's point of view. One commission was to paint the portrait of the chancellor of a university; unfortunately he had just died and so the face had to be done from photographs. I, being the student, had to sit for the body! I learnt then just how important it is to sit absolutely still. I was dressed in silk robes, which did not make my life any easier. Robin reminded me that every time I moved all the folds in the silk would be different when I put my arm down again, so I couldn't scratch; but, as he pointed out, it was 'all part of your training'.

Specialising in portraits, it was inevitable that Robin was asked to paint a number of debutantes – feats of sheer endurance and I cannot understand how he managed to stand the mental anguish. The girls came along at 10.00 in the morning dolled up in their best evening gowns and covered in makeup. Many of them had faces that seemed rather like pudgy puddings and some were accompanied by Mummy to make sure that we behaved ourselves. (I reckoned that it was a very small risk to the girls concerned – with faces like puddings at 10.00 in the morning, there was very little incentive to do anything but paint!) Sometimes, Mummy used to say to Robin 'Make Angela prettier than she really is, won't you?' If Mummy then left, Robin used to say 'Go behind that screen, take off all that makeup, let your hair down, put this polo-neck sweater on, and then I'll paint you'. The result then was usually more than satisfactory. I regarded Robin as probably one of the finest portrait painters around.

They were wonderfully happy, hilarious days, painting with Robin out on the streets of London; but they had their problems too. Even on a Sunday, we were often such an attraction that we would have one or two hundred people standing behind us – some actually in front of us so that we could not see what we were trying to paint – and, on occasions, we were offered fatuous and stupid advice on how to do it. 'I wouldn't do it like that in my art class', was one comment. The girl who said this as she brushed by looked, I imagined, exactly like the paintings that she would create at her art college – chair legs and torn up cornflake packets nailed onto bits of plywood. People would sometimes stand so close behind us that we could smell the peppermints they breathed down the back of our necks. We always had a way of dealing with those who really wouldn't get out of our way – a quick step back, flourishing a paint-covered palette, worked wonders.

Crowds did, however, become exceedingly tiresome at times. Although we were not causing the obstruction (it was the crowds watching us) there were times when we had to be moved on. It was heartbreaking, just as one was 'getting into' the painting. On just a few other occasions, we fell foul of the law. Robin and I discovered that from somewhere in the dim and distant past there was a law which said that if your easel had three legs you had to have a permit, if it had two legs, it didn't; presumably with two legs, anyway, it falls over! One day, we were approached by a young policeman who was obviously rather too keen to impress us with his knowledge of legal matters. 'Have you got a permit to do that?' he asked, slightly officiously. We both knew how to cope with the situation. The policeman, like so many others, obviously had the idea that all artists are pretty crazy 'up top' and we played on this supposition. Robin and I dropped our lower jaws and adopted a completely vacant expression without issuing any audible sound at all. It worked like magic. The policeman obviously thought that we were completely mad, walked on – and we continued painting.

I was a bit arrogant, even in those days. I remember one particular sunny Sunday morning when I was painting in Shepherd Market. A very large saloon drove up and stopped in the road beside me; two extremely glamorous models got out, dressed in their evening gowns, followed by a gentleman with several cameras around his neck who was obviously a fashion photographer. He proceeded to twist and turn the girls into ludicrous and impossible anatomical positions on the traffic island for his photograph, which was no doubt destined to appear in *Harper's* or *Vogue*. I then suddenly realised that I was going to be a blur in the background. I had no intention of being a blur in anyone's photograph and asked him to go somewhere else – I obviously already had very big ideas!

We certainly made our mark on the streets of London. On one occasion, at the commencement of a day's work, my palette fell face downwards and, when I picked it up, there were fourteen little coloured pyramids of paint on the pavement. Inevitably, during the course of the day, our watching public walked through these little piles of paint. Coloured footmarks went off in all directions and they are probably still there.

While working with Robin I had a break each summer. During one of these holidays I was lazy; but I did complete one canvas, an aviation subject, which I really thought was going to please Robin, at long last. I took it up to his studio at the beginning of the new term; he took a long look at it without saying a word. My heart sank into my boots. He finally said, 'To look at that, it looks as though I have never given you a lesson in my life.' He was quite marvellous at knowing just how far to go without breaking my spirit. Several times, in a screaming temper, I was on my way down the stairs to my car parked outside, all ready to pack it in for good and go home. On one of the more emotional of these occasions he leaned out of the window and shouted down at me, 'Come on back, you silly little blighter, I am still teaching you, so you must be worth teaching.' That was, as far as I remember, the only kind thing that he said in three years; but it made sense. It was no good telling me that everything I did was marvellous, which it wasn't, because I would have learnt nothing. Since those days, Robin has undoubtedly mellowed. I suppose I have too. It is therefore a source of enduring satisfaction that we are now very close and the warmest of friends. He is a truly wonderful man and I shall never be able to repay him for what he taught me.

After three years, Robin reckoned that he had taught me all he could and that I should now be on my own. We both knew that there was no better way to get work seen than to get it into an exhibition, wherever and whenever we could. I started to send in my work, therefore, and sometimes had it accepted. One of the best showcases for any artist has, for many years, been the open air 'free for all' art exhibition during the first few weeks in May on the Thames Embankment. The whole idea of mixing up a complete cross section of the amateur and professional art scene and putting it in front of the public must be a good one. I believe there is scarcely any more productive or enjoyable way of doing it than hanging paintings on railings in public places – indeed, the idea seems to have spread because many lengths of railings in London now have paintings hanging on them on Sundays. The marvellous thing about the Thames Embankment show is the hotch potch of so many dif-

ferent sorts of painters and paintings. Painters of completely different social and financial backgrounds mix happily together. A large length of chain link fencing is put up along the edge of the path in the gardens and this is sub-divided with tapes in approximately 6ft x 6ft sections. When I was exhibiting on the embankment, artists would arrive the night before and, when Big Ben struck midnight, they would put a picture up and claim a pitch. We could then go away and risk the painting being stolen which, oddly enough, it never was – or else stay there until the early hours. Each pitch was provided with a tarpaulin on the back of the fence so that when it rained, which it very often did, this could be pulled over the pictures. The whole thing cost the artist absolutely nothing.

There were always more artists than pitches available and at the end of each day we ballotted for the next day. We never knew where our pitch was going to be and we would always be next to somebody new. The great thing about this exhibition, quite apart from the fact that there was no selection committee or hanging fee, was the wonderful freedom. You could put one small picture in the middle of your pitch or cover the entire six square feet with miniatures. You could come and go as you pleased and sell for whatever prices you thought reasonable and the public loved it. Enormous crowds of people would come through in the lunch hour every day, particularly in warm sunny weather. Being on the Embankment, you never knew who was going to come out of the Savoy Hotel!

The sense of comradeship between us all was a side of artistic life which I have only ever experienced on these occasions. The traditional ones amongst us, those who paint something recognizable, are chasms apart from the Bohemian types who fire paint out of a gun and ride their bicycles over their pictures, but we all mixed in happily together. I used to sit on the seat opposite my pitch in all weathers and if I had not sold much and was thirsty or hungry, I asked whoever was next to me to look after my pictures while I went into Bert's cafe under Charing Cross bridge. I would do the same for whoever sat next to me.

Unfortunately the open air show acquired a bad reputation, quite unfairly, because the sensational press used to come down every year and write a lot of rubbish about 'Bohemia among the tulips'. This, and other sickening clichés about starving artists, used to appear in the evening papers every year. One day I was sitting opposite my pitch in the sunshine, wearing slacks and an open shirt, with my Stowe public school silk square around my neck. No wonder the Old Stoic walking through the exhibition in his lunch hour from his city office, complete with bowler and pinstripe suit, looked aghast to see another Old Stoic apparently on his beam ends. I have never seen such a pompous expression on anyone's face; he obviously thought that I was letting down the school. However, his attitude changed after he had heard of my sales of the previous days. 'Good grief, you lucky blighter, I can't earn that in three months in my stuffy office!' I think that he went away seriously considering taking up painting for a living.

Fashions used to change in the open air art exhibition. One year it might be flower pictures, and then landscapes. I remember one artist who 'caught on' to such an extent that he was busy wrapping pictures up all day like a barrow boy in Oxford Street; then he used to dash home and paint a whole lot more for the next day. Two elderly ladies came every year and used to paint hundreds of pictures especially for the exhibition. They came up at the beginning of May and established themselves in a comfortable hotel. Their pitch was completely covered in little flower pictures, never much more than 6in x 4in. For five shillings you got two flowers in a pot, and for two and sixpence you got one. They sold like hot cakes, enabling them to live comfortably in Hove while they painted another lot in the remaining eleven months of the year.

There were several professional artists like myself who recognised the embankment as a marvellous show case; indeed, people used to come down from the opening of the Royal Academy Summer Exhibition, which took place at roughly the same time, and say what a breath of fresh air it was to see some real painting at last. In fact, it was from the open air art exhibition of the first year that I sold my very first picture – and learned a lesson at the same time. It was a small English landscape priced at twenty-five guineas. A smartly dressed gentleman walked through the gardens, saw my picture, and offered me twelve guineas for it. He obviously thought that I was look-

ing fed up – which I was. He beat me down pound by pound until I gave in. I then carried the painting along to his car, he handed the painting over to his chauffeur and was driven off in his Rolls Royce. I swore that I would never be beaten down again in that fashion. (I am, quite often, but only when it's with friends, and it's fun.)

It was at this time that I was learning fast about a lot of other things as well. I began to see for myself some of the less pleasant aspects of London's exhibition scene. I hope that it has changed now but I wonder sometimes. Robin was highly successful, and he made enemies. On occasions, when he submitted a picture for an exhibition, we would see it chalked with a rejection cross before it was even seen by the selection committee. It was in 1954 that I sent in a painting to the Royal Academy for their Summer Exhibition and, by sheer chance rather than merit, it was accepted. An impossibly large number of paintings are sent in every year to this show and I believe that it is physically impossible for a selection committee to sit for more than a week before a continuous stream of paintings going past them. Occasionally, I reckon, an academician opens one eye, lifts a hand, and the painting is accepted; then everybody goes to sleep again. However, it was a prestigious thing to be accepted – my picture was of a little antique shop, and it was number 648 in the catalogue. It was hung above an electric plug socket, if I remember, in gallery heaven knows what number, at almost floor level.

My mother and father were, not unnaturally, proud that I had a picture hanging. My father put his best suit on, which was always a bit of an effort, and we went to the private view. We walked up the steps of Burlington House and the commissionaire's arm came down across my father's chest preventing him from entering. 'Haven't you read your ticket?' he said, rather aggressively, 'It does in fact say "Admit two, including exhibitor".' I went down to the office for another ticket and this was refused, so I had to take my mother around the exhibition, put her into a 'crawling position' to see my picture and then leave her out in the car park while my father went in. This was bad enough but the thing that really annoyed me was that so many of the people drinking champagne at the private view in front of our pictures were celebrities who had nothing whatsoever to do with painting – for example, film starlets being photographed by their agents and the press in the hope of getting a star part. To them it was just a social event at the beginning of the London season and this kind of sham facade gives painting exhibitions, particularly this one, a bad name, which I think is a pity. I believe that the Royal Academy should move with the times far more; if they have to exhibit door knobs, chair legs and torn up cornflakes packets, they should also realise that the public want to see realism as well by 'popular' artists.

People sometimes ask me, 'Who is your favourite painter?' I say, without reservation, Rembrandt. I have said elsewhere in this book that if he had been alive in the steam railway era, he would possibly have painted the most fabulous railway pictures. The genius of Rembrandt, in my view, is that he painted in what I call 'singing colours' – no pure reds or blues squeezed straight out of the tube like toothpaste like so much modern art. He was able, in sombre tones, to make his paintings glow and 'sing' with warmth.

When Robin was training me, we didn't have the time to go round art galleries looking at other people's pictures. He was teaching me how to paint so that I could earn my living. He said that I could always go round art galleries later if I had the time or read up the history of art in books. Robin also said something else: 'Art is like any other profession. As the world goes on turning, we get better and better. Farmers are now farming much better than they did centuries ago. Electricians, accountants, the same applies.' When we did manage to go to one of the great art galleries, I could see what he meant. He pointed out that we could learn so much from those who have gone before us. 'Look at the way that arm is painted – the artist didn't know any better.' Sure enough, the arm looked like a piece of wood. I believe, as Robin does, that there are artists now, perhaps totally unknown, who are painting better pictures technically, simply because we have learned from those who preceded us. Robin went further. 'It is sad to think', he said, 'that so many artists in the past died in the most appalling poverty and misery – think of Van Gogh – because they could

not sell their work, or if they did, they sold it for what they thought was a fair market price. Now, those pictures are beyond price – simply because they have been regarded solely as investments, for one dealer to make money when he sells it on to another, who makes even more, pushing the price higher and higher until the dealers and the auctioneers are rubbing their hands with glee, and the poor chap who painted the thing in the first place is not gaining one penny from it. It makes me feel very angry indeed and I hope that it will never happen to me.

As Robin taught me so well, any artist who wants to make a success of his work must be taught the fundamentals of good colour sense and how to draw. Learning when Botticelli painted his nudes can all be found in a text book and will not, in any case, help to pay the bills. If, after his training, an artist wants to tear up cornflakes packets and stick chair legs to a piece of hardboard, that is up to him. I do not personally understand it and I think that an increasing number of people would agree with me. I don't believe that this is arrogance; I believe it is common sense. We have been hoodwinked too long into believing that because building bricks and bits of bent wire get into the great art galleries, it is great art. It is there simply because a few influential people without any consideration for the general public put it there. Nevertheless, there obviously are great painters who I admire for what they were and there would probably be many more if I had more time to go round the galleries. After all, Leonardo was not only possibly the greatest genius of all time, but he invented helicopters, bicycles and, it seems, just about everything else! What I do object to is a painting changing hands for a million pounds when it simply consists of a few lines and blobs of paint which were dropped on to the canvas in what looks suspiciously like an accident.

For the years immediately following my training, I was able to take life at a much slower pace than I do now. I did not have financial or family commitments, and I was able to paint many pictures purely for the joy of it. I was also, of course, learning hard all the time and those formative years were undoubtedly more valuable to my future career than I then realised. Several of these pictures appear in this book.

Luck still continued to play its part. When I left Robin, my parents allowed me to stay at home for a full year. I therefore did not have to earn my living immediately. However well I might have been trained, my work was obviously immature and had I had to support myself from the beginning, I might well have suffered through the necessity of my having to take every sort of commission that came my way. Instead of this, I was shielded by my parents' generosity, and I was able to spend the whole of that twelve months at London Airport. I had always been fascinated by aircraft, ever since the days when I lived as a small boy during the blitz. It seemed natural, therefore, that having concluded my training with Robin, I would specialise in aviation painting.

London Airport was not the concrete jungle that it is today. I had a permit which enabled me to paint almost anywhere I liked, and I painted some twenty pictures from life, in and

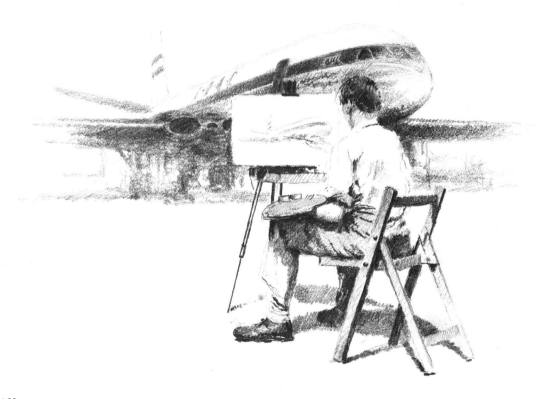

around the hangars. I was allowed to hang my pictures in the public enclosure and my work gradually became noticed. At this time, I was also giving paintings of Viscounts and Comets away, as I realised that this was perhaps the only chance of hanging in the boardrooms of the big aviation companies. Indeed, on at least one occasion, they felt, in the end, obliged to commission me.

Since the completion of my training in 1953, I had been adequately earning my living from commissions, painting aircraft, railway pictures and English landscapes. Then, in the early part of 1960, an official-looking letter arrived one morning with the envelope marked 'C-IN-C, BFAP'. The letters meant nothing to me; but inside was an invitation from the Commander in Chief, British Forces Arabian Peninsular, inviting me out to Aden to paint as a guest of the RAF. As I read on, I realised that there was no guarantee of any commissioned work at all. The RAF would simply fly me out to Aden, show me around their whole sphere of activity, and the rest would be up to me.

216 Squadron flew a regular service from Lyneham to Australia through Aden, and the Chief of The Air Staff in London arranged a free passage for me on one of their Comet aircraft. On arrival in Aden, I was met with a warm RAF welcome. The following morning I started my tour around the many squadrons based there, showing them photographs of my work and various sketches. The reaction was totally apathetic, if not almost hostile. It turned out that a lady artist had visited Aden just before I arrived there, and made such a nuisance of herself that the RAF had been frightened off any artist ever coming in their direction again. This was disappointing to say the least, and wholly unexpected. A couple of nights later the Commander in Chief hosted a special dinner for me attended by a number of senior officers from all three services. After dinner, we sat around the table and it was decided that Shepherd would be flown home again in the first Comet that might be coming through from Australia, back home to England. It was all rather casual and nobody seemed to mind that I had come all the way out to Aden. I had had a very relaxing few days and met a lot of wonderful people; the aircraft was flying anyway, so I

had not cost the taxpayer anything. But no Comet home was due for over a week so, rather than sit on my backside and do nothing, I decided to explore.

It seemed perfectly obvious from talking to everybody that Aden had only two reputations. One was that it was a stinking, humid place full of bad smells, which you came into and got out of as soon as possible; the other that, being a free port, it was a marvellous place to buy cheap cameras, tape-recorders and washing machines! In those days, when the British were still there, it was a bunkering port for all the big liners going to and from Australia. Even in the short time that I was there, several of the beautiful P&O ships came in. Their passengers swarmed off the decks and descended on the Arab traders. The camera shops stayed open as long as there was custom, and they made fortunes wrapping up movie cameras as fast as they could. There was, however, another side to Aden which none of these people ever saw for, as in so many other places, the typical tourist has neither the time nor, perhaps, the enthusiasm, to take a little trouble to look around him. I had been told of a place called Slave Island. Here the Arab fishing vessels – the dhows – were still being built in almost exactly the same way as they had been in the days of the Bible.

Just occasionally in his creative lifetime, an artist may perhaps paint a picture which he feels is rather special, either because of its quality or for some other reason. I have painted some three thousand paintings in my career so far but 'Slave Island' must be a major landmark if only because of all the things that led from it.

I spent several days on Slave Island and painted the whole picture on the spot. When it was completed, I showed it to the Commander in Chief. He said, 'That's a hell of a lot better than the sketches and photographs that you were showing us, let's have another party.' We hung that painting up on the wall and I obtained forty-eight commissions that evening. It now seemed that everyone in Aden wanted my work. I was commissioned by Shell, BP, Aden Airways, a large number of Arab traders, all three services and various shipping lines. Furthermore, the RAF said, 'We won't fly you back to England now, on the first Comet. We will fly you up into the edge of the

Empty Quarter in the West and East Aden Protectorates. Then, if you like, we will fly you down to Kenya.'

The six weeks that followed completely changed my whole life. First of all, I spent a hectic and exciting time flying in the early hours of the morning every day of the week on what the RAF called the 'bread run'. This meant flying in many diverse and different sorts of aeroplanes up into the Radfan over the most incredibly hostile landscape where, if we crash-landed, we would have little hope of being found. We would then land on little dusty airstrips in the middle of nowhere to take supplies up to the small encampments of British troops stationed under canvas in the mud-brick villages. These places had not changed since the days of the Bible and, because I actually set up my easel and painted places such as these, the whole area has left an indelible impression on me forever. In this overcrowded world, it is quite something to go somewhere where you know no other artist has ever been.

Many people in Aden had waxed lyrical about the beauties of the Hadhramaut and everyone told me that I simply must get there if at all possible. Thanks to the Royal Air Force, I did and I must be forever grateful to them for showing me a part of the world which, all other places I have visited considered, I still feel is the most awe-inspiring and breathtakingly beautiful part of the world that I shall ever see. Mukalla was the stepping-off point for the Hadhramaut. By road, it was an arduous and indeed uncertain journey by Land Rover taking several days, time which I did not have. However, by sheer good fortune, the Royal Air Force were chartering a DC3 from Aden Airways in a few days' time and I was promised a lift in that.

The flight eastwards from Aden in the Aden Airways DC3 was hot and bumpy, but finally I saw Mukalla below us. It was an incredible sight – an ancient collection of gleaming white buildings around a bay, in an impossibly blue sea, with a precipitous mountain towering up behind the town looking rather like a cake with strawberry on the bottom layer and chocolate on top.

The airstrip for Mukalla was called Riyan. A few RAF personnel lived here in a tented camp and the runway consisted of flattened-out coral, just long enough to land a DC3. As no bits of broken aeroplane were to be seen at the end of the runway I assumed that it was safer than it looked.

The doors of the aircraft were opened and it was just like putting one's head into a very hot oven. In spite of this the first thing that I noticed was a game of cricket in progress beside the runway! Friday is the Sunday in this part of the world and apparently the commanding officer at Riyan airstrip had challenged the eight Europeans living in Mukalla to a cricket match. I only had a few precious hours in the town but I had to wait until the match was over before there would be any transport to take me there.

Mukalla seemed to be just about as remote and cut off from other places as it could possibly be. Once every month, hopefully, a steamer dropped anchor off the bay to deliver a new land rover or fresh fruit, butter and petrol. The eight Europeans living in the town were Foreign Office people, bank officials or military personnel. Their only contact with the outside world seemed to be either by radio or the irregular air service, operated by Aden Airways when there were enough people, chickens and bags of flour to fill a DC3. However, progress was beginning to make itself felt. Electricity had recently

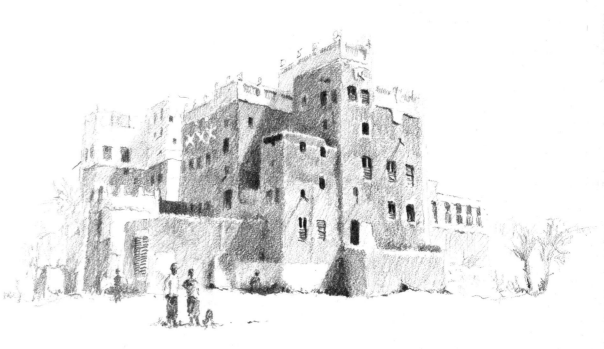

been laid on in the town and the inhabitants were very proud indeed of the modern street lighting down the main street. The contrast of the concrete lamp standards with the lovely old buildings defied comment.

The only vehicles in the town were a few battered ex-Army Bedford trucks and one private car. This was a very dilapidated pre-war Humber. Because it was there, an enterprising Arab shopkeeper had put up a beautifully painted sign which read 'Rootes Group Dealer' above the little hole in the wall which represented his shop. I took a photo of this and showed it to the Rootes Group HQ in Piccadilly in London just for fun but they took it frightfully seriously. 'This is not one of our official accredited agents.'

The beautiful Arab buildings climbed up the foot of that remarkable mountain. The windows had no glass in them, just gauze shutters to keep out the flies and sun. I never ascertained why, but most of the buildings had daubs of blue paint artistically applied around the windows on the glistening white walls, all adding to the incredible beauty of the place.

The central feature of the curving waterfront was the mosque. Unfortunately, I discovered that progress had arrived in another form too; the faithful were no longer called to prayer by means of a megaphone from the top of the tower – it was now done with a wind-up gramaphone.

I did several sketches in Mukalla and, each time, was surrounded by hordes of Arab children, full of smiles and begging for cigarettes. I count myself highly privileged to have seen this lovely place and almost certainly to have painted the very first picture of it.

I have described this unique place opposite the painting in this book. During my days in Mukalla we made every possible effort to get in touch with the political agent in Saywun, one of the three ancient Arab cities in the Wadi Hadhramaut. We had no success for the first three days and then, finally, the signal came over the air: 'Ref yours 10.20hrs yesterday; artist welcome. House available. Arab cook, American anthropologist thrown in for good measure.' Taking my life in my hands and not really knowing what to expect, I nevertheless could not resist the temptation now that it was before me. I knew that I would never get another chance. A DC3 was flying back to Aden via the Hadhramaut and so, throwing everything into a Land Rover, we dashed off to Mukalla's airstrip at Riyan.

The aircraft flew over a lunar landscape where there was no kind of habitation or greenery. Then we saw the Wadi. It looked rather like the Grand Canyon. We flew the last few miles below the top of the Wadi's walls and dropped down on to the airstrip at Gatn, coming to a halt in clouds of dust.

The Hadhramaut certainly lived up to the description that I had been given. The Wadi stretches for over 160km (100 miles), rather like a gigantic channel cut deep into the barren landscape. Over 6km (4 miles) wide along its length, the Wadi floor is flat bare sand and, on either side, towering to 305m (1000ft), are enormous sheer walls of sandstone. Little clusters of castellated mud-brick houses huddle together here and there to form the most picturesque villages. The air was crystal clear, and there was a feeling of total peace and stillness such as I have never experienced anywhere else in the world.

That night, I stayed in the political agent's house in Saywun with the American anthropologist. The house was a traditional old Arab building, painted white inside and out for coolness. The bathroom was virtually an indoor swimming pool, with the water coming through a hole in the wall.

After our evening meal of goat-meat and spicy sauces, we sat on the flat roof and watched the sun going down, a sight I shall never forget. As the fiery red ball dipped lower and lower towards the horizon, the shadow on one side of the Wadi climbed up the other side until, at the last moment, a brilliant gold strip was sharply edged along the top of the escarpment until it too disappeared. I painted this from life, and had to work very fast! We then sat on in the clear cool night air, without speaking. The human voice seemed an imposition in such a setting. Then my American friend put a record of Max Bruch's violin concerto on a transistor gramaphone and never have I appreciated classical music more deeply. As we listened to this sublimely beautiful music, the only other sounds were the tinkling of goat bells and the occasional braying of a donkey.

After all this excitement seeing such places that I could never have dreamed of, the Royal Air Force then flew me down

to Nairobi as promised. I could not have imagined then how that would shape the rest of my life.

In those days Kenya was still a colony and the Royal Air Force were based at Eastleigh, just outside Nairobi. There I met the Station commander. 'Yes, we would like two pictures for the Officer's Mess, but we don't want aeroplanes because we fly them all day. Do you paint local things like elephants?' 'No', I answered, 'but I'll have have a bash – I suppose that I have got some feeling for such things because I always wanted to be a game warden.' I painted my very first elephant painting there and then for the Royal Air Force, charged them £25 including the frame, and my career took off from that moment, all thanks to Slave Island.

Ever since that visit I have specialised in painting wildlife and I have no doubt whatsoever that I owe all my success since those days to those paintings of wildlife and, particularly, my jumbos.

Something else happened as a direct result of that journey to Aden and Kenya with the Royal Air Force in 1960 – something so fundamental that, again, my whole life was to change. When I finished my work with the Royal Air Force, I drove down to the Serengeti National Park in Tanzania for a few days. Driving out into the park very early one morning with the game warden in his Land Rover we saw an incredibly large number of vultures flying over the horizon. 'There's something wrong over there, David, we had better go over and see; that's not just a normal lion's kill.' We drove over the horizon and came across a waterhole which had been poisoned by a poacher. Around it, we counted 255 dead zebra. Although I have seen an infinite number of similar and even worse scenes since those days, I will carry to my grave the sight of that first dramatic introduction to the horrors that man perpetrates on his fellow creatures.

On my return home, my career began to take off rapidly. I had my first one man exhibition in London, of wildlife paintings, in 1962. The whole lot sold in the first twenty minutes and I have never looked back since, having, permanently, a full order book for one to two years ahead. It was at this time that I painted 'Wise Old Elephant' which has possibly done

more to put me on the map than any other painting. At the same time, I was rapidly getting more deeply involved in wildlife conservation. Most important of all, my success as a wildlife artist was enabling me to raise quite large sums of money by donating paintings, in order to repay in some small way my huge debt of gratitude to wildlife for what it was doing for me. This is the greatest source of satisfaction to me in my life now. The first painting I gave in 1961, raised, I think, somewhere in the region of £200. I am thrilled beyond measure to realise that I am now onto my second million; and I do not put this in print because I want thanks. I tell people simply because it is so incredibly exciting to raise money so easily for a cause for which one feels passionately. I am miserable if I am not painting. The paintings which I have given were going to be painted anyway.

Since those days, I have learnt a very great deal. I am not an ecologist or scientist, and never could be. I am, however, an emotional person and, through painting wildlife, I have become more and more involved with the horrors that man is perpetrating to the wildlife around him and, more important still, the habitat on which all wildlife, including man himself, depends. I have seen my favourite animal dying in agony from poisoned arrows. It takes six weeks for an elephant to die from

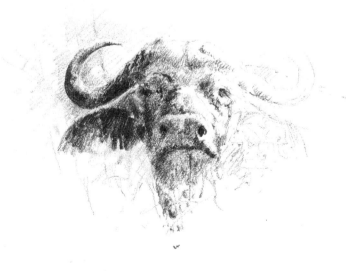

this treatment, and I have wept openly in disgust and anger that this barbarity can be perpetrated by a few people who are motivated entirely by greed and money. I have stood on the ice flows of the Gulf of St Lawrence watching three thousand baby seals, less than five days old, being bashed on the head with clubs, in one morning, until the sea around them was like tomato ketchup. I will never be able to understand how civilised man can descend to such depths of depravity; but he does.

There are certain paintings in this book which mean something very special to me. I had only painted two or three portraits during my training when, in 1963, I was faced with the most daunting challenge so far in my entire painting career. It seemed that a group of army chaplains were discussing the matter of a memorial to all the regiments that have ever been stationed at Bordon Camp, near Petersfield in Hampshire. All the usual and obvious suggestions were made – carved pews, altar screens and stained glass windows – and then one chaplain asked if David Shepherd might be approached to paint a reredos. I was asked, and I didn't even know what a reredos was. I was informed that it usually took the form of a painting or a screen hanging behind the altar.

The army chaplains and I met, and I asked them why on earth they had chosen me of all people. The answer was rather encouraging: 'We have chosen you, David, because we want the sort of painting that will bring the men into church' (whatever that meant). 'We don't want something frightfully modernistic, nor do we want something with fat great cherubs floating about.' Their turn of phrase was quite splendid – the army are very down-to-earth people and tend to be slightly philistine, sometimes, when it comes to art. They chose me, it seemed, because they hoped I would provide a down-to-earth and realistic portrayal of Christ as a man.

At that meeting, the enormity of the challenge did not even begin to sink in. It did on the way home. I well remember stopping and pulling my car into a layby, at which point I started feeling quite sick at the thought of what I had just taken on. It was one thing to have painted a few minor portraits but quite another to take on a challenge such as this. The problem was all the more awesome because I was told that the funds to pay for the painting would be raised through public subscription collected through the media. Shortly afterwards, the appeal appeared in the press. I saw some of the answers in the chaplains' office and these did not help my frame of mind; 'I enclose £50 in memory of my late husband who was stationed at Bordon in the thirties and who was killed in the war, and do wish that chap David Shepherd the very best of luck.' This was one of many, and when I read them I began to quake at the knees!

The months, in fact well over twelve of them, went by with my doing absolutely nothing about it. I was too terrified to start. Then I began to get little nudges from the army. I realised that I could never attempt to paint such a painting unless I had a model. Even in the great religious masterpieces of the past, models were used. However, how on earth was I to find someone suitable? I had awful visions of spending years desperately searching up and down England, stopping anyone in the street who happened to be wearing a beard. My model would have to have a strong face, full of compassion, and such people are not easy to find.

It is so easy to sound trite, but from this moment the miracle started working. I believe that it was a 'miracle', because everything associated with this painting went more smoothly than with any other picture I had painted, or have painted since. I found my model and it all seemed so incredibly easy. I was living in Farnham at that time and the *Farnham Herald* did an article on my desperate plight. The article was headed 'Artist searches for model for painting of Christ'. It then went on to say, in effect, that if anyone thought that he looked like Christ, would he contact the newspaper office? That is exactly what happened. A man rang up the *Farnham Herald* and said, 'I'm known as Jesus by my mates, do you think I will do for that bloke David Shepherd?' Acting on impulse and to his everlasting credit, one of the reporters for the paper decided to go up and see the person concerned. He was so impressed that, without a word of warning, he brought him into my studio. I had found my model. It was just like Christ walking through the door.

Having found my model; I now had to think about costume. I went along to one of London's theatrical costumiers, and the whole thing became a farce. It was May, which month did not seem to have any particularly religious significance. It was neither Easter nor Christmas, but I was told very bluntly that all the Christ costumes were 'out'. I was then offered an alternative; the costume, complete with bloodstained arm, that had been worn by Peter O'Toole in the film *Lawrence of Arabia*. I pointed out that I didn't want Peter O'Toole, I wanted Christ, and walked out in a huff.

I had no strong preconceived ideas about what the costume should look like. However, I remembered seeing a film called *The Robe*, in which Christ was dressed in a simple white costume with a cord tie round the waist, a robe of lovely red homespun cloth over his shoulder. This concept seemed ideal and, furthermore, it would present no problem in the making. I now had visions of spending months going into shops looking for the right material, but the 'miracle' worked again. I went into D. H. Evans in Oxford Street and there, right in the middle of the counter on the ground floor, was an enormous roll of exactly the right material in the colour and texture I was looking for. Moreover, it was in the sales! The rest of the costume presented no problems whatsoever to my wife; she made it up in a couple of hours.

By now, I was getting more reminders from the War Office. 'Had I finished the painting yet?' I had not started it, and I realised that it was about time I checked that the model was still around. With great difficulty I found him. He was self-employed as a timber cutter living in a caravan in a wood near Alton. It was a January evening by the time I found out where he lived, and it was pouring with rain. I was driving up a narrow lane and in front of me I saw a tractor approaching. We just managed to squeeze past each other and there, on the back of the trailer, was a mud-spattered apparition. It was my model covered in mud from head to foot, but he still had his long hair and that was what mattered. 'I have been waiting for you, where have you been?', he asked.

Suddenly, something happened which made me panic. I was told where to park my car for the consecration service! The War Office were obviously getting tired of waiting, and Her Majesty's Chaplain General to the Forces, who was a busy man, had been booked for 24 July. There were three weeks left and I still had 2.5m (8ft) of stark white canvas staring at me in the studio, without a brush mark on it. I had visions of the Chaplain General consecrating the painting in instalments! That evening we had a little private dinner party. One of the guests was a retired group captain friend of ours. I was so sick with worry at the daunting challenge before me that I never said a word all evening. As my RAF friend left, he said what is probably the most significant thing I have ever heard: 'Don't worry, David, I know you are worrying yourself silly about this painting, but you are going to have some sort of religious help in painting it; goodnight and good luck.'

Next day, the model arrived. He had never been in an artist's studio before. I knew what it was like to sit for a painting because it had been part of my training with Robin; the mental and physical demands on the sitter are just as great as those on the artist. My model showed a dedication and application which was quite magnificent. I had to erect a strong photographic flood lamp about 1m (3ft) away from the side of his face. This was necessary in order to obtain an exaggerated lighting on his features, bearing in mind that the finished picture would be viewed at a distance and in an inadequately lit church. He had to stand for hours at a time and that, coupled with the heat of the lamp on the side of his face, would have deterred most people, but he never gave up or complained. Worst of all, perhaps, was the painting of the costume. I explained that if he moved when I was painting it, all the folds in it would immediately change; therefore he had to stand absolutely still while I painted the entire costume in one go. It took some six and a half hours. It is possibly the longest painting session I have done without stopping; and it was certainly the longest period that my model had stood, without flinching.

The background to the painting had to consist of many different cameos, each representing a regiment that had been stationed at Bordon Camp. It was decided that we would not go back earlier than 1910. Behind the central figure of Christ was an army chaplain, and then three soldiers representing

three different periods in history – World War II, World War I and 1910. Then came the various different military scenes; small individual pictures portraying, for example, ATS girls working a primitive radiolocation set early in World War II, military police with a dog, Sappers building a bridge, the Parachute Regiment leaping out of gliders, REME with a Scammel recovery vehicle and land rover, a World War I Royal Artillery gun battery, a tank, and various other scenes. The challenge was to knit all this together into one unit, and I think it worked quite well. Anyway, the whole painting was completed in less than three weeks without a hitch. Religious guidance? – I don't know.

The problems were by no means over. The painting was so large that the canvas had to be taken off its stretcher to get it out of the studio, and then temporarily put back on the stretcher for transport in the removal van to Bordon. The whole thing was a nightmare because the painting was still wet. When we arrived at Bordon, the picture then had to be taken off its stretcher again, to enable the latter to be rebuilt behind the altar of the church. All the time this was taking place, the painting was lying face upwards on the path outside, still wet. Every time a bird flew overhead I had 'fifteen heart attacks'! The canvas was then carefully taken into church and put back onto its stretcher. Actually painting the picture was almost the easy part!

The day of the service arrived, and it was a very moving affair. All my family were there and I felt quite emotional when the chaplain raised his hand to consecrate my painting. After the ceremony was over, all the VIPs went into the marquee for a celebratory tea and I was left for a few minutes on my own in the church, with the Chaplain General. He especially asked me to tell him all about the background to the painting. He complimented me by saying that it was one of the best religious paintings that he had seen. He then asked, 'Aren't you the chap who normally paints elephants?' It seemed that I could not get away from my favourite animal even here in church; however, as they are responsible for so much of my present success, I did not really mind too much. Of one thing, I am quite certain. If I am remembered by anything I have ever

painted, long after I am dead, I would like it to be for my painting of Christ.

Other paintings have played a major part in the development of my career; some of these in particular because they have raised very large amounts of money for charity. The most celebrated of these must be 'Tiger Fire'.

The World Wildlife Fund launched Operation Tiger in 1973 because this magnificent animal – in my view, the most beautiful in the world – was on the brink of extinction. Tigers in India had been reduced in number from 40,000 in 1947 to 1,827. I had never painted a tiger before, but I decided to try to raise some money, so I flew out to India to attempt to see a wild tiger. After trying very hard for three weeks I had failed, so I came back home to England. I went down to a zoo near Canterbury which is noted for its collection of tigers; in fact it is one of the largest collections in the world, numbering over forty. The owner was away for the day but the head keeper was there and he said, 'You can go in with Zharif, he is perfectly OK.' I am not brave. Some people might say I was stupid; but I would prefer to say that I trust people. If the keeper said that it was safe, then that was OK by me.

Zharif was in a very large enclosure and, as I entered and the iron gate clanged shut behind me, the noise woke Zharif up. He

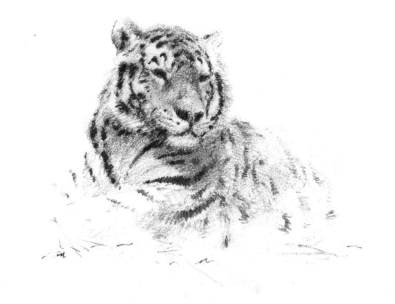

came bounding towards me like an express train and I stood there feeling rather foolish. I looked round to ask the keeper what I should do. To my dismay and slight surprise, I saw that he was outside the enclosure and I was on my own on the inside. All I managed to hear him say was, 'Just stand still and let him get to know you.' I didn't have time to find out precisely what this meant because the very rapidly approaching Zharif was getting bigger by the second. The enormous animal skidded to a halt, and the first thing he did was to rub his head up and down my legs, mewing like a domestic cat. He came up to my waist; tigers are big animals. He then rolled over on the ground with his legs in the air and allowed me to rub his vast white fluffy tummy. He then got up, pointed his back end at me, lifted his tail, and squirted urine over me. As I stood there getting soaked to the skin, the keeper, still outside, was leaping up and down with joy saying, 'Oh he loves you, he loves you.'

Over the years, through experiences such as this, I have learned quite a lot about animal behaviour. One thing I now know is that to establish immediate rapport between yourself and a tiger, the best thing to do is to stand still and let him urinate all over you! Zharif and I were obviously friends and the keeper now joined me in the enclosure. I explained that I needed a photograph of a very angry tiger. After all, I had to try to capture the essential fiery quality of this glorious animal and I was not going to do that by painting it lying on its back asleep with its legs in the air. 'You'll have a hell of a job, because he is so nice', said the keeper. Then he added, 'I tell you what, he's extremely hungry. We haven't fed him for over a week, so you get your camera ready, we'll do a countdown, "five, four, three, two, one", and on "one", I will pull his lunch away.' I pondered a while and considered this suggestion. There I was standing a couple of feet away from a very large tiger. However, I thought it was worth a try; I would probably get a first-class picture of an angry tiger – posthumously!

So it was arranged. The meat was brought in, and we allowed Zharif to tuck in and settle for five or ten minutes. Then, with the camera ready and my finger on the button, we counted, and his lunch was unceremoniously pulled away just in front of me.

Absolutely nothing happened, except that the tiger looked up at the keeper with a smile all over his benevolent face, as if to ask for his lunch back. It seemed that the whole thing was going to be a disaster. We then trod on poor old Zharif's front foot and he didn't mind that either; just more smiles. In the end, we had to resort to prodding him with a stick and that did in fact produce one very angry snarl which, miraculously, I managed to capture on film. He then started smiling again. I shook him by the paw, explained all about the World Wildlife Fund's Operation Tiger and the plight of his wild cousins in India. He seemed to understand, because we parted great friends.

I have already described how, on my first day of art training, one of the many misconceptions about painters, that they can only paint when they are inspired, was abruptly shattered. Nevertheless, inspiration does sometimes come, and with this whole exciting project I actually had two inspirations in the same evening, one following fast on the heels of the other. I was in my bath at the time. That is always the best place to relax and think of the things that really matter in life, such as tiger conservation. It occured to me that if we ran off a single limited edition of 850 signed and numbered prints of the painting, and gave all these to the World Wildlife Fund to sell, and if we charged £150 for each print, that would bring no less than £127,500. Then it came to me that if we put a lucky number on one of those prints and that person won the original painting free, that would be an added incentive. It was, and all the prints sold in six weeks. I invited Prince Bernhard of the Netherlands, the Fund's International President, to the final ceremony. After drawing the lucky number out of the hat, and without any warning, the Prince presented me with his special and personal award, the Order of the Golden Ark, for services to wildlife, in particular to Zambia and to Operation Tiger. It was one of the greatest thrills of my life.

'Tiger Fire' raised nearly a quarter of the total amount, worldwide, that the World Wildlife Fund hoped to raise for Operation Tiger. To cap the project nicely, and at the request of the Indian Government, I did a second painting which I took out and presented to the late Mrs Gandhi. She was completely dedicated to wildlife conservation and I was privileged

to meet her and hand over the painting, which raised a further substantial amount of money to save this beautiful animal.

It was inevitable, I suppose, that following the huge success of 'Tiger Fire', many different charities would ask me to do a similar scheme for them. The phone started to ring immediately, and one of the first to contact me was the Royal Air Force Benevolent Fund. I owe a huge debt of gratitude to the Royal Air Force because they started me on my wildlife painting career, so I felt that this would be a wonderful opportunity to repay some part of that debt. I suggested that I might paint a Lancaster, which happens to be my favourite aircraft. The reasonable comment from the fund was that they didn't really mind which aeroplane I painted as long as it hopefully would raise a large amount of money. I pointed out that, in order to paint a picture of any aircraft, it is essential to fly in it. This is not strictly true, but I saw this as an opportunity to actually fly in 'City of Lincoln', the one remaining Lancaster bomber that is maintained in full flying condition and owned by the Royal Air Force Battle of Britain Memorial Flight. It was, needless to say, a highly emotional experience for me. Indeed, I was so excited that I could hardly think straight as I sat in the mid-upper turret, with the Spitfire on one side and the Hurricane on the other. At times, the two pilots nudged up to the Lancaster so close that I could see the expressions on their faces.

The anecdotes and stories behind the setting up of this painting and its successful completion could fill a whole book. I could have gone to the Imperial War Museum and browsed through their library of many hundreds of photographs of such scenes taken at Lancaster dispersals during the war. However, this is not my way of doing things. However authentic that might be, I wanted my own ideas. I received the fullest co-operation and was allowed to 'borrow' *City of Lincoln* for three or four days at Coningsby, Lincolnshire, where the Royal Air Force Battle of Britain Memorial Flight is based. I wrote to a group called The 39–45 Military Vehicle Group. They collect and cherish World War II vehicles of all shapes and sizes, just as I have a penchant for collecting steam locomotives. A vicar produced a 1943 Hillman pickup, the type used as a station 'hack' by squadron and station commanders. We found a genuine refuelling bowser of the period. An oiling vehicle was towed out of a farmer's field; he was feeding his pigs from it. The Royal Air Force even found some World War II bombs on a genuine trolley of the period, together with a tow tractor, a motor bike, and a 1940 bicycle.

We set the whole scene up at Coningsby. I took a large number of photographs and did a number of sketches over the four-day period, moving everything around to my heart's content, to get everything right. Behind the 'Lanc' was a hangar full of Phantom jets; I put in some elm trees instead. An artist's task is so much easier than that of the photographer!

At the end of the four days' sketching and photographing, during which time the weather was perfect, I suddenly realised that a wet runway, creating the effect of an evening shower, would give me vertical reflections and create further atmosphere. As it had no intention of raining, I asked the Station Commander if we could borrow the airport fire tender. The crew drove over and deposited five hundred gallons of water on the runway below the Lancaster, accompanied by a few muttered oaths of protest. It seemed they were just about to go off duty and had decided that all artists were completely mad; but it was all wonderfully good humoured and I got my reflections and the mud which, I was told, was so much a part of World War II bomber stations.

All of us who owned vehicles and equipment were put up in the Officers' Mess at Coningsby for the period of my research. We were all offered expenses at the end, and one of my happiest memories of this whole project was of the vicar who owned the staff car. On being offered petrol money, he held up his hand and, beaming all over his face, said, 'It is enough reward to me to have my Tilly [why are Hillman staff cars always called Tilly?] under the wing of that beautiful and memorable aeroplane.'

For me, the most poignant memory, however, was of the evening after I had flown in the Lancaster itself. After dinner in the Mess, I asked the Station Commander if I could go on my own into the hangar where she had been put to bed. He said, 'Here are the keys, you can let yourself in but don't pinch any bits off the Phantoms.' Whilst I get fairly excited by

modern jets, the Lancaster was the aeroplane for me. I let myself into the hangar, walked past all the Phantoms parked at one end and there, at the other, was the dim outline of *City of Lincoln*. There was one light on in the roof of the hangar and, standing in the gloom under a wing, the feeling was almost indescribable. Having flown that day, the four Merlins were still ticking as they cooled. I was too young to fight in World War II, but it was at that moment that I could feel for those who flew the greatest bomber of World War II and understood why they had such an affection for her.

When it became known that the Royal Air Force Benevolent Fund was going to produce 850 signed and numbered copies of the painting, I received, in one week, two letters from ex-Lancaster pilots, both of whom expressed a strong interest in the project. However, so strong is the feeling on the part of each 'Lanc' pilot for his own particular machine that they both made it quite plain that they would only buy a print if it showed 'their Lanc'. 'I did thirty-eight ops in M *for Mother*, I don't want any other Lancaster.' *F for Freddy* was my Lanc, it got me back from Cologne on three engines; I will only buy the print if it is *F for Freddy*.' The answer was simple. I placed the oiler in front of the fuselage where otherwise the code letters would show and the evening sun is shining on the nose where, again, the identification letter used to be painted. Both Lancaster pilots bought a print!

The painting, which I called 'Winter of '43, Somewhere in England', raised £95,000 for the Royal Air Force Benevolent Fund in a few weeks. If the buyers of the print were prepared to pay an extra £100 to the fund, they received the signatures of Dr Barnes Wallis, inventor of the 'bouncing bomb', and Marshal of the Royal Air Force, Sir Arthur 'Bomber' Harris, Commander in Chief Bomber Command, 1942–1945. A total of 176 people took up this option, and I had the thrill and privilege of taking the prints to the homes of these two great gentlemen, spending a day with each of them while they were signing. Moreover, my print, No 1 of the 850, has Leonard Cheshire's signature on it as well, and is therefore unique. I have that print hanging, framed, in my hall; the original painting lies against the wall in my studio covered in dust, because it

is that much bigger and won't fit the wall. No wonder people call artists a bit crazy.

People said, after the publication of this painting, 'Aren't you marvellous, David, doing all that for the Fund?' Not at all; I had the fun and thrills of flying in my favourite aircraft and met some wonderful people; if in the process, a bit of money can be raised, then that's OK by me.

I have mentioned my enormous debt of gratitude to the Royal Air Force. Perhaps it is some sort of a record for a civilian to be able to say that he has flown in thirty-two different types of aeroplane, most of them military. For me, all this excitement goes back to the early days when the RAF started taking an interest in my work in the 1950s, and then flew me out to Aden. As I made friends in the service, I began to get more and more commissions.

I did several paintings for No 3 group, RAF Bomber Command. These paintings, of V-bombers, certainly gave me some of the most thrilling experiences that I have ever had. The first and possibly the greatest challenge was to paint an in-flight re-fuelling subject. I naturally had to see this for myself as I knew that it would be quite impossible to paint such a complex subject otherwise.

First of all, permission had to be obtained from the Ministry of Defence for me to fly in the aircraft concerned as the Valiant, Vulcan, and Victor were our first-line nuclear deterrent and tight security was involved. Then I had to pass the statutory and fairly strict medical examination to see if I was fit enough. (I believe that the theory was that it would be cheaper to kill me on the ground than in an aeroplane costing many millions of pounds!) I therefore had to go through a decompression test to see whether I would survive a partial decompression if, for instance, a window might blow out of the V-bomber at 30,000ft. I went to RAF Bassingbourne where they had the appropriate equipment. I was told what the RAF proposed to do to me and what I had to do if, as 'never happened', there might nevertheless be a malfunction or an emergency. They shut you in the chamber, and then a chap outside works a lot of dials and simulates the effect of you descending with incredible speed from 30,000ft to ground level.

They shut the door, and I sat in my pressure suit opposite an RAF officer going through the same treatment who, presumably, had done it all before; he was calmly reading *Country Life* while I was shaking at the knees. I was in contact with the man outside and, when asked if I was OK, which I was, he sent me up to 30,000ft. Everything was fine until he pulled the switch to 'blow the window out of the plane'. The pressure on my head immediately became so intense that I was sure I was going to die within seconds. I was yelling to the operator outside to let me up again, but nothing was happening. Then, by sheer chance, the officer opposite happened to look up and, noticing my impending and immediate doom, told them to send me up again quickly!

It turned out afterwards that my communication with the operator outside had become faulty and nobody knew that they were killing me. With apologies all round, the operator said, 'If you can survive that, you can survive anything – you're OK.'

I then went through the pre-flight briefing to ensure that I was aware of what was involved. After all, I was in effect becoming a member of a crew of a multi-million-pound jet bomber. It was all quite fascinating but way above my head. All the technicalities of my oxygen equipment and so on were explained to me – I couldn't understand a word of what he was talking about. I was then told to strip to my underpants by a flight sergeant and while he seemed to be talking fifteen to the dozen, various items of equipment were heaped on to my protesting and inexperienced frame; my pressure suit, my parachute, bone dome, oxygen mask, and lots of other things which I thought it was probably best to ignore as I wouldn't have understood them anyway. As he was dressing me, he was telling me what I should do if I had to bale out at 30,000ft.

'Don't pull that ring until you twist that thing, and then when you have done that, punch that lever, but don't do that until you have done the other thing.' This seemed to go on for an interminable amount of time and none of it sunk in. I need not have worried, however, because – but at the end of it all – he said, 'You'll freeze to death anyway, so don't worry.' That would not have happened, of course. After painting so many pictures for the three services over the years, I knew that this light-hearted attitude was simply to put you at your ease. In fact I have always had complete confidence in the total dedication and professionalism of all involved.

The first flight was in a Valiant late in the afternoon, to show me the procedure. We took off as the evening shadows were lengthening and within minutes we were high above the clouds as the setting sun sank over the horizon. I will never forget one of the most beautiful sights I have ever seen from an aeroplane. We were in a flight of three and I was flying alongside two other Valiants, one giving fuel to the other. The aeroplanes were now a bright pink in the setting sun and, because of the great height at which we were flying, our contrails were a bright pink plume trailing from behind the aircraft. I had my movie camera with me and that little piece of film must, I suppose, be quite historic. It is indeed a treasured memory of a unique experience.

A few days later, I flew in another Valiant for a seven-hour sortie which gave me the opportunity to do the full research for the painting. I had to paint the whole scene from the cockpit of my Valiant as we were taking on fuel from the tanker just above us, in the dark. It was quite a challenge because everything has to be absolutely correct.

As before, we took off just as it was getting dark. The conditions were very cramped in a Valiant and I had to sit on a sling attached between the seats of the pilot and the co-pilot. After a couple of hours, the strain began to tell. Apart from all the equipment that I had heaped upon me, I had my movie camera for the early part of the flight, plus my sketch book, equipment and a torch.

It was so exciting sketching that I could hardly concentrate on anything. In the pitch dark we nudged up ever closer to the Valiant above us until we were only 40ft below the tail, both aircraft flying at approximately 400 knots. The whole of the underneath of the tanker aircraft was floodlit and, as the drogue floated in the dark towards us to attach itself to our probe, the pilot's hands were on the throttles to ensure that we were flying at precisely the same speed as the tanker. We made perfect contact the first time, as I expected. Towards the end of the flight I began to feel very queezy and I only just avoided disgracing myself before we landed.

The following morning, I sat in the cockpit of a Valiant on the ground with the captain. Then, going across every single dial and gauge, he told me where each needle should be. The painting had to be scrutinized by the Ministry of Defence on completion to make sure that I was not giving any secrets away to the Russians, though they probably knew it all anyway! I painted the picture, and as on so many other happy occasions, it was unveiled at a guest night in the officers' mess.

As I have already pointed out, I have to avoid simply creating a colour photograph. Particularly when I am involved in a painting of such technical content, it is essential to inject some 'humanity' into the work. Furthermore, I don't believe that any machine, however well and professionally maintained, can always be absolutely perfect. That is why I deliberately dropped the revs on the port inner engine of my Valiant. I did it to make people look at the painting. It always works! After dinner in the mess, the painting was unveiled in front of the large assembled gathering. The curtain was pulled aside and for a few minutes there was the inevitable silence. Then, on the instigation of the station commander who had already seen the painting and passed it absolutely correct, there were various nods of approval. However, a young flight lieutenant who obviously wanted to show off his technical knowledge – or simply wanted to show off – said 'I notice, Sir, that David Shepherd has got the revs a little low on the port inner engine'. Before anybody had a chance to say anything at all, I said, 'They were'. With laughter all round, he was firmly sat upon.

After this exciting experience, I had a number of flights in the last of the V-bomber trio, the Victor. However, I was by now getting more and more involved with wildlife commissions and doing fewer paintings for the services. There seemed little chance of actually being commissioned to paint what I regarded as the most exciting and glamorous of the V-bomber trio, the much-loved delta-winged Vulcan. Time was slipping by fast and this marvellous aeroplane was coming to the end of its 25-year service life. I was all the more determined, therefore, to be one of the very few civilians to have flown in all three V-bombers. I therefore decided to telephone a friend in 35 Squadron at Royal Air Force, Scampton, and see if I could cadge a lift. I was not sure of the response. Of one thing I was sure however – whether it's the Royal Air Force or anyone else, the best chance of success is usually through the back door. Avoid, if possible, asking for anything officially because the answer will probably be no after four or five years, when it will be too late anyway. Once again, it worked.

'Of course, my dear chap, I am sure that we can arrange something – come up and see us next week when we are going on a seven-hour training sortie.' I am not sure to this day whether the Ministry of Defence ever found out; it all seemed so incredibly easy. I drove up to Scampton. I had already had the decompression test and, although I was now many years older, they did not bother with trivialities like that. They simply put me in the Vulcan simulator and demonstrated what I would have to do if there was an emergency. There is no ejection seat for an extra person in a Vulcan; a trap door in the belly of the aircraft opens and you fall out! I fell out from the flight simulator onto a mat and this was, I thought, potentially far more dangerous than the actual decompression test.

Once again, after the statutory pre-flight briefing, we all piled into our Vulcan and off we went. An extra crew member in a Vulcan has to sit sideways several feet below the pilot and co-pilot, facing the opposite wall in the belly of the aircraft. Within minutes I was feeling queezy, and within half an hour, I was being violently air-sick. I was utterly miserable. When one is suffering to an extreme degree from this affliction, suicide is the first thought. However, they would not let me bale out; the flight was seven hours, and that was that. No way could they turn back to base simply for a sick passenger. It was particularly sad because of where we were going. We were scheduled to fly over the Isle of Skye. A great friend of ours who is a retired admiral lives in a beautiful little croft on this lovely island and I had rung him up the previous evening to tell him to look out for a Vulcan flying over his roof. I would be in it. I told the crew this. As we were approaching the island, the pilot and co-pilot beckoned to me to climb the ladder and have a look. It was tragic, because by now I was feeling like death. However, with a supreme effort, I climbed the ladder. I will never forget the sight. First of all, our Captain asked me particularly not to look

at the altimeter. Intending to give my admiral friend a surprise, we were, I was told, flying a little below our permitted altitude – to put it mildly! In fact, it seemed that we were going to whip the tops of the waves as we zoomed up in to the island between the mountains. We then flew over a ridge right over Roddy's croft, just as I had to collapse rapidly down the ladder, once again to disgrace myself.

When we landed back at Scampton, I was feeling more dead than alive. However, as one does, I recovered very quickly and was my old self within half an hour. The flight crew were super. 'If we had told you what it was going to be like, you would never have come with us.' Apparently, most passengers in Vulcans are air-sick and I was told that the previous passenger they had taken up, a very senior German Air Force Officer, had disgraced himself all over the aeroplane. At least I had confined myself to the sick bags and I was told that I was the cleanest and best-behaved passenger that they had ever had! I would not have missed it for worlds.

A much later experience that I have had with the Royal Air Force emphasises once again the very close association all my life seems to have with wildlife conservation. I was in Germany as a guest of the Royal Air Force Police, raising money for the World Wildlife Fund, and I was doing two of my talk shows. The evenings collectively raised £7,000 for the Fund and, at the end of the second evening, a guest in the front row of the audience came up to me and said, 'Jolly marvellous raising all that money to help save elephants, David. Would you like a flight in one of my Harriers tomorrow?' Although he was not in uniform, I had done my homework and knew that he was the commanding officer of 3 Fighter Squadron, RAF Gutersloh. I was longing to fly in a Harrier jump jet and if he had not offered, I would have probably asked anyway.

Once again, I had to have a medical. I was passed as fit by the medical officer, who simply tapped me with his stethoscope and said, 'You're OK.' That pleased me no end because I am quite convinced that I am the most geriatric person to have flown in a Harrier. The following morning, I was flying around the skies of Western Germany for a couple of hours – for part of the time actually flying it. Particularly memorable was the moment just as we were coming in to land; by this time, I had naturally handed over the controls to my pilot but just as we were about to touch down with the runway coming up towards us, he said, 'Shall we stop, go backwards, and do that again? The Royal Air Force are certainly very good friends.

A few weeks after the success of 'Winter of '43' the telephones rang again. This time, it was a call from the Fleet Air Arm Museum at Yeovilton in Somerset. As one of my ambitions had, for years, been to go onto a great aircraft carrier at sea, and we only had two left anyway, I thought that this was at long last my chance – my last chance – to 'play' with the *Ark Royal*.

In 1978, HMS *Ark Royal* was coming home from the Mediterranean on her final journey to the scrapyard. The Navy arranged for me to fly out to Malta, and I joined the great ship there to spend five days on this her last journey. To someone like me, the flight deck of an operational aircraft carrier at sea was so full of excitement that I could hardly think straight. Gannet aircraft seemed to be coming from around every corner, and every few seconds, it seemed, a Buccaneer or a Phantom was either being catapulted off the deck or was storming in and landing on the arrester wires. Everywhere, aircraft seemed to be moving around folding and unfolding their wings, and coming up from the inner depths of the ship on the lifts. I spent most of those five days in the Air Sea Rescue helicopter which, whenever flying was taking place, always had to be in attendance in case of a 'ditching'. I sat in the helicopter several hundred feet above the *Ark* sailing below me through a calm, blue Mediterranean. Although it was a memorable sight, the unfortunate thing was that, suffering from vertigo, I was scared out of my wits in case I fell out. But the Navy said, 'Never mind, you have a sling round your waist, so if you do fall out, we can always just haul you back in again!' Swinging below a helicopter on a wire is not my idea of fun and, fortunately for me, this did not happen.

If I have an inflated ego, I believe that it was this experience on the *Ark Royal* that is responsible. I have never worn a uniform in my life, so it was all the more of a thrill, as a mere civilian, to ask the captain of the 50,000 ton carrier to steer in

a different direction, and then watch while he did it. I had noticed, for instance, that the shadow cast by the overhang of the flight deck on the hull was creating some fascinating shapes, and it occurred to me that if the carrier swung a few degrees to starboard, this might inspire some further ideas for the painting. In radio contact with the captain via the helicopter pilot I asked, therefore, if he could turn just for me, and minutes later the great ship started to swing round. I got carried away with this and, by the end of five days, when the captain and I were on Christian name terms, I was well and truly 'playing' with the *Ark Royal*. On one occasion the sun was in the wrong position and, as it was easier to move the ship than it was to move the sun, Captain Anson began turning to go all the way back to Malta. On being flown off in the helicopter at the end of my stay as his guest, to fly home from Italy, I apologised for all the trouble I had caused. 'Don't worry, David, it gave the navigator something to do, going home in a zigzag instead of a straight line!' The Navy are super people.

When the arrangements were being made for my visit to the *Ark Royal*, I asked if we could have the Russian spy ship in attendance. The world knows that wherever the *Ark Royal* used to go, a Russian trawler, ostensibly fishing but in fact bristling with antennae and aerials of every possible description, was always hanging around in case it could glean any military secrets. With typical British aplomb and diplomacy, an official signal was sent from Yeovilton to the Captain of the *Ark Royal* stating, 'Artist requests Russian guests to be in attendance'. In fact, the Russian's didn't turn up. I can only assume that at this stage in her long career, the Russians knew everything about the *Ark*'s technology anyway.

I enjoyed the most wonderful hospitality on the *Ark Royal*, and did a couple of talk-shows for the World Wildlife Fund in the wardroom – conservation getting mixed up with everything once again. This raised a good amount of money from the crew, who were all very responsive. The only thing that I didn't like was the early morning tea. I have never served in the Navy but I suppose if you do, over a lifetime you get used to it. I can drink almost any type of tea in any place, but the stuff that was poured out of a bucket into a tin mug at 5 o'clock in the morning was

indescribable. But there was a touch of light relief while I was on board. The wardroom piano (stolen from the RAF a few years previously) had come to the end of its useful life. It was solemnly carried at the slow march to the catapult, accompanied by funeral music from the ship's military band and, at a signal from the captain, was given a burial at sea with full military honours. There was hardly a dry eye on board at that moment – I only wish the Russians had been watching.

The principal challenge when painting any aircraft carrier for the Royal Navy or aircraft for the Royal Air Force, is to meet their demands for accuracy; the aircraft or the ship has to be the right shape. The Navy are perhaps the most demanding of the three services, and I had to have the painting of the *Ark Royal* scrutinised by the captain before it went to print. It was inevitable that I had made a few mistakes. For example, I had painted the jet-pipe intake covers on the Buccaneers on the after part of the flight deck as little touches of red, but as I was told that their engines would be running I had to paint these out. I had also included a little yellow tow truck in front of one of the Gannets on the flight deck, but this also had to go. There was also another problem. I suspect that, because of her age – and she was showing it – the *Ark* had some difficulty in reaching maximum speed; but I had to see what a bow wave looked like when the prow of a great fleet aircraft carrier is cutting through the sea. This was impossible with the *Ark*, so, after my return home, I was given HMS *Bulwark* to 'play' with! It all fitted in very well. HMS *Bulwark* ('old rust bucket' as she was affectionately known by her crew) was scheduled to sail from Portsmouth on a visit to the United States, and I joined the ship on her departure and spent that night on board as guest of her captain. Once again, I took the opportunity to do a film and talkshow, and raised some more money for the World Wildlife Fund. It was arranged that early next morning I would fly off in a helicopter and photograph and sketch *Bulwark* going fast around Mount's Bay in Cornwall – again, especially for me! I don't suppose that the stokers thought much of it, but I was rewarded with the most magnificent sight. There was the 'Old Lady' going flat out below me, creating just the bow wave I wanted, and which I put in front of the *Ark Royal*.

I would suggest that there are more misconceptions about professional artists than almost anyone else. One, as I have already suggested, is that we are supposed to be able to paint only when we feel like it. It is, in fact, a business, seven days a week, although I love every minute of it and, thanks to Robin Goodwin and his training, 'I eat, sleep and think' painting every breathing moment.

Robin made another point when I was with him. I should never let a painting 'beat me'. If I had the idea that if a painting was going badly I could simply shove it up in the attic and start another one, the time, paint, and canvas involved would all be wasted and these things, particularly time, were expensive. The temptation to give up is sometimes very strong. However, Robin taught me the self-discipline to fight until I had won. Because of this training, I almost never do let a painting beat me and this means in turn that I have almost nothing in my attic where we keep all the other family junk.

Because of the apparent ease with which I seem to be able to raise money for charity – which is super – by giving a painting, I am asked to do so with ever-increasing frequency. The point that does rather aggravate me is that when I inevitably have to say no far too often, a surprising number of charities then write back and say, 'But surely you must have something in your attic.' I then have to point out that there are probably only a couple of oil paintings in my attic at any one time and that they are only there because they are so awful that the battle was lost right from the beginning. In those circumstances, I am hardly likely to let anyone see them, let alone sell or give them away. It would be more than my reputation and pride was worth.

There was one exception to all this many years ago which I remember with some amusement. An extremely persistent American client visited us and asked if I had anything available. I was by now at the stage when I was working on commissions for several years ahead and there was no chance of him being able to go away that evening with a picture under his arm. Then he asked if I had anything 'in the attic'. I told him that there was just one wildlife painting there. It was there because it was too ghastly to show anybody. We had a few drinks and, after supper, we both went up into the attic, pulled the

painting out from the corner and put it on the floor. I remember it with horror. The painting consisted of two rather stupid-looking lionesses gazing at me, with a big male lion in the middle. My American friend suddenly said, 'Why don't we just cut out the lion in the centre and I'll take that?' I got a razor blade and ripped through the canvas, leaving the two soppy lionesses with a hole in the middle. We both realised that the painting was infinitely improved. I was happy, my American friend was happy, and the lionesses are still up in the attic, now with the hole between them.

It was in 1967 that the success of my jumbo paintings was to play a rather unexpected part in my success story. I have described already how, in 1955, I painted a number of pictures of the interiors of steam sheds, and these are now part of the

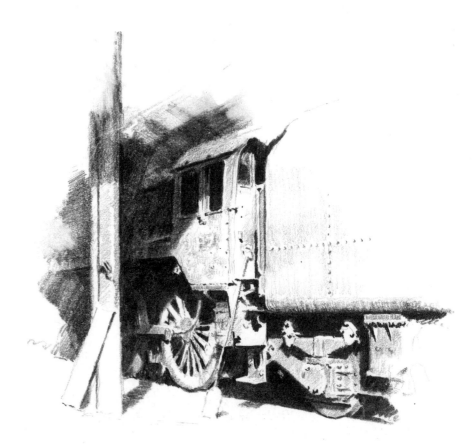

national collection in York Museum. From then on, however, until 1966 I had been too preoccupied with earning a living to give railways a thought. In any case, they were all around us – perhaps it is human nature to only notice a thing when it has gone. Then, in 1967, it dawned on the many railway enthusiasts in Great Britain that our steam age was dying fast. For my part I was painting to commission all day long but the magic pull of Guildford and Nine Elms locomotive sheds, then in their death throes, finally became irresistible. I found myself dashing along to Guildford in every spare moment to record on canvas in a last feverish rush something of the fast-vanishing steam era.

One of my best known railway pictures came out of those hectic days at Nine Elms. 'Nine Elms, the Last Hours' portrays the very final minutes of steam in the south of England in July 1967. Meanwhile, it was at Guildford and Nine Elms that I got the preservation bug. I was meeting enthusiasts who, like myself, were desperate to try and save something of our steam age. I began to dream of owning my very own steam locomotive. Now, so many years afterwards, the very thought makes my hair stand on end!

In 1967 I had a major one-man exhibition of wildlife paintings in New York which sold out on the first evening. In a state of euphoria, and acting on impulse, I picked up the telephone and spoke to a senior friend of mine in British Railways.

'I want to buy two steam engines, Bob.'

'Why on earth do you want two?'

'Because two are more exciting than one!'

I must have sounded completely mad to British Rail, but then there were plenty of lunatics around like me at that time. We were buying engines as though they were packets of cornflakes. British Rail deserves the greatest credit for taking us seriously. 'You're in luck, David, we have just overhauled 92203, she's probably the best Standard 9 we've got so you can have her.' So, as a result of that telephone call, I found myself the proud but totally bewildered and slightly frightened owner of two enormous steam locomotives. Number 75029, built in 1954, had cost me £2,200; number 92203, just eight years old, brand new, cost just £3,000. Both locomotives were in full

working order and a great number of spares were thrown in for good measure through the kindness and support of the employees that I had met in British Rail – but that's another story.

Several months later I went up to Crewe South locomotive shed in Cheshire, where my two locomotives has been dumped for my collection, and panicked. I had no money left, no home to go to, and an eviction order to get rid of them. Locomotives weighing 130 tons in full working order are very heavy indeed and not that easy to take away!

It was through one of those funny twists of fate that a first home for my locomotives was found. The Army operated the Longmoor Military Railway in Hampshire very near Bordon, and it was for Bordon Garrison Church that I had painted my picture of Christ, which appears in this book. It was during the research for that painting that I met an army officer who happened to be stationed at Bordon and who was also a railway enthusiast. It was through him, therefore, quite unofficially in the first instance, that the locomotives had a home to go to.

The two locomotives steamed down through the Midlands from Crewe to Longmoor on the weekend of Saturday and Sunday, 7 and 8 of April 1968. It was a momentous occasion. Many thousands of people lined the route and I wonder now if, perhaps, some of us began to realise even in those early days the potential that steam locomotives would prove to have as tourist attractions in the future.

The scheme to save the Longmoor Military Railway failed and we had to leave. The long struggle to find a permanent home then started. A number of my friends had joined me from the very early days and we looked at no less than thirty-one different places before we found a little village in Somerset called Cranmore. We did not start with very much. We had a derelict station and signal box and two acres of land covered in stinging nettles and old corrugated iron. Since those days in the early 1970s we have built a magnificent Victorian steam locomotive shed and workshop, we now own three miles of track, have fully restored the station, and we are a registered charity. The whole of this operational steam railway, which is open to the public every day in the summer and on weekends, runs a regular

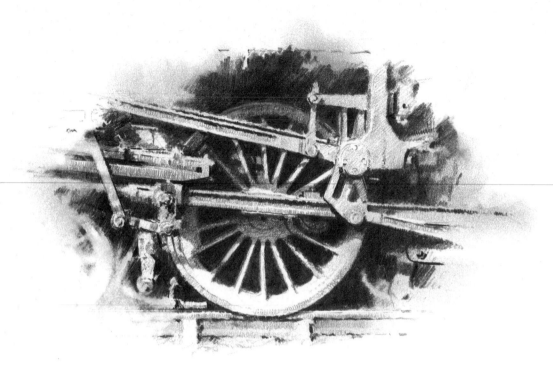

steam-hauled passenger train service, operated by a dedicated and enthusiastic team of volunteers and gives pleasure to many thousands.

The two halves of my life, the preservation of steam locomotives and the conservation of wildlife, came together on 20 June 1975. On that day, my friend Prince Bernhard of the Netherlands, then the International President of the World Wildlife Fund, came over from Holland to open the railway officially, and it was all in aid of the World Wildlife Fund. We raised some £7,000 on that afternoon and afterwards a friend of mine wrote to me: 'How very appropriate to have such fun running up and down with your two steam engines, to help save elephants.' I am proud and thrilled that I have been able to set this enterprise up and if it had not been for the success of my elephant paintings I would not have been able to buy *Black Prince* and *The Green Knight* in the first place. No wonder I am crazy about jumbos.

I suppose it was inevitable that eventually my passion for preservation of steam locomotives would spread to Africa but I never dreamed of the extent to which this would happen. It was in 1971 that I took on a World Wildlife Fund project which was to buy a Bell Jet Ranger helicopter to present to Zambia to combat poaching. I took seven of my paintings out to Reno in Nevada and, together with other paintings and items donated by generous people and organisations, we raised the money in twenty minutes. A few months later I flew out to Zambia with the dismantled helicopter and presented it to President Kaunda.

It just happened that at this time the Zambezi Sawmills Railway was closing down. I first became acquainted with this extraordinary old railway on my first visit to Zambia in 1964.

I was driving away from the Victoria Falls and back to Livingstone when I noticed a railway track crossing the road at right-angles and disappearing into the distance. Running alongside the line which, to put it mildly, looked as though someone had dropped it from a great height, was a dirt road. I drove up it. I soon came to a group of ancient and dusty wooden buildings, one of which was obviously a locomotive shed built of massive timber supports and beams with a tin roof. Behind it stood a tall and shady palm tree. A beautiful jacaranda tree was in full flower just behind the wreck of an ancient steam engine standing up on piles of wooden blocks with all its wheels missing. A corrugated-iron water tower was covered in bougainvillaea in full flower. Inside the two-road shed there was even an inspection pit although it was full of water and frogs.

Locomotive bogies, wheels and axles were everywhere, all disappearing gradually in the long dusty golden grass of an African dry season. The sun caught the maze of cobwebs which were enveloping these various pieces of railway equipment, strewn in total disorder wherever I looked. Other cannibalised engines in various states of decay were lying around, some leaning over at precarious angles and looking as though they would topple at any moment. They were resting on a track that has long since disappeared into the vegetation and sand. Some had sizeable trees growing through their cabs or through the gaping cavities where the driving wheels once turned. The searing hot sun of the many African summers had burned the sides of the tenders and, under the peeling and faded paintwork, the lettering of past owners was revealed.

I kept a watchful eye out for snakes. I had been told that the old locomotives and coaches provided a cool and shady resting place for many a cobra wanting to escape the hot African sun. Honey bees were nesting in one of the holes from which the plugs had long since disappeared. I fought my way through the cobwebbed undergrowth and climbed up on the cab of one of the ancient engines. Here was the greatest surprise of all. The engine was complete, with all the gauges and fittings. Most of the locomotives still sported their whistles and, on their buffer beams, the heavy and beautiful solid cast-brass number plastes. Obviously these items didn't have the intrinsic value that they had in England – back home, everything would have been stolen months before.

Being an inveterate collector of such items, I went back to the main offices of the company, another collection of dusty wooden buildings. I asked the general manager whether it might be possible to have some of the number plates off the 'old engines in the scrap line'. His answer amazed me: 'Yes, I'll get someone to take some of them off for you but I would like to point out that the engines are not in the scrap line. When we get around to it, we will tow them up to Mulobezi and give them an overhaul.' Then, with an absolutely straight face, he went on to say: 'But you know, the problem is, it's awfully difficult to get the spare parts.' Considering the locomotives dated from 1896, I wasn't the least surprised!

The Zambezi Sawmills Railway used to use a fleet of ancient cars for getting around the system. These were adapted in a highly precarious fashion to run on the rails. When the BBC and I made the documentary 'Last Train to Mulobezi' in 1974 which told the story of the railway, we resurrected one of these old cars, a 1938 Ford Prefect. We just about got it going for a few hundred yards when it finally expired once again, to return finally to the scrapline forever. On completion of the film, the sawmills at Mulobezi closed down and the rolling stock of the railway was dumped in the bush. I could not bear to see this and, with the blessing of the President, No 993, built in Glasgow in 1896, and still in full working order, became mine. I also acquired, for a knock down price, the *Queen of Mulobezi*, their main line Class 10 built in Glasgow in 1922. A beautiful

1927 sleeping car, still complete with its mahogany panelling and green leather bunks, was thrown in for free.

There I was with two large steam locomotives and a coach in the heart of a landlocked African country. How on earth could I get them home? We started investigating the possibility of taking them over the bridge into Rhodesia – the famous Victoria Falls bridge which spans the Zambezi River and forms the border between Zambia and what was then Rhodesia. This border was one of the most delicate in Africa at that time, dividing as it did black Zambia from white Rhodesia. Although the local customs officials in Zambia assured me that my new acquisitions could be classified as my 'personal affects' – all 200 tons of them – and that there would be no problem in getting over the bridge although it was officially closed, I did realise that some higher authority was surely needed. Fortunately, through knowing the President so well, I was invited out to talk to him when he was taking a brief and well-earned holiday in the Luangwa Valley. The result was his personal blessing to my request to take my engines 'over the bridge'; this took the form of a state document, for 'immediate action from the Office of the President'. Consequently, with the help of everyone on both sides of the border, the locomotives and coach made their historic journey over the bridge and down to Bulawayo. There, the Class 10 had reluctantly to be stored and it is now back in Zambia forming the nucleus of the new railway museum in Livingstone which the Zambian government has set up. The Class 7 and the coach journeyed down through Mozambique to Biera for shipment back to England – fortunately a very generous friend of mine paid the bill for all this! At last they reached Manchester and have found a temporary home at Whipsnade Park Zoo. Eventually, the Class 7 and the coach will come to the East Somerset Railway to add to the immense tourist attraction that this enterprise now is.

Steam railways have certainly become a major part of my life and although I believe that I have obtained my grey hair in the process, I have met some of the most marvellous people that I am ever likely to come across and every minute has been worth it.

There is one particular elephant who, with her friends, has

posed as my model in several of my paintings. Her name is Eleanor. Far too many people think that elephants are dangerous. They are only dangerous if man gives them reason to be so. In fact, not only are they highly intelligent, but they are the most gentle and benevolent of creatures. Eleanor was the leading light in a family of orphaned animals that 'belonged' to David and Daphne Sheldrick. David, until he died a few years ago, was warden of the Tsavo East National Park in Kenya. During the very many years that my wife and I knew David and Daphne at Tsavo, they had become, without choice, the guardians of a number of orphaned baby elephants, zebra, rhino and buffalo. These baby animals may well have been found standing beside their dead mothers who had fallen victims to the tragedy of either poaching or natural disaster, and had been brought in by the tourists to the warden and his wife to look after. The intention was simply to rear these babies until such time that they were able to take care of themselves and then hopefully return them to the wild and natural environment to which they belonged. I came to know Eleanor well from the time when she was a tiny baby to when she had become a fully mature cow elephant. During this period, she did run wild for a time with a herd, but she returned to David and Daphne because she evidently preferred human company.

Although Eleanor had never been mated and therefore had never had a calf of her own, she had a mother instinct as strong as anything that I could ever have imagined. My wife and I were staying with the Sheldricks on one occasion when a tiny baby elephant was brought in by a visitor to the park. The helpless little creature was almost too young to stand, and it was still covered in long thick hairs. She was an enchanting creature. From many years of experimenting, Daphne had probably learned more about handling orphaned baby elephants than anyone else, and had achieved a large degree of success rearing them on an elephant-milk substitute which she put into a squash bottle. In this particular case, she was distraught trying to get the baby elephant to the teat. Eleanor, by now a full-grown elephant, was contentedly annihilating Daphne's favourite vegetable garden. In an attempt to get the orphan to take to the bottle, Daphne thought that she would try some-

thing which she had never attempted before; she went up to Eleanor and, reaching up, pulled her by one ear to where the baby elephant was standing. Eleanor didn't seem to mind. I then witnessed the most remarkable spectacle. Daphne stood between Eleanor's front legs and, with arms outstretched, held the bottle between Eleanor's breasts, hoping that the baby would come by instinct to where the milk supply should be. I then watched a rather bored cow elephant standing placidly with a human in between her front legs with an upturned squash bottle. The idea worked in an instant! As soon as the young elephant had taken to the teat, Daphne was then able to dispense with Eleanor who wandered back to what remained of the vegetable patch, and the baby followed Daphne wherever she went. Sadly, the baby elephant did not survive; but I tell this story to illustrate what wonderful animals elephants are.

I suppose that it is reasonable to assume that any artist who wants to get somewhere in his profession would want to see his work in print. In my case, my progress in prints has followed closely the development of my career. In the days when my work was totally unknown, I inevitably took commissions whenever they came my way for Christmas cards and calendars. Indeed, one major card firm owns some thirty paintings, all of which were reproduced in their Chistmas card range. One of their most successful of mine, 'Ludgate Hill in 1890', appears in this book. Some of these early commissions helped to further my career and from those early beginnings I was able to progress into full-scale fine art prints. Almost at once, some of my paintings were in the top ten popularity charts and pictures such as 'Winter Plough', 'The Last Bales' and 'Elephants at Amboseli' undoubtedly did a very great deal to put my name in front of the general public. Indeed, I mentioned 'Wise Old Elephant' earlier. This must surely be one of the most famous pictures of an elephant ever painted. The publishers reckon that there must be 100,000 copies hanging in people's homes all over the world. It obviously means that a very large number of people love elephants. An interesting point about this painting is that the publishers were very reluctant to publish it at all. 'Do you really think that anyone will buy a print of an elephant?' They did, and it was in the ten top selling prints for at least three

years running, on two occasions proving more popular than Constable's 'Hay Wain' or Canaletto's pictures of Venice.

Whilst I was obviously pleased to have my work sold through the chain stores in those early days, nevertheless there were now some warning signals. Every time, it seemed, that I had a print in the top ten, the publicity I was getting in the newspapers was getting more and more puerile, and was obviously going to damage my reputation. One headline in the *News Chronicle* ran 'Out goes that ghastly green woman (which we all remember) and now, so help me, you're buying elephants.' Because of that journalistic rubbish, I realised that I must now think very seriously about accepting the very tempting offers that were coming my way. Because I had made elephants 'popular', it seemed that every art publisher in the country was trying to jump on the jumbo band wagon. 'We'll offer you a blank cheque for the reproduction rights if you'll let us "do" an elephant.' I knew that if I accepted these would go some way to paying for my four daughters' education; on the other hand, I had to think in the much longer term of my reputation and the demand for my original work which also mattered. I knew that if I over-popularised myself I could very well run the risk of descending into oblivion, following on the heels of several artists who I can think of – some of whom seemed to paint nothing but ducks flying in all directions – and who had already gone that way. I could not run the risk of this happening to me. My art meant far more to me than money. Robin had taught me that. I decided to make the transition upwards into limited editions only. In a way, my publishers were disappointed at this choice but we agreed that I would do one more painting for the mass market. So I painted 'March Sunlight'. I still consider this to be one of my best English landscapes. It was painted with no thought of reproduction in mind, but as a plain statement of fact; a record of a subject that I love as much as any other, the English landscape in winter, with bare elm trees and a watery sun. I delivered the painting to the publishers and I was not a little relieved when their comment was 'That'll make a super print but it will not get in to the top ten.'

Imagine my surprise and feeling of some concern, therefore, when the publishers rang me up at the end of 1967. 'You're not going to like this, David, 'March Sunlight' has just been judged the top selling print of the year.' I waited anxiously for the publicity which I feared would follow. It did, but it was even worse than I could have imagined. Quite the most extraordinary piece of editorial writing appeared in one of the London evening papers under the heading 'Sex Symbols'. In reviewing the print it went on to say, 'The symbolism is obvious to any amateur psychologist. The bursting buds on the elm trees represent awakening sex, and the icy pools of water in the gateway represent sexual longing'. So much for 'March Sunlight' – it has been known affectionately as my sex painting ever since! David Frost read this nonsense and invited me on his TV show and asked me if I could explain this interpretation of my painting. The only answer that I could give him was that I thought there must be a chap on the newspaper's editorial staff who was either a sex maniac or a raving idiot, or both.

I knew that it was definitely time to go into limited editions. It was a decision which brought with it a lot of heart-searching. Worse, I was now getting just a few letters from members of the public who were saying that they couldn't afford my limited edition prints and that I was denying them the chance to buy my work. This made me feel awful. However, I had to do what I thought was right. Now, I do three or four subjects a year in single editions of only 850 signed and numbered copies. While this does inevitably mean cutting out a certain amount of the mass market, limited editions are nevertheless a compromise between those who cannot afford an original painting and those who do not want a print that hangs in everyone's sitting room. I am proud to say that when my limited editions have sold out, they immediately become collector's items of some investment value. More important still, because of this I have been able to raise very large amounts of money for charities which are so close to my heart, with my paintings such as 'Tiger Fire', 'African Afternoon', and 'Winter of '43', Somewhere in England'.

If I have any regrets at all in my life, it is the fact that I do not now have quite enough time to paint pictures just purely for the sheer joy of it. If I was able to take a six-month sabbatical, which I cannot, I would spend the entire time painting steam

railways. I almost never have time to paint these subjects because I am commissioned all the time painting wildlife; but if an artist is lucky enough to be successful in his lifetime, he can't really grumble. The only opportunity I have now to break away from commissioned work is when I paint a picture especially for a limited edition. I can choose the subject, and this has given me in the past three years an opportunity to indulge myself in painting conversation pieces and pictures which remind me of the Victorian age. 'Playtime', 'The Lunch Break', 'The Old Forge', and 'Cottage Companions' are all examples of this new genre. People are saying that it is the 'new David Shepherd'. It is not a new David Shepherd at all; it is simply that I am trying to break away and diversify my subjects just a little.

A number of people often ask me how I work, particularly in Africa. Whilst it would be ideal to paint all one's pictures on the spot, the conditions for oil painting in the heat of an African day are far from ideal. From my experience in the Middle East, I know that within a few minutes, the whole effort would be wasted because the painting would be covered in dust and ruined in the back of a bouncing land rover. In fact, I work from a combination of colour notes, photographs, and sketches. There is nothing wrong with working with the aid of a camera providing that one does not become a slave to it. This

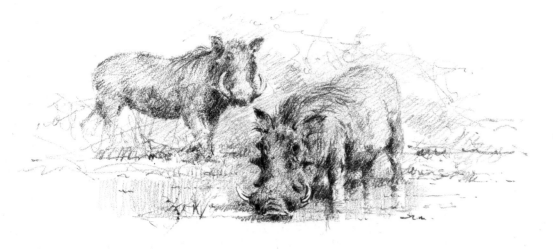

is why I will always insist on working from my own photographs and no one else's. I believe I have been blessed with a very retentive memory, after my marvellous training and thirty years' experience, and I believe that I am now reasonably able to remember the subtlest of colours in a particular part of Africa. All the camera is doing is recording the shapes in front of me. I take literally hundreds of photographs on each visit and, because I know that no one will ever see them, I do not even bother to hold the camera straight. However, I will take just as many photographs of little bits of dead wood and shadow cast by a branch overhanging a river bank as I will of an elephant, because I believe with complete conviction that it is as important to get the habitat right, in which the animal lives, as the animal itself. I was seen on one occasion bending down taking lots of photographs of a particularly attractive piece of dead wood. It was so much more practical than laboriously bending down and drawing what was in front of me. As I was taking the photographs, there was an elephant a few yards behind me watching me, but I had seen elephants in plenty all that day and the wood was more important!

I have, however, painted elephants from life. The BBC decided, a few years ago, to film my life story, 'The Man Who Loves Giants'. They obviously wanted to include an elephant sequence and they said – 'How about filming you walking up to some elephants and painting them?' 'Don't be so stupid – no one has ever been crazy enough to do that.' 'Well, you're probably mad enough, so let's have a try.' It was that marvellous British 'stiff upper lip' spirit – we'll probably all get killed but won't it be exciting?

I suppose it must seem a bit daft to walk up to two bull elephants sixty paces away, carrying a studio easel and a very large canvas, sixteen tubes of oil paint, a palette, brushes, linseed oil and turpentine, then set up all the equipment, and expect the elephants to stand still while you paint their portraits.

We all trailed off to the Luangwa Valley in Zambia – the producer of the programme, myself, my wife, the programme secretary, cameraman, assistant cameraman, sound recordist and three African game scouts. Most important, however, Johnny

and Rolf also joined us. Johnny was head game warden at that time and Rolf was a professional hunter (he has since given up because he couldn't stand the killing any more). From past experience, both of them knew that I am my own worst enemy; I am inclined to get over-excited whenever I see an elephant and we could not afford any possible chance of me doing anything stupid, particularly with a whole team of people around us. Johnny and Rolf both knew more about wild animal behaviour than I ever would in a thousand lifetimes, and I knew that we would be safe with them to look after us.

We all piled into a couple of land rovers and off we went into the bush. I was in the back of the second land rover with everything ready – telescopic legs of the easel already stretched out, all my colours squeezed out around the edge of the palette, and brushes at the ready. Coming round the corner, we saw an elephant about a mile away under a tree, sleepily flapping its ears to keep itself cool in the heat of the midday sun. Quietly we stopped the land rover and Rolf, who was driving, leaned out of the cab and whispered, 'Will that one do?' 'I suppose so.' (I couldn't even see it without my glasses.)

We stopped both vehicles and hid them in the bushes; then a quick run-down of procedures as if in a military exercise – what to do in an emergency, and how to behave. First, the element of surprise; without that, the whole thing would be a waste of time. Elephants have very bad eyesight but, if one is very very quiet, and the wind is in your favour, it is possible to almost walk up and touch an unsuspecting jumbo. As in the old Hollywood films, we picked up the dust to see which way the wind was blowing. It was OK. It had to be because elephants have a very strong sense of smell. (I was remembering at least one embarrassing situation; on that occasion, I must have been at least a quarter of a mile away when their trunks went up, and I had had a bath that morning too!)

We walked as quietly as ghosts. I was carrying my easel above my head. If I hadn't, the legs would have got caught up in the bushes and the elephant would have heard the jangle of the brushes and bottles knocking each other. If a group of tourists had come round the corner at that moment, they would have decided that everybody in Zambia must be raving mad. They

would have seen twelve people in a long line, just like the old pack trains, carrying various large items of mechanical equipment, from cameras to easels, all walking up to an unsuspecting elephant. It worked. We got to within sixty paces, when by sign language, Rolf, who was beside me with his rifle just in case, indicated that I had gone close enough. I could see her eyelashes. It was so hysterically funny; the only sound that the elephant might hear would be my giggling.

The next thing I remember was Rolf suddenly yelling to me, 'Leave your easel and run!' It all happened so quickly. I seem to remember three or four tons of extremely angry cow elephant suddenly running towards me. I dropped my palette, turned round, nearly knocked my wife over, and we all started belting back to the land rovers as fast as we could. I looked over my shoulder and saw the elephant charging flat-out for Rolf, straight past my easel.

Game wardens all react in different ways in situations like this. Some fire in the air. This is almost guaranteed to stop a charging elephant, so I am told. Rolf does not believe in doing that. Both of us hated the sound of rifle shots, particularly in a National Park. Rolf believes in shouting. He is gifted with a very fine deep base voice. However, it was not the resonance of

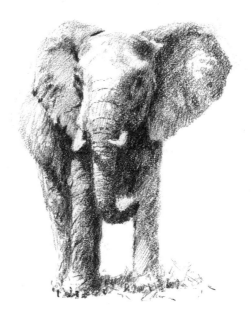

his voice echoing throughout the bush that stopped the elephant in her tracks, it was the obscenity of his language! I am totally convinced that that cow elephant spoke perfect English. I swear to this day that I saw her stop in astonishment and blink her eyes in disgust at the torrent of abuse thrown at her. It worked but only temporarily, because, after she had recovered from the shock, she charged again. She charged four times at Rolf. Everytime she stopped, it gave us more time to get back to the land rovers. Eventually she gave up. Rolf told us afterwards that on the last charge, if she had taken one more pace, he would have had to shoot her, firing vertically upwards, as she was virtually on top of him. Thank heavens that that did not have to happen. I would never have been able to live with myself again if we had had to kill an elephant, in a National Park, just for me to be filmed painting her portrait.

When it was all over, I asked Rolf what I should have done, had I been charged by an elephant on my own, unarmed. 'You'd be dead.' Rolf knew me pretty well and he had as little faith in my strength of character in an emergency as I had. The thing to do, apparently, is to stand stock still. Then, as the charging elephant is getting bigger by the second, one is supposed to take off one's coat and hurl it at the elephant. If this doesn't work, then the ideal thing to do is to actually charge towards the elephant, screaming one's head off and waving one's arms about (I'm not an idealist). Apparently, the charging elephant is so surprised to find that the person that it is charging is actually running towards it, that it doesn't really know what to do, and stops. Running away is certainly a waste of time; an elephant going flat-out can out pace even the fastest runner in a few paces.

Back at camp in the evening, we lit the camp fire and, over a few drinks, started talking about the day's experience. Rolf and Johnny inevitably started telling some wonderful, slightly coloured, stories about tourists caught in emergency situations such as we might have had that afternoon. I asked Rolf, 'What else do you do if you are alone, unarmed, with an elephant coming at you like a steam locomotive?' 'You climb vertically upwards.' Apparently, Rolf said, even with one leg, and aged ninety, even the most geriatric and infirm American spinster can find herself at the top of the tallest tree without even realising the enormity of her achievement, if she has a charging elephant as the incentive. Then came an unending stream of hysterically funny stories about tourists in Africa. But there is no space to tell them here, and some of them I suspect, are hypothetical anyway. One thing I do know: I do not recommend any of this for an aspiring artist who wishes to paint elephants in Africa.

To me, the elephant is a highly intelligent animal, probably more so than most of us, but we know so little about him. I hope in a way that we never solve many of the mysteries about elephant behaviour. There is a mystical quality about elephants and I would prefer to leave it like that. Of one thing I am completely certain; they deserve a better fate than would appear to be theirs at the moment. It is not the fault of the poor old jumbo that he carries on his head a valuable commodity. Far too many people who ought to know better will go to any lengths to deprive the elephant of his ivory using the most appalling methods: poisoning waterholes with battery acid, blowing their feet off with landmines, poisoned arrows, high powered automatic weapons; there seems to be no limit to man's depravity. I have seen a group of sixty elephants bathing in a river, playing with their 'kids', and just minding their own business, meaning no harm to anybody. We can learn a lot from them. It's time that we started. Within my lifetime, this gentle animal could be extinct in the wild and it will be our loss. We can always recreate a Mona Lisa, but we can never recreate a magnificent bull elephant, carrying tusks so huge that he has to lift his head when walking. It is too late for these; they have all gone already. It's time more of us woke up to the fact that 'Ivory Looks Best on Elephants'.

As I see it, almost the only hope for wildlife in India or those African countries that are privileged to have it is to convince the heads of state of those countries that it is a priceless national asset which, if exploited in the form of tourism, can bring in large amounts of foreign exchange which, in turn, will build the hospitals, roads and other facilities which those countries so desperately need.

I put it in its most simple terms when I speak, as I do on

frequent occasions, to children, particularly, in those African countries such as Zambia. 'What happens', I say 'when copper runs out?' (Copper is, of course, Zambia's number one asset.) 'You will end up with the biggest hole in Africa; up on the copper belt, there is one hole which is three miles across and one mile deep – and no more copper. Copper does not renew itself like wildlife does. It is your other great treasure, which will go on renewing itself forever, if left alone. It could be your main source of foreign exchange if you can 'sell' that priceless asset to people all over the world who will pay large sums of money to come and see it. What do you call a man who goes into a copper mine and steals the copper? He is a thief and a criminal. You put him in jail for his crime. What do you call a man who goes into a national park and kills animals so that he can sell the ivory, skins and horn? He is also a thief and a criminal and should be treated in exactly the same way.'

The future of wildlife and the environment obviously lies in the hands of the children and I sometimes feel like giving up in utter despair when I see what man is doing to his fellow creatures; at the same time there is such a great response from so many primary school children to whom I speak. They really are keen, and they must be given every possible encouragement from outside.

One of the most encouraging things that I have seen in recent years was a photograph sent to me from the *East African Standard* of Nairobi. Right in the middle of the very worst of the poaching period in Kenya, when elephants were dying at the rate of 20,000 a year, African children who were members of the Kenya wildlife clubs (and there are 60,000 of them) decided to take matters into their own hands and march down the main street in Nairobi carrying placards saying, 'Hands off our wildlife, stop the poaching.' They do care.

In Zambia a few years ago I was asked to judge a nationwide painting competition for primary and secondary school children. This was open to all children in Zambia and the response was phenomenal. The subject for the painting was wildlife conservation. Entries came from many of the remotest schools and some of the paintings were scribbled on bits of brown paper in chalk because that was all they had. The two prizewinners were to win a return airfare to England to 'see their first elephant'. There was a tremendous response to the press release put out in this country. I was receiving telephone calls myself. 'What do you mean, to see their first elephant; they're surrounded by them out there in Africa.' Such is the misconception so popularly held. In fact, the chances of any child in Zambia seeing any animal bigger than a bushbuck is remote indeed. Virtually all the wildlife is now confined to national parks to which the children have no chance of any access because they have neither the transport nor the money. They will certainly never have seen an elephant.

I was somewhat fearful of the reaction on behalf of the prizewinners when they arrived at Gatwick. I need not have worried. I was not there myself to meet them but I did meet them a couple of hours later at Regents Park Zoo in London. By this time, they had seen their first elephant and their eyes were popping out in wonderment. The smaller of the two, a Zambian child of eleven, was holding forth in perfect English to the *Manchester Guardian*, *The Daily Telegraph*, and *The Times*. I stood back and listened. 'I have been down to the sea for the first time. I have been into the House of Commons. I bet Mr Shepherd hasn't.' (I haven't – and I am almost a Cockney by birth!) The press were enthralled. It made a wonderful story and it illustrated just how little we know about the real situation concerning the wildlife of Africa, and the people who will be its future guardians. So there is hope – something President Kaunda of Zambia said to me once implied that, if he could, he would turn the whole of his country into a national park.

The early Victorians wrote of 'darkest Africa'. It is hard to imagine a more inappropriate description of a landscape that is a blaze of sunlight. To someone who has been there and whom the magic has touched, words from someone else are unnecessary; he already knows. Africa calls the traveller back again and again. One can forever remember the smell of early morning in the bush when it is still cool; the sun is rising – that so sudden sunrise when it is immediately full daylight – and life begins to stir. Or, how, at night, one feels totally at peace with nature under an African sky impossibly filled with stars. On foot, confronted by a herd of elephants a few yards away, how small one

feels. And there is so much more – the thick bush which I love, the hot dusty yellow thorn scrub through which one can always imagine eyes peering at the intruder, the great sweeping cloudscapes of the Serengeti and the feeling of infinite space. Who can forget the experience of standing on the edge of an escarpment and looking across mile upon endless mile of nothing except bush, straining one's eyes to their limit for a pinhead of movement, and seeing one after a long search? Can it be an elephant so far down below, going about its daily business undisturbed?

Man has an unparalleled ability to destroy. We are the most powerful animal; but we are only another animal, totally dependant on all life around us. For centuries, in his infinite stupidity, man has been killing, poisoning, burning, cutting and destroying for quick commercial gain and senseless greed, but never more so than in the last seventy years. How long can our fragile earth, our only earth, survive this treatment? If he destroys all life around him, man destroys himself. He is, I believe, on a suicide course. Will he ever learn?

The future of all life on earth now is in the hands of our children. Time is running out fast for the elephant, tiger, the great whales, the tropical rain forests and countless species of bird, plant and insect life, all of which form part of the intricate and priceless ecosystem of our natural environment. The lesson must be learned, quickly, for in his infinite wisdom man has also an unparalleled ability to repair the damage. He has, however, very little time left in which to do so.

I feel privileged that I have been one of those relatively few people who have experienced, and been a small part of, the great African scene which forever leaves such an indelible mark on one's mind. Memories of impala grazing peacefully, hippo basking in the heat of an African midday, or sixty elephants playing in a river completely undisturbed, are treasures that I shall always cherish. I always feel better when I have been watching such a scene, but have I been in on the final act? I cannot help but wonder. Is there really room on earth for the magnificent elephant or the prehistoric rhino? But although I believe the future for all my wildlife friends is indeed bleak, one must have faith. I have seen and seen again the still unspoilt beauties of Africa and India, and if in some minute way in the scheme of things I have been able, through my paintings, to enlighten just a few and to give pleasure to those who will never be as fortunate as I, then I am a happy and very, very lucky man.

I would like to most sincerely thank all my friends who have helped me in the preparation of this book.

When the idea of a collection of my paintings was first conceived, I thought that it would be a simple matter of just selecting some seventy pictures out of more than three thousand that I have so far painted. As time went by, the project grew in scale alarmingly. Not only did I realise very quickly how difficult it would be to choose which ones would make up a representative selection; as I reflected on each painting, I recalled so many memories and anecdotes that I found myself tempted to write a book on each.

No discourtesy is intended if, in some cases, no credit is given as to the ownership of a particular painting. It is simply that over the years many of my pictures have changed hands and I no longer know where they are. The most appropriate thing, therefore, is to thank everyone and I hope that you are not too surprised if you suddenly find your painting in this book.